The Folk Arts of
Norway

The Folk Arts of Norway

by Janice S. Stewart

SECOND ENLARGED EDITION

DOVER PUBLICATIONS, INC.
NEW YORK

Published in Canada by General Publishing Company, Ltd.,
30 Lesmill Road, Don Mills, Toronto, Ontario.
Published in the United Kingdom by Constable and Company,
Ltd., 10 Orange Street, London WC 2.

This Dover edition, first published in 1972, is a revised and
enlarged edition of the work originally published by The University of Wisconsin Press in 1953.

International Standard Book Number: 0-486-22811-8
Library of Congress Catalog Card Number: 74-184687

Manufactured in the United States of America
Dover Publications, Inc.
180 Varick Street
New York, N.Y. 10014

PREFACE TO THE DOVER EDITION

THIS EDITION OF *The Folk Arts of Norway* contains 47 supplementary illustrations which were not included in the original edition. They have been placed at the ends of the various chapters and numbered separately from the original illustrations, beginning with S1 following page 54. The five color plates in the original edition have been omitted and the 20 color illustrations in this book substituted, as more successful representations of Norwegian folk art material. The text has not been altered significantly.

J.S.S.

PREFACE TO THE FIRST EDITION

IN VIEW OF the popularity of peasant art of all kinds, it seems quite timely to write a book on the peasant art of Norway. This is, so far as I know, the first book to be published in English on this subject. Norwegian art in the form of *rosemaling* has come into the popular interest in the last few years through the efforts of professional decorators such as the late Per Lysne of Stoughton, Wisconsin, through magazine articles, handicraft groups, antique dealers, and as the heritage of people of Norse descent living in the United States. It is adaptable both to colonial or provincial styles of decoration and to modern *décor* and so has a universal appeal.

In this book I have covered the six main types of Norwegian folk art: carving, *rosemaling*, weaving, embroidery, costumes, and silverwork. I have tried to place them in their natural setting by presenting the conditions from which they arose and in which they existed. In any book of this sort, one of the most important features is a large number of illustrations. Here the illustrations have been chosen to serve as examples from which amateur craftsmen can adapt designs into their own work. They will also serve as a means of comparing the art of Norway with that of other countries, Russia, for instance, whose peasant art is very similar to that of Norway. And they will be of interest to anyone interested in historical matters since most of the objects pictured have historical value. Perhaps most important of all, these illustrations provide a visual acquaintance with Norway's folk art for those whose interest is purely cultural.

Professor Einar Haugen, head of the University of Wisconsin Scandinavian Department, has been a most patient and encouraging

mentor in this undertaking. I wish to thank him for the many hours he has spent going over my material, and for the countless other ways in which he has eased the production along. It was through his efforts that I received a research grant from the University of Wisconsin.

Mrs. Tora Sandal Bøhn, a curator of the museum in Trondheim, Norway, read and corrected the script for all except the chapter on metalwork. Her close acquaintance with Norwegian folk art made her suggestions very valuable.

Miss Helen Allen, professor in the Home Economics School of the University of Wisconsin, corrected the script for the chapters on weaving and embroidery. She was able to clarify certain of the processes for me and to provide American terms where Norwegian expressions did not permit a direct translation.

I wish also to thank the following people and organizations: Rikard Berge for permission to use the quotation in Chapter Five; Tora Sandal Bøhn for permission to use the quotation in Chapter Four; writers of the various books from which I drew material and which are listed in the bibliography; the Norwegian museums and publishing houses and the Norwegian-American Museum, Decorah, Iowa, for permission to print the many pictures for which they are credited throughout the book.

Locating the necessary pictures was a particularly difficult job since the prints were scattered all over Norway and many that I requested were no longer in existence. Fru Kari Løchen, a museum worker of Oslo, Norway, did a very commendable job of searching for and selecting the best available pictures. Illustrations for the costume chapter have been made from slides taken in Norway by Professor Einar Haugen.

Finally may I credit my family with a great amount of patience and tolerance, and hope that they will find their part in the making of this book worthwhile.

<div align="right">Janice S. Stewart</div>

Chippewa Falls, Wisconsin
May, 1953

CONTENTS

LIST OF ILLUSTRATIONS

SUPPLEMENTARY ILLUSTRATIONS

on or following page

COLOR ILLUSTRATIONS

(*Following page 8*)

THE SCANDINAVIAN REGION

OUTLINE SHOWS THE LOCATION OF
THE MAP OPPOSITE

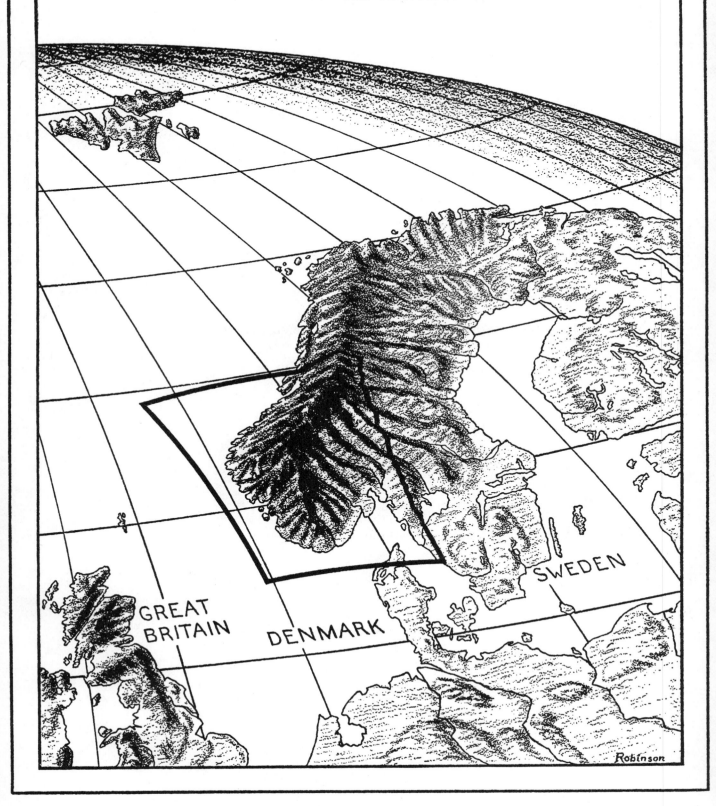

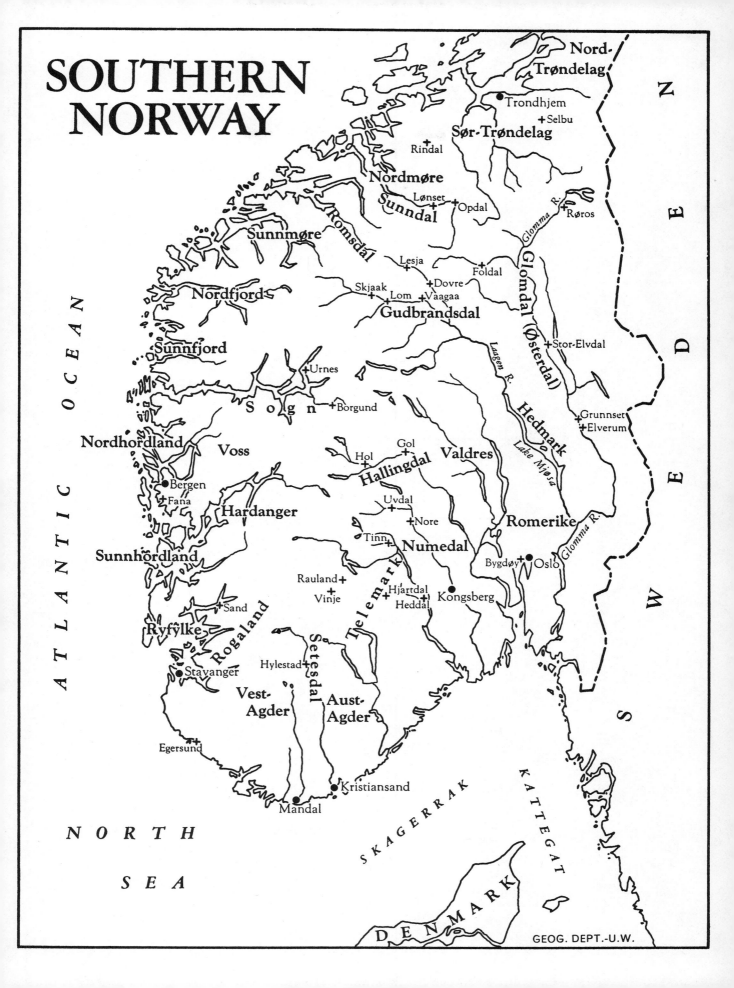

SOUTHERN NORWAY

Nord-Trøndelag

Trondhjem
Selbu

Sør-Trøndelag

Rindal

Nordmøre

Lønset
Sunndal
Opdal
Røros

Romsdal

Lesja
Foldal

Sunnmøre

Skjaak
Dovre
Stor-Elvdal

Nordfjord

Lom
Vaagaa
Gudbrandsdal

Glommal (Østerdal)

Glomma R.

Sunnfjord

Urnes

Laagen R.

Hedmark

S o g n

Borgund

Grunnset
Elverum

Nordhordland

Voss

Hol
Gol

Valdres

Lake Mjøsa

Hallingdal

Bergen

Fana

Uvdal

Hardanger

Nore
Romerike

Tinn

Numedal

Glomma R.

Sunnhördland

Bygdøy
Oslo

Rauland
Vinje

Hjartdal
Heddal
Kongsberg

Sand

Telemark

Ryfylke

Rogaland

Hylestad
Setesdal

Stavanger

Vest-Agder
Aust-Agder

Egersund

Kristiansand

Mandal

A T L A N T I C O C E A N

N O R T H

S E A

S K A G E R R A K

K A T T E G A T

D E N M A R K

N
E
D
E
W
S

GEOG. DEPT.-U.W.

The Folk Arts of
Norway

Of Vikings and Farmers

1

THERE CANNOT be complete understanding of an art unless there is a comprehension of the human element in it and the conditions under which it grew. Norway's folk art is a particularly striking example of this premise and one with a long and fascinating history.

It would not be practical in a book on folk arts to discuss thoroughly every phase that preceded the period being studied, in this case, the seventeenth, eighteenth, and nineteenth centuries. However, in Norway's folk arts there are many design elements that go back to Romanesque times and some even to the Viking period. The techniques used in this art are still more ancient and represent a more truly continuous development than design. Designs could be copied, techniques had to be learned. It is this very fact that makes it possible for us to trace the slow spread of civilization from the Mediterranean into the North and to realize how extensive travel and trade must have been, even in the Stone Age.

Norway's Stone Age lasted until about 1500 B.C. and was characterized by stone implements, shore-line habitation (Norway's mountains line the coast as well as occupying most of the interior), and a hunting and fishing culture with little agriculture and no real architecture. It was a mobile population, wandering about the Scandinavian peninsula and mingling with the tribes from Sweden and Finland and Russia, crossing the water to Jutland and various islands along the coast, and perhaps even to England. This conclusion is indicated by the similarities in manufactured objects and burial methods found in widely scattered locations, and later by the ship drawings carved into rock at various places throughout the country.

Denmark was Norway's source of inspiration and supply from the Stone Age throughout most of history. Material objects were most quickly taken over, often being copied in a more primitive material. Art forms followed one upon the other in a constant order as they had done in every preceding civilization all the way across the continent. Ideas of religion and society were accepted slowly, the time interval in direct ratio to the distance traveled. Northernmost Norway was still in the Stone Age when the southern part of the country was well into the Age of Bronze.

As with all primitive peoples, geometric motifs predominated in Norway's paleolithic art. The beautifully done full-scale animal forms that were carved or painted on rock were apparently not intended for decorations but for luck in the hunt. These drawings were executed only in outline with an understanding of anatomy and movement. They were supplanted in the Bronze Age by very stiff, almost unrecognizable animal drawings which were purely symbolic and still not intended for decoration.

The art of the Bronze Age added the classical spiral to the geometric motifs of the preceding age and used it on everything from buttons to axes. In time the designs became bolder and more exaggerated. Human and animal figures were introduced from southern Europe,

first as incised surface designs and later as cast figures for an early form of amulet. Casting and incising were the only techniques used in Scandinavian metalwork at this time, but they were highly developed. Norway's treasures from the Bronze Age, while much fewer than those of Denmark, supply evidence that bronze objects were made within the country as well as being imported. Bronze had to be imported by both Norway and Denmark from eastern Europe. Denmark had good supplies of amber with which to barter for metal, but Norway was virtually without trade goods. This helps to explain why Norway's early bronze finds are so meager.

The trend toward an agricultural society that had started in the previous period developed rapidly during the Bronze Age. The climate was warmer and drier than it is now and the people were seminomadic, moving from place to place as the soil became depleted. Their dwellings were rude huts of wattles and clay; they needed no permanent shelter until a sudden change in climate around 500 B.C. forced them to build more effective protection from the weather.

Inclusion of the fire within the dwelling was doubtless the first step toward more comfortable living. This meant an increase in the size of the building and the construction of a smoke vent in the roof. In time the house acquired a rectangular shape and a length of thirty to ninety feet. It had low outer walls of stone and earth and a row of pillars down the center surmounted by horizontal lengthwise beams to support the roof. Animal shelters and fences were also constructed, and thus the first farms were built up, the beginning of the farm society which has been the foundation of Norway through the centuries.

During the Bronze Age new developments had been carried to the north along ancient trade routes from Italy and southeastern Europe and ultimately from Asia. But with the approach of the Iron Age (500 B.C. in Norway) these routes were cut off by the Celtic migrations and the only contacts were with Celts themselves. Their domain

extended all the way across central Europe to the Black Sea. Contacts with southern Russia and the Mediterranean countries brought Scythian, Greek, and Roman influences into Celtic art and indirectly to Scandinavia.

The increased use of iron was a direct result of Scandinavian intercourse with the Celts. Iron bogs were plentiful and the method of extraction was easy to learn. Two thousand years later Norwegian farmers were still making iron in virtually the same way. Weapons were quite naturally the most numerous items in this new metal, but it was also used for ornaments, though not to the extent that it displaced bronze.

Norway's situation at this time appears to have been worse than in the preceding period. The change in climate and loss of direct contacts with the Mediterranean because of the Celtic barrier, together with a paucity of trade goods, prevented any real advance in this period. But with the establishment of the Roman Empire the situation changed. The Romans never actually reached Norway, but their arrival at the mouth of the Rhine marked the beginning of a lively trade. Norwegian furs and blond hair were introduced to Roman shops. Blond, blue-eyed Norwegian men gained great favor as soldiers in the Roman troops. And Roman ceramics, glass, and precious metals found their way into Norwegian homes.

Of more importance than the introduction of articles made in Rome or in the Roman provinces of central Europe was the new knowledge of ironworking techniques and more efficient tools such as the timber-axe, scissors, and distaff which the Norsemen quickly adopted. Locally made drinking vessels, bowls, and ornaments acquired a Romanized design including filigree and inlaid stones, and were made in much larger numbers than previously.

Wars in central Europe during the second half of the Roman period (third and fourth centuries A.D.) cut off direct trade between Norway and the South, and the trade routes shifted eastward. The

Goths, a Germanic tribe from some Scandinavian land, had moved down into southern Russia toward the end of the second century. They kept up their contacts with Germany and Scandinavia, bringing richer ornaments and new customs from the Roman frontier to the northern countries throughout the remainder of the Roman period.

It was a more complex and civilized age for northern Europe, a fact that was pointed up by the introduction of runic writing from the south German tribes sometime after A.D. 200. Runes were not meant to state facts but to work magic. They were replaced early by other writing in south German territory but lasted well into the Christian Middle Ages in Scandinavia.

About the middle of the fourth century the Huns chased the Goths from southern Russia, starting a mass migration of Germanic tribes into western and southern Europe and touching off the struggle between barbarians and civilized peoples that was to keep Europe in a turmoil for two centuries. Rome's cultural influence came to a standstill, and she had to pay huge subsidies in gold to nearby tribes to insure herself some degree of peace. The hoards of gold thus acquired by certain Germanic tribes were used in their trade with the North, making possible a much increased goldworking industry even in Scandinavia.

Norwegian goldsmiths developed the bracteate, a medallion-type gold pendant patterned originally on the old Roman coins. It was worn as a charm, a fact that is indicated by the runic inscription and the design, consisting of a head, a four-footed animal, and a bird, swastika, or triskele. Bracteates, large silver brooches, and the reintroduction of runes were Norway's contribution to the continental culture during the migration period.

The brooches have a special interest in that they present the first development of the Scandinavian animal ornament, the so-called migration style. It was a barbaric form of art, made up of highly stylized animal shapes and baroque heads. The brooch was massive,

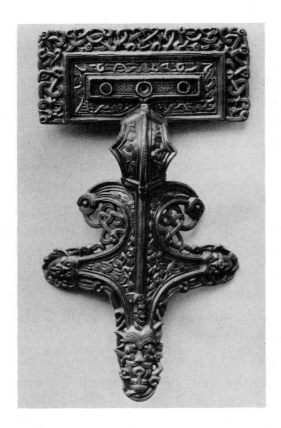

1. Migration-style ornament from about A.D. 500. UNIVERSITETETS OLDSAKSAMLING

up to eight inches long. It was cast of silver, heavily decorated with gilt, and sometimes set with garnets. It had a cruciform pendant and a rectangular headplate. The animals, executed in pierced-work, engraved relief, and filigree, are barely recognizable. They were purely decorative and not intended as a representative type of art.

There is disagreement as to the origin of the animal motifs used in this phase of Scandinavian decoration. It may have been inspired by Roman manufactures, by Oriental impulses coming in from southeastern Europe, or it may have been a completely original development. At any rate it was a highly localized style, concentrated in the countries around the North Sea (including England). This and other features of the migration period show how close was the relationship between Scandinavia and western Europe, a situation that was to become still more pronounced as far as western Norway was concerned.

I. Chest from Vestlandet. MITTET FOTO A/S

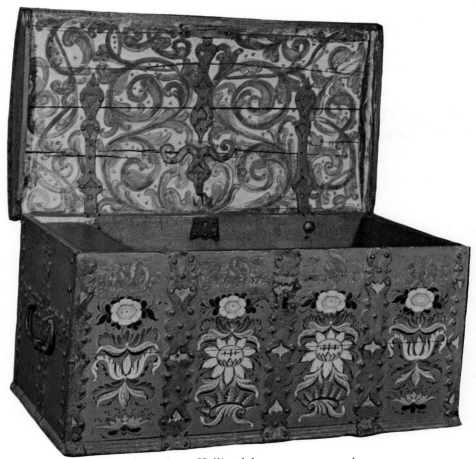

II. Chest from Hallingdal. MITTET FOTO A/S

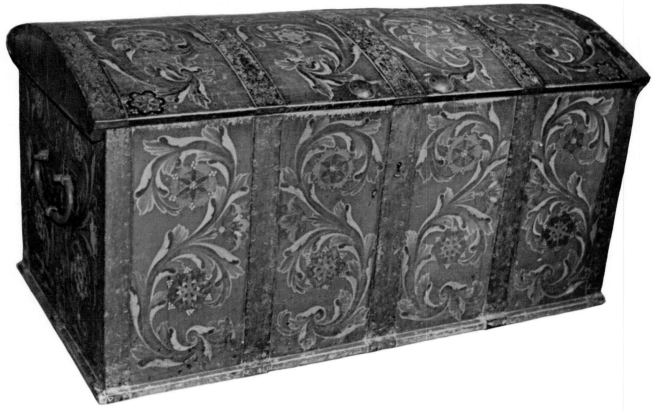

III. Chest from Gudbrandsdal, now on the Bjørnstad farm, Maihaugen.
DEAN E. MADDEN

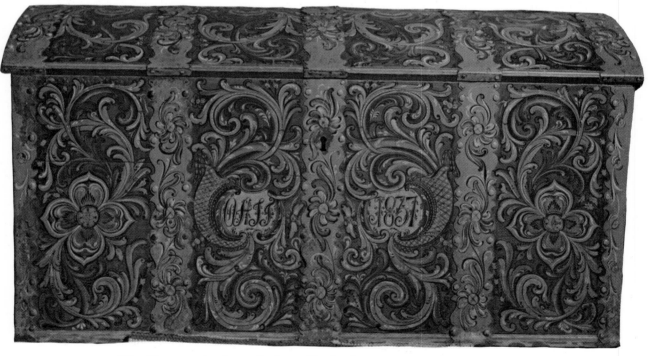

IV. Chest on the Lognvik farm, Rauland, Telemark. DEAN E. MADDEN

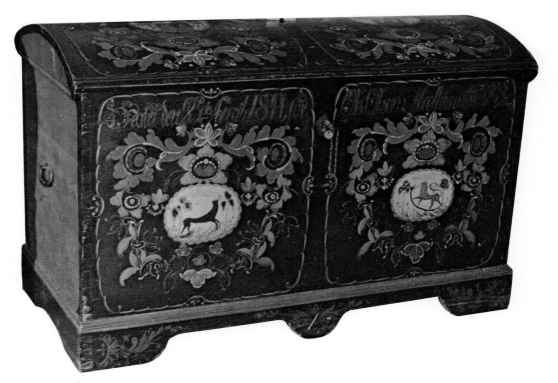

V. Chest from Hol, in Hallingdal, now at Drammen Museum. DEAN E. MADDEN

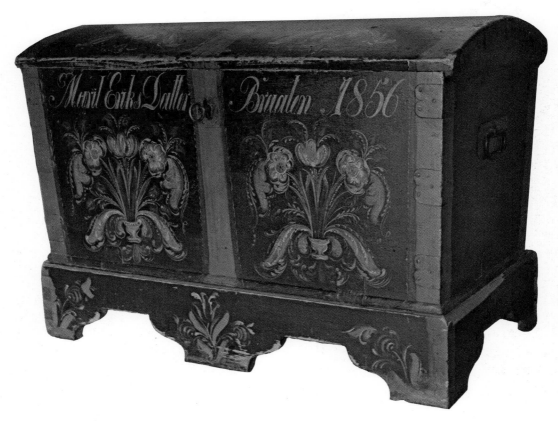

VI. Chest from Valdres, at Valdres Folk Museum. DEAN E. MADDEN

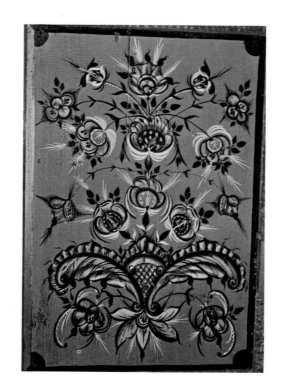

VII. Door panel by Hauk-
jem, Numedal. Now at
Drammen Museum. DEAN E.
MADDEN

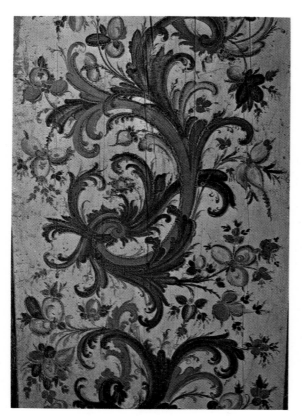

VIII. Part of door panel by Knut
Mevasstaul, at Klomset farm in Tele-
mark. DEAN E. MADDEN

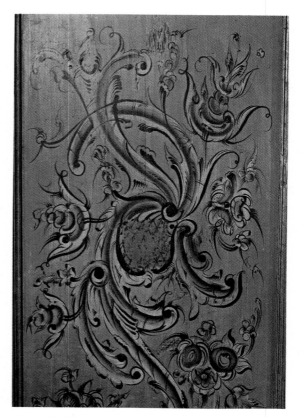

IX. Part of a door panel from Skur-
dalen in Telemark. DEAN E. MADDEN

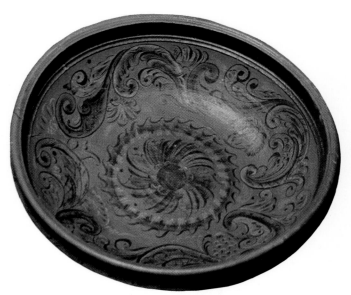

X. Ale bowl from Gudbrandsdal. NORWEGIAN-AMERICAN MUSEUM

XI. *Rosemalt* wooden basket from Telemark, at the Fylkesmuseet for Telemark and Grenland. DEAN E. MADDEN

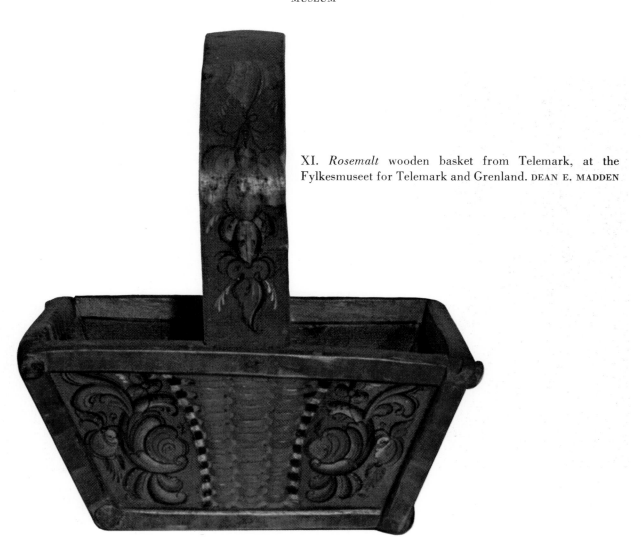

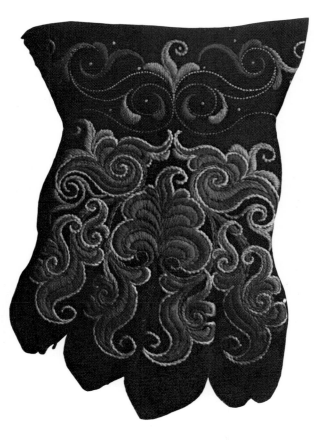

XII. *Rosesaum* glove from Telemark, in the Bergens Museum. DEAN E. MADDEN

XIII. Bodice and cap of Hallingdal costume, with *rosesaum*. DEAN E. MADDEN

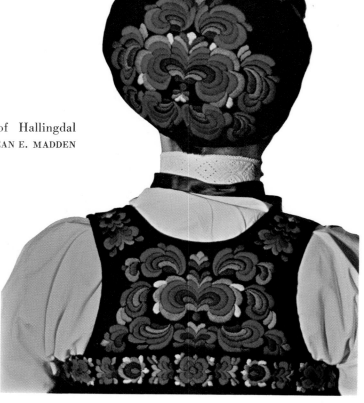

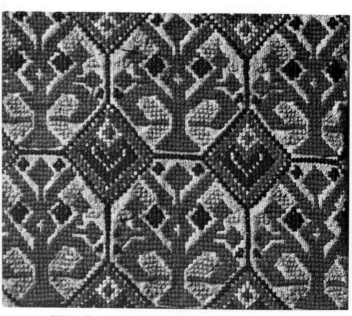

XIV. Appliquéd breastpiece for Sogn
costume. DEAN E. MADDEN

XV. Cross-stitch breastpiece. DEAN E.
MADDEN

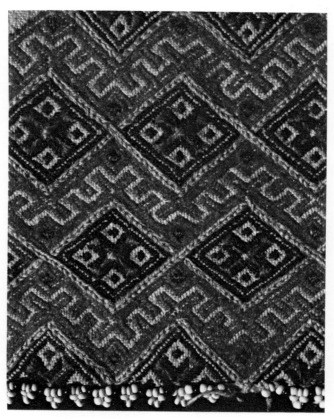

XVI. Pattern-darned breastpiece. DEAN
E. MADDEN

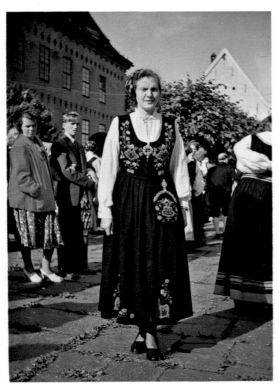

XVII. Valdres costume. EINAR HAUGEN

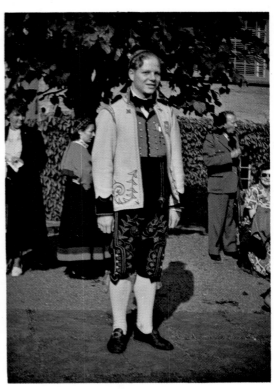

XVIII. Hallingdal bridegroom's costume. EINAR HAUGEN

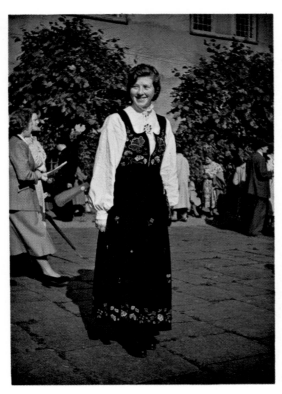

XIX. Gudbrandsdal (Vaagaa) costume. EINAR HAUGEN

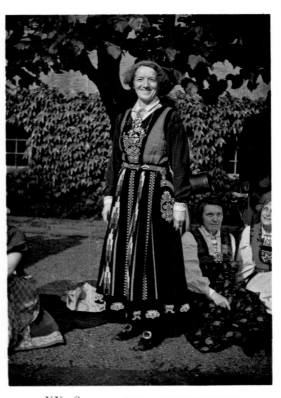

XX. Sogn costume. EINAR HAUGEN

During the two centuries between the end of the migration period and the beginning of the Viking era, changes occurred in Scandinavia and in central Europe that opened the way for the worst and most prolonged siege of piracy history has ever known. The changes touched every phase of civilized living from political organization to ship building.

A general taming down in east-central Europe had made it possible for trade to follow the eastern way again. Sweden lost no time in establishing trade with the Black Sea countries, thereby laying the foundation for later raids. Norway and Denmark developed faster and better ships with the aid of the new type axes and increased their contacts with the North Sea countries. In Norway there was a growing tendency toward combination of small groups or settlements into larger units under the rule of chieftains or kings, chosen from among the *bønder*, or landowning farmers. The resultant friction between groups and the abuse of power by many leaders who gained and held their positions purely by force, together with the increasingly crowded farming conditions along the coast, were the instigating forces behind the Viking explorations and raids of the ninth and tenth centuries.

Meanwhile, Sweden was becoming stronger both politically and economically. Her trade with Italy and Byzantium had brought in examples of the interlaced band ornament that was to gain popular

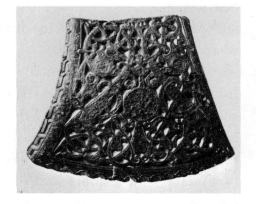

2. Interlaced band ornament from the 8th century. UNIVERSITETETS OLDSAKSAMLING

use throughout Europe during the seventh and eighth centuries. Eastern Scandinavia was first to combine bandwork with the animal ornament from the migration period. In its early stages this combination is mainly a symmetrical pattern of lines of constant width, interlaced in any of various ways, and with animals as the connection between the several parts of the design. During the eighth century the design becomes freer, the width of the bands richly varied. It is mainly a surface treatment with very little modelling. Sweden and Gotland produced large numbers of technically excellent bronze engravings in this technique. Examples of Norwegian work from this period are few.

It was in the Viking period, the ninth and tenth centuries, that Norway came into her own. Very little had been known about the country by other Europeans even though it had figured in trading long before Roman times and had infrequently been written into Roman travelers' accounts from the first years of the Christian era. But with the Viking explosion, the Norwegians became all too famous. Beginning with scattered raids around the year 800, the Viking movement grew into a full-scale conquest, with colonization as both motive and result.

The Norwegians established bases in England, Ireland, and France from which to make their attacks. They acquired well-defined realms in all three countries and in Scotland, as well as on some of the North Sea islands. Their forays from Ireland extended into Spain, Italy, and Africa, and netted them Moorish captives, Arab silks, and other costly items.

Sometimes the Norwegian Vikings joined forces with Vikings from Sweden or Denmark. Danish operations covered the southern shores of the Baltic and the Frisian coast west of the Danish Jutland as well as England. As a rule, the Swedes confined their activities to the Baltic coast and Russia. They brought some degree of civilization to Finland and Estonia and established political control over the conglomeration of tribes in Russia. They built cities and made laws,

and traded the furs, wax, and honey taken from their Slavic subjects for the luxuries of Byzantium and Bagdad. To judge from the coins that have been found along the Viking trade routes, there was even some commerce with India and the Orient.

It is evident from the foregoing that Norwegian Vikings made contacts with most of the cultural centers of Europe and part of the Near East during the ninth and tenth centuries. Riches gained on such expeditions raised the artistic standards and increased the wealth of the country as a whole, but not everyone profited.

From the archeological remains and sagas of Norway, and the written accounts of other countries, it is evident that the Viking society was a natural development from the age of *bonde* chiefs, with a further movement toward national unity under fewer and fewer kings. There were thralls or slaves, free men who owned little or no land, the *bønder* or landed gentry, and the chieftains or kings. Chieftains began to take over many farms, retaining servants, and forming an aristocratic, though not quite feudal, society.

There were fights between the chieftains and with returned Vikings, who turned their lawlessness on their own countrymen. The general disorder gave impetus to the movement for national unity. This was achieved under the direction of the two Olafs, Olaf Tryggvason and Olaf Haraldsson. Both men were Vikings and traveled widely. Separately, they made trips to Russia, where they found Christianity strongly established. Olaf Haraldsson, by strong-arm tactics, virtually completed the Christianization of Norway before his death. He was sainted soon afterward.

The remains of the Viking age in Norway are extremely valuable as a record of life during the last part of the Dark Ages, not only in Norway but in Europe generally. In no place outside Scandinavia have graves been so completely furnished during this period, for Christianity had arrived elsewhere with its subordination of material possessions.

In Norway the old heathen custom of ship burial was still in use,

that is, burial in a ship with all the accoutrements of earthly living. Dirt or turf was piled over the whole so that the tomb became a huge mound. If a man was poor his casket was only a small boat, but a highborn person required a ship. Thus the Viking queen buried at Oseberg was given a full-size ship of the broad, low type used on inland seas.

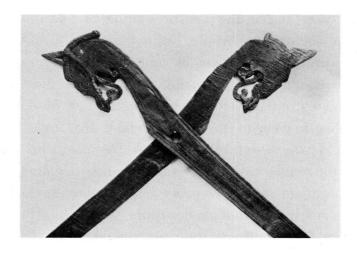

3. Tent staves from the Gokstad ship, *ca.* A.D. 900. UNIVERSITETETS OLDSAKSAMLING

It is a particularly graceful ship, built at the height of Viking glory. It contained everything a queen would need in Valhalla, including a servant woman. There were beds, chests, weaving and cooking equipment, sledges, a wagon, figure weavings and pattern weavings. Horses, dogs, and other animals were provided. Combs and jewelry, shoes, food, nothing was forgotten. As in previous finds the small items such as brooches are decorated in the prevailing style. But since this is the first instance where really large decorated pieces are preserved and since they reflect the same styles as the smaller items, the large wooden carvings will provide the most interesting examples.

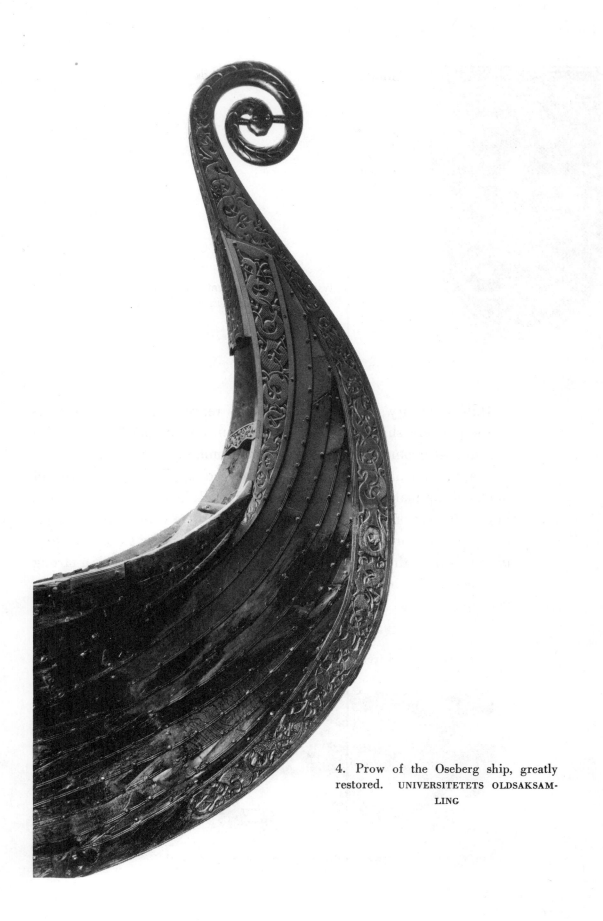

4. Prow of the Oseberg ship, greatly restored. UNIVERSITETETS OLDSAKSAM-LING

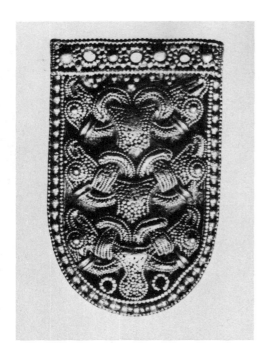

5. Viking-style ornament for a spur strap, *ca* A.D. 950.
UNIVERSITETETS OLDSAKSAMLING

Half a century's artistic turbulence is represented in the carvings
of the Oseberg ship. Classical motifs from Carolingian France and a
flat, almost geometrical band ornament combined with the inevitable
animal shapes are used on the oldest pieces. Then a new type of
modelled animal ornament is brought in, crude and barbaric at first
but an indication of the powerful style that is to come. As this style
develops, the preoccupation with surface decoration gives way to a
type in which the detail is subordinated to the whole form, a strong
and fierce, yet often exquisite art. The dragon head found on
the Oseberg ship is a refined example of this mid-ninth century style.

6. Carved sled from the Oseberg ship. UNIVERSITETETS OLDSAKSAMLING

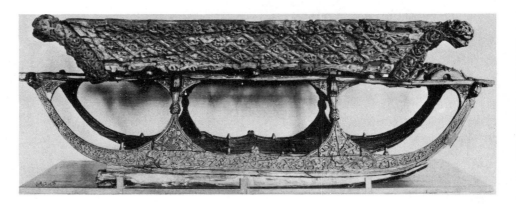

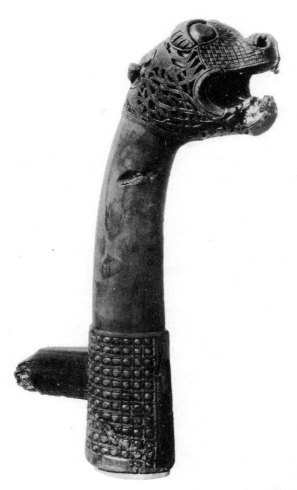

7. Carved dragon head
found in the Oseberg ship,
now in Universitetets Old-
saksamling. NORSK FOLKE-
MUSEUM

By the end of the ninth century and the beginning of the tenth, the pendulum starts the backward swing to surface decoration of lines in which form has no part. Celtic influence is largely responsible for this change. The animal motifs are still there, but they are soon joined by lobate leaf forms which eventually, for a short period, displace animal forms entirely. The plant designs are reminiscent of the animal and band interlacings of the postmigration period. They may have been introduced from western Europe, or they may have come from the Near East, by way of Constantinople, for it was at this time that Viking trade through Russia was at its height.

Concurrent with the plant decoration, there appears a pictorial art in Scandinavia in which ships, men, and animals are presented

in story form. They may be carved in stone or cast in bronze and are representational rather than ornamental. In time they are treated more and more decoratively and their final development, the last phase of Norse animal ornament, is represented in the Urnes church carvings of the second half of the eleventh century. The animals are highly stylized, the convolutions elegant. The intertwined bodies fall in several planes and are roundly modelled.

The Middle Ages in Norway covered the period from 1030 to 1536. Now for the first time, through the introduction of Christianity, Norway was culturally and religiously part of Europe. Churchmen, sent from England and Denmark by the pope to develop the new religion and to train Norwegian priests, were also effective spreaders of European culture. They brought the Roman alphabet and adapted it to the new language. Church art, which required the services of great numbers of woodworkers, metalworkers, weavers, and other

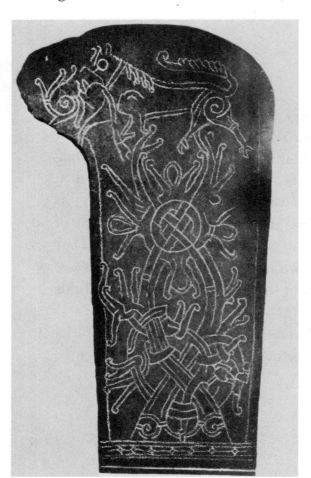

8. Eleventh century stone from Vang, Opland, showing transition to plant motifs. UNIVERSITETETS OLD-SAKSAMLING

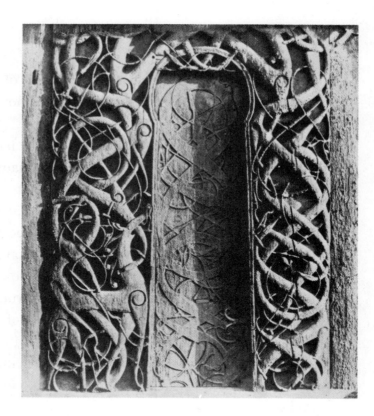

9. Urnes church carving *ca.*
A.D. 1050.

craftsmen, was based on European styles and showed an emotionalism
new to Norwegian art.

Though the old Norwegian civilization was too firmly established
to be displaced completely, it absorbed much of what Europe had to
offer and applied it to the local situation. When one realizes that the
new Norwegian priests were but recently converted from paganism,
one can easily see why pagan symbols and festivals were carried over
with little change into the Christian church. Heathen gods became
trolls, the heathen rites were turned into Christian ceremonies, and
though the cross protected the church from within, the heathen
dragon stood guard on the ridgepole.

It is thought that the early Norwegian stave churches, Urnes in
particular, were a perpetuation of old pagan temples. Intriguing as
the question is, it will probably never be fully answered. There are
no pagan temples left in Norway. The general belief is that Christian
churches were built on old temple sites, perhaps even making use of

part of the old building. Just how much of the Viking-like carving is a direct inheritance from pagan art and how much is a Romanesque development is difficult to determine.

Urnes church, in Sogn, is supposed to have been rebuilt around 1150 A.D., over a century after Christianity was imposed. The carving on the door belongs to about 1050, the final phase of Viking ornament, and may actually have been part of a pagan temple. The church is the single-nave type with the roof supported on large wooden pillars placed along the long walls. Its construction was evidently based on shipbuilding techniques and its plan is similar to that of the Iron Age house. Thus it would seem to be basically a native development. However, the use of carved capitals and the addition of a choir is definitely a Christian influence. In the later stave churches, there are many features in common with the Romanesque basilica, such as the triforium, clerestory, triple nave, and arches.

The external appearance of the larger stave churches is remarkably suggestive of pagodas. This is due to the succession of roofs and to the dragon heads that rear from the main gables. The lowest and outermost roof covers the *svalgang*, a semienclosed walkway around the church proper. The second roof covers the aisles and, like the first one, extends all around the church. An ordinary gable roof rises high above the nave, and astride the ridge there sits a "roof-rider" or cupola with three roofs of its own. The apse and the choir also have three roof levels to harmonize with the rest of the structure. A separate bell-tower houses the bell, a little way from the church. Diamond-shaped shingles are used on the roofs and sometimes on the walls as well. The whole building is of wood, built with a thorough appreciation of wood's possibilities and limitations.

Romanesque influence effected minor changes in the church portal designs without, however, losing the close rhythm and the multiple plane presentation of the earlier carvings. Gradually the major

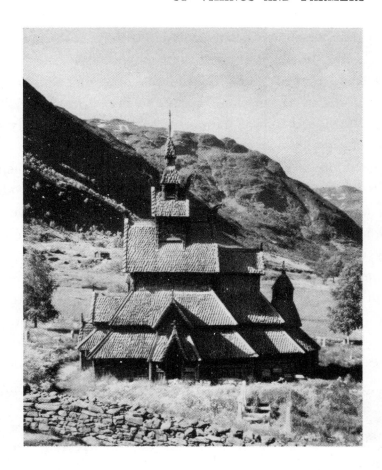

10. Borgund stave church. FOT. NORMANN

part of the portal acquired plant motifs, with the large winged dragons and sometimes a lion only at the top. The carving still has a strong Scandinavian mood.

Another development of Romanesque art brought figure carving into Norwegian church art. Worked out in low relief are whole panels of Biblical scenes or pictured legends, the most popular being Sigurd the Dragon-killer. Pictorial portals are not very numerous and are concentrated in southern Norway. The Hylestad portal from Setesdal, with its six scenes from the saga of Sigurd is the best of

those remaining. Each scene is encircled by a Romanesque vine which like the dragon is rhythmically convolute.

This trend toward a new type of plant carving and some figure representation was Eastern in origin and may have come directly to the North with returning Crusaders as well as indirectly through Europe. Its point of distribution was Constantinople. It should be mentioned that carving of wood in bold designs was not the only art connected with medieval churches. Many treasures were produced for church use, among them beautiful wall hangings and silver vessels. They were imitated by the farm people for use in their homes, though usually in cheaper materials.

The majority of the stave churches were built in the twelfth and thirteenth centuries. Of the hundreds that were constructed, only a few are left. Log walls began early to replace the old pillar and vertical plank construction, and in many parts of the country stone churches were built right from the start. Gothic styles were intro-

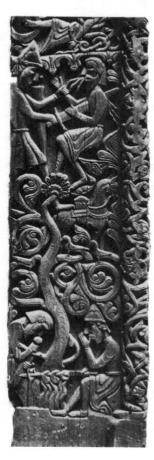
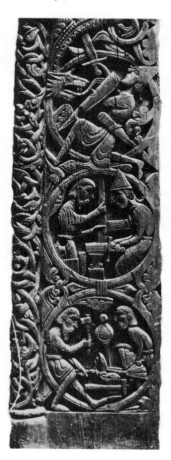

11. Remains of the portal of Hylestad church. UNIVERSITETETS OLDSAKSAMLING

duced to the country in the twelfth century but never became very popular in the country districts. Instead the Romanesque vine-carving continued in use until the Renaissance and in some districts even longer.

Extensive trading in the thirteenth century brought a host of foreign influences into Norwegian ports, from which they gradually worked inland. The country was quite cosmopolitan. Cities began to grow up around the market places, the clergy gained more and more power, the nobility acquired large land holdings, and the farmer's position declined correspondingly. Many of the old free-holders lost their lands and became tenant farmers, though there were still enough landowners left to start a series of civil wars in the twelfth century.

The thirteenth century has been called Norway's Age of Greatness. It was politically strong, and better organized than most other European countries of the time. Foreign trade was still flourishing and cities were growing fast. Artistic standards were high and although the farm families could not hope to compete with professional artists, their handicrafts were good enough to have a market in town. Most important, they themselves were patrons of a highly developed country art produced by rural artists, in which the native styles were seasoned with the continental.

Toward the end of the century fortunes began to change. Wars with Denmark forced Norway to give up much of her trade to the Hanseatic cities. She became involved with them both financially and politically, and the situation was made much worse in the mid-1300's when the Black Death destroyed so much of Norway's farm population that there were not enough people left to maintain the food supply. The drop in land prices wiped out many an estate and both the church and the nobility suffered. More borrowing from the Hanseatic merchants, together with weak royal policies, put Norway under domination of Denmark and Sweden in the fourteenth cen-

tury, and by 1397 the country was completely in Danish control.

All this upheaval was much harder on the upper social stratum of Norway than it was on the lower. Cultural life of the higher classes was at a standstill during this period, but the *bonde* families carried on the old traditions with little change. Pride of family and of their position as hereditary landowners was so deeply ingrained in the *bønder* that even when they later were reduced to the same circumstances as other farmers, they remained conscious of their special position in Norwegian society and avoided intermarriage with other farm classes.

Many of the *bønder* were of noble or even royal ancestry. They were respected even by the upper classes, and when Danish officials tried to relegate them to serfdom, the *bønder* would not submit. Their ancient rights were being abrogated. The one to settle the problem was, of course, the "father" of the national family, the king. So they took their grievances to him, time after time, and he rarely turned them away. Such fearless insistence on justice, at a time when the farmers of other countries were little better than slaves, is a revealing trait of the Norwegian *bonde*.

This belief in hereditary rights and in the king as a benevolent patriarch did more to hold the country together and to preserve the unique rural culture of Norway than any appeal to nationalism could do. Distrust of the officials sent in from Denmark and Germany soon brought on distrust of anything foreign. Thus began the resistance to new ideas, the reputation for backwardness, that was to last well into the nineteenth century.

Even in the field of art, or perhaps especially in the field of art, the *bønder* were reluctant to accept anything new. The rich Catholic furnishings that had been stripped from the Norwegian churches during the Reformation were replaced by Renaissance art at the beginning of the seventeenth century. But it was not until the end of the century that the Renaissance showed any real effect on the folk art, and in many places it made no inroads at all.

By this time *bonde* art was really a folk art. Unlike the Middle Ages, when the leading farm families had been patrons of the national art and had kept up with European trends, they now harbored an art distinct from that of the higher classes and nearly independent of the continental styles. Lack of artistic interchange resulted in a diversity of styles within the country far greater than that of the Middle Ages. It was the beginning of district art. The richest development of this art came in the eighteenth century when, because of various factors, the country's position had been strengthened substantially, and both the wealth and the social position of the landed farmers had regained something of its former status.

Trading was once more widespread, though controlled by Dutch or English shippers, and foreign influences other than Danish or German again flowed into the country. The interior was opened up through the construction of new roads and removal of marketing restrictions, development of natural resources continued, and the population grew by leaps and bounds.

A wave of building activity spread through the country. The old open-hearth log houses were replaced by two-story houses with masonry fireplaces, or old houses were remodelled to incorporate the new conveniences. Whole communities converted to new houses within a decade, furnishing the homes with baroque-styled furniture and decorating furniture and doors with a polychrome floral decoration called *rosemaling*. The rate of conversion varied from district to district. Some areas were too poor to do any extensive restyling during the eighteenth century. Others were resistant to the new methods of building. The distinction between city and country homes was still appreciable, and except in the vicinity of the cities, it remained so until the late nineteenth century. But in the country as a whole, modernization moved along at a gratifying rate.

Patriotic fervor was growing stronger in Norway, as it was in France and in America, fed partly by new social concepts and partly by pride in the national army, the one really Norwegian thing that

the people could fasten their loyalties to. The Danish alliance with Napoleon against victorious England and Russia resulted in Norway's being handed over to Sweden in January, 1814. Norwegian patriots protested the action. Four months later, on May 17, 1814, they drew up a declaration of independence, framed a new constitution, and elected Christian Frederick of Denmark king. The Swedish king made a token invasion of the country, but within two weeks an armistice was declared. In November of that year Norway agreed to the Swedish proposition that she keep the new constitution but accept the Swedish king. Almost a century later, in 1905, the union with Sweden was dissolved and Prince Carl of Denmark was chosen king. He took the name Haakon VII. Thus Norway was once more an independent monarchy.

The latter half of the nineteenth century had a deteriorating effect on Norway's folk art. Cheap factory-produced goods displaced the more expensive handicrafted objects. Loss of pride in the *bonde* traditions, due partly to the shift of emphasis toward the individual rather than the family, made the farm people disdainful of anything characterizing the *bonde* life. The market for rural products dwindled rapidly and would have disappeared entirely had it not been for the Romantic movement.

Beginning as early as the 1840's, this movement sought to preserve the old folk costumes, songs, and crafts, in short, the superficial features of the *bonde* culture, without any real understanding of the philosophy behind them. The farmer was idealized in poetry, song, and art, arousing a new form of national pride in city and farm people alike. This did not mean a mass return to the eighteenth century life with its inconveniences, but it did mean that many old buildings were saved for outdoor museums, and that knowledge of handicraft techniques was not allowed to die out.

In time Norway came to appreciate its folk art for what it was, and with its halo off, it could be evaluated more realistically. There

was much that was poor in it but also much that was very good. Handicraft organizations have taken the good parts and applied them to modern needs, even modern materials and techniques. They have revived the old skills and have taught the people to appreciate form and color and to express it in their own way. Finally, they have built up a market for the new folk art and have provided retail outlets. Thus its future is assured.

In the Peasant Home

2

LIFE FOR THE Norwegian farmer has been filled with frontier hardships all through the centuries. Norway's terrain is for the most part not given to the use of combines and tractors. Many a farm clings to a steep mountain slope, many a field is still being ridded of its boulders, and communication with some districts is still difficult. The Norwegian farmer has won his living from time immemorial only through his own stubborn strength, and this power is evident in all phases of his art.

The most obvious example of this force is found in the old buildings. They were made of logs, huge ones, sometimes so large that three or four would make a wall's height. Great care was lavished upon their construction, for family feeling was strong, and a man built his house to last for his sons and his grandsons and great-grandsons.

With such a long-time view, he thought it not unreasonable to

26

spend years, perhaps even a lifetime in selecting the most perfect logs and in curing them to stonelike hardness. This he accomplished by topping a particularly desirable tree where it stood, usually a red deal or pine tree, and making a few deep gashes in the bark so that the resin would be drawn all through the wood. After a couple of years the tree was cut down, and in time it became extremely hard and highly impervious to moisture.

The greatest care was exercised in the construction of the house. Each log was carefully trimmed to lie tightly on the log below it. Even the extensions at the corners, where the logs crossed and fitted into each other, had to be so carefully notched and trimmed that a knife could not be slipped in between. Red or green homespun or moss was use for chinking, and this was forced into a slit in the underside of the log before it was laid into the wall. There was no need for great white strips of clay to fill cracks left by a hasty workman.

Sod roofs were the rule, and their weight demanded strong under-construction. First of all, a head beam was laid across at the top level of the side walls. This was to tie the walls together, keep them from spreading under the weight of the roof. In the oldest houses a roof beam extending the length of the house was fitted into both sides of each course of the gable, so that in the completed house, there might be one to three huge round beams on each side of the ridge beam or *mønsaas*. Across these, from side wall to ridge beam, planks or split logs were laid, with a cross board at the bottom to keep the sod from slipping off. Several layers of birch bark acted as protection against leaks, and sod was placed on top of this, grassy side down. Grass seed was then sown on top. The mass of roots and grass blades combined to form a solid covering.

Boards called *vindskier* were fastened to the edge of the roof to prevent the wind from getting underneath the sod and bark and tearing it loose. These *vindskier* usually ended in dragon heads or

12. Building in the Sandvig collection, Lillehammer, showing *sval, vindskier,* and gable ornament.

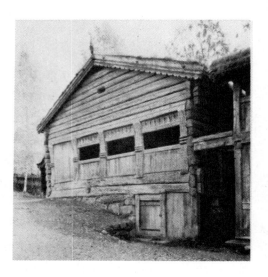

13. Close-up of carved gable boards (*vindskier*) and sod roof.

some such design, and were a carry-over from heathen times and Viking ships. Originally they were thought to be a protection from evil spirits.

Along the timber-poor west coast, simple vertical rafters or rafters with a *mønsaas* replaced the heavy lengthwise beams. Here the roof boards were laid horizontally, with the rest of the roof construction more or less the same as in the first type. When the last roof beam was in place it was time for the wreath party, and someone, usually the head builder, climbed to the top of the house and hung a wreath on the ridgepole. It was a gay time, made gayer with food and liquor. And if the refreshments seemed to the carpenters not quite fine enough to do justice to their workmanship, the owner might later find some little flaw in the finishing of his house!

Except for some changes in the method of joining the logs at the corners, the main construction of the buildings remained the same for many centuries. Sometimes the logs were split lengthwise, and after the coming of the water saw, heavy planks replaced whole logs,

particularly in the sparsely forested areas. But the walls still consisted of one layer on top of another, and we find the greatest development inside the house, especially around the fireplace.

In the oldest type of house, the *aarestue*, the hearth was simply a flat stone in the center of the dirt floor. There was no chimney, only a hole in the roof, covered when the fire was low by animal membrane stretched on a wooden frame. There were no windows, though there might be a small hole in the wall to furnish a draft for the fire. This hole was called a *vindauga* or wind-eye and is the predecessor of our "window."

The lowest row of logs was dug down into the ground to keep out the cold. The door was small and the doorsill high for the same reason. To enter, one had to step high over the huge log doorsill, and down onto the sunken floor, at the same time ducking one's head for the low door frame. Once inside, it took a few minutes to get accustomed to the dim light in the smoke-filled room. At the hearth one might find the housewife cooking one of the two hot meals of the day, while the rest of the family worked or rested on benches around the fire.

A wooden platform near the fire was used for eating and sleeping, and benches filled with dirt were lined up along the walls, serving the dual purpose of furniture and insulation against the cold. In such

14. The "old house" at Brottveit, Setesdal; an *aarestue* type. In the foreground is the stone hearth with the iron pothook above it. Carving on the doorposts is Romanesque.

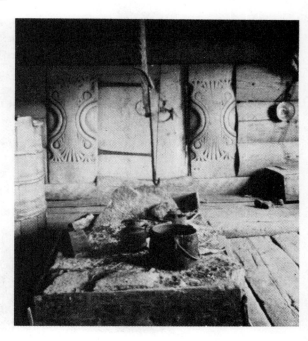

quarters the chief concern was in keeping warm, and little was done in the way of art. Colors would soon be blackened by smoke, and in any case, the room was too dark to display handwork properly. What decoration there was, was found on the doors and doorposts, which were carved in Romanesque or Celtic designs or even in the twisted animal forms of the Viking period. On special occasions bright tapestries might be brought out and hung on the walls and rafters to lend a festive air, but such decorations were meager compared to the flamboyant display of later centuries.

For a long time during the desolate period after the Black Death, little progress was made. Gradually, as life returned to normal, improvements appeared in housing, the first of which was to move the fireplace over into the corner next to the door. There still was no chimney, but there were stone walls on three sides of the raised hearth. These served to hold the heat during the day so that ordinarily, it was unnecessary to fire up except at morning and night. This new type of fireplace was called a *røkovn* or smoke-stove and the

15. Aamlid house from Setesdal, now in the Norsk Folkemuseum, Bygdøy. *Aarestue* type from about 1650. In the background are a *kubbestol* (tree-trunk chair) and a bed. On the shelf above are the trough-like wooden vessels used for serving or mixing. Table and bench are at the lower right corner. Doors lead to a storeroom and the entryway. NORSK FOLKEMUSEUM

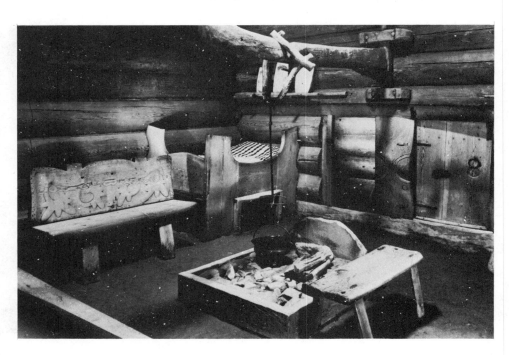

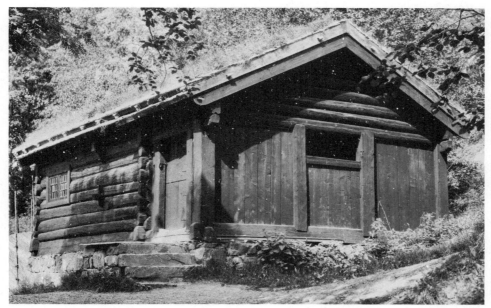

16. *Røkovnstue* in the Sandvig collection, Lillehammer. WILSE

house in which it was found, a *røkovnstue*. In some places the *røkovn* was constructed with a cooking hearth in front, in others the open hearth still was retained in the middle of the room for food preparation. Because of its heat-retaining properties, the *røkovn* was a wood-conserving device along the west coast. Farther inland, beyond the area of the warming Gulf Stream, the *aare* provided greater warmth, and since there was no fuel problem, the old open hearth was used until the introduction of the chimney.

The *røkovnstue* had achieved some changes in floor plan from the *aarestue*. Instead of having only one room, there was now a little foreroom or hall, quite often partitioned off at one end, which acted both as storeroom and as weather buffer. This *sval* was sometimes part of the log structure of the house, and sometimes was made of vertical planks, set in a log frame, with carved openings, large or small, depending on how much danger there was of enemy attacks.

In the main room of the house the *røkovn* was usually in the corner at the left of the door, with a high, boxed-in bed next to it. Next came the *høisæte,* or high-seat, the place of honor, used only by the head of the family. Actually it was just a bench, similar to the other

benches lining the sides of the room. In some homes it was distinguished by decorative panelling on the wall behind, or by a wall hanging, and a pillow with a decorative woven cover was placed on it. Originally the high-seat had been in the middle of the long-bench, but after the stationary table came into use, it was moved to the end of the table.

In front of these benches was a long table, parallel to the end wall, so as the men ate along three sides of the table, the women served and ate at the fourth. It was an arrangement for safety as well as convenience—no one was in the dangerous position of having his back to the door. And should it be necessary to leave one's meal in a hurry for the defense of his household, the table was quite strong enough to be leaped upon, for it was made of huge planks, laid upon two massive legs. It had had an interesting history.

In Viking times Norwegians had no tables as we know them. Men dipped their porridge from a common kettle and ate from wooden

17. Interior of a Hardanger *røkovnstue;* from a painting by A. Tidemand. The *røkovn* or stone-walled hearth is at the right of the door. The *ljore* or roof opening allows light to enter, and smoke to escape. Note the painted decorations around the walls. The carved plank extending above the fire screen was a talisman to protect the house against fire.

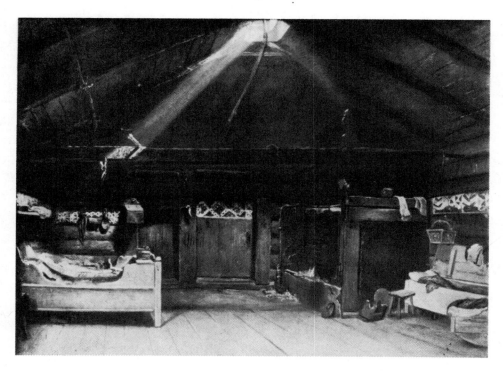

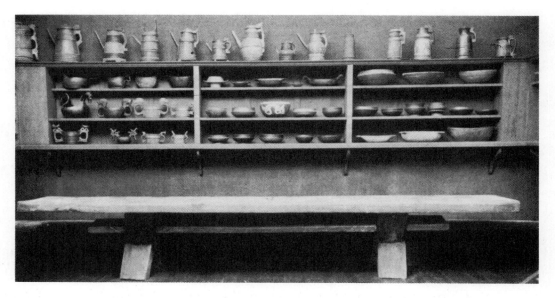

18. Early-type table from Setesdal. On the shelves above are ale bowls, tankards, *kjenger*, and *staup* from various parts of Norway (see Chapter 3).

trays, often round ones, which they held on their knees wherever they chose to sit. However, the trays were hard to balance, and they soon tried supporting the *borddisk* (related to our "dish" and the German *Tisch* or table) on three wooden legs. This worked quite well, but the table had to be hung on the wall out of the way between meals. So they attached it to the wall by one side and equipped it with a collapsible leg. This was all right for daily use but rather unsociable for festive occasions.

The first banquet table was a long board held on the knees of the banqueters. The obvious drawbacks of this method were reduced by setting the board on two stools or logs, with the men seated on benches on opposite sides. When not in use, the board was hung on the wall. There was a solemnity connected with gathering around a table, and for this reason the table was brought out only on state occasions. It was a long time before a table with a permanent base became common. But finally in the fifteenth century the two stools

19. Gothic-type trestle table from Romerike, dating from the 18th century. NORSK FOLKEMUSEUM

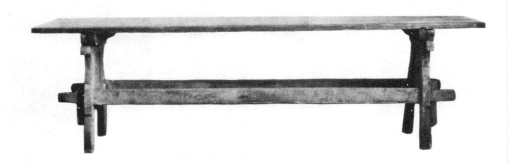

were joined by one or two lengthwise pieces, and the table was given a permanent place along the gable wall.

Chairs were not much used in the medieval farm home. There was something sacred about them, probably because they resembled the throne of the king or the bishop's chair, and their use was confined chiefly to churches and the homes of nobility. Sometimes a chair was used as a high-seat, but more often the seat of honor was only a bench. *Kubbestoler*, round chairs carved from solid logs, were mentioned in the sagas and continued to be used in modern times. Other than these and a few stools, the only type of seat used was a stiff-backed bench which could be converted into a bed when the occasion demanded.

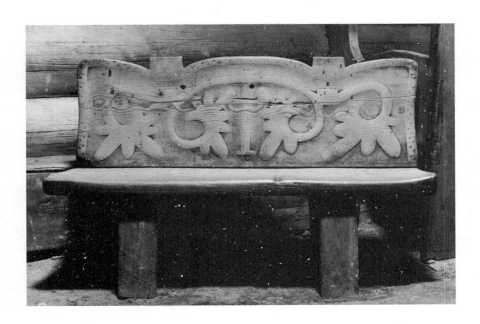

20. Bench from the Aamlid house, Setesdal. NORSK FOLKEMUSEUM

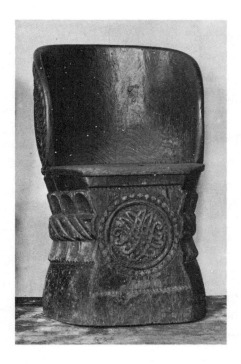

21. Front and back views of a *kubbestol* from Hallingdal. Shows gouge carving and popular monogram motif. NORSK FOLKEMUSEUM

With the coming of the Renaissance, chairs gained in popularity and became much more common during the baroque and rococo periods. High-backed, panelled chairs with turned legs and carved crosspieces were widely distributed in eastern Norway. Three-legged chairs were used in some parts of the country. They had turned or carved legs and a low back curving around to provide arm rests.

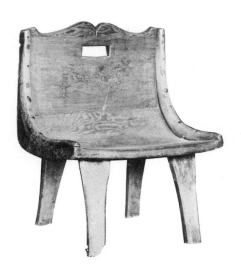

22. Early-type chair from Setesdal. NORSK FOLKEMUSEUM

Continental furniture styles were copied faithfully in rural Norway in the nineteenth century; so the later chairs are often completely lacking in local character.

The typical *røkovnstue* of the early 1600's was still without windows, though in some cases they were cut in later. Wooden floors had begun to make their appearance, at first along the high-seat wall and then over the whole floor area. In some districts the floors were of stone.

Carving was the main form of decoration in the pre-Renaissance home. In some instances it may have been painted, but as a rule it was simply sanded. *Rosemaling,* the painted decoration on flat surfaces, was not much used as yet. That had to wait for a less sooty atmosphere. But on festive occasions, the walls might be whitewashed, particularly the gable area and the upper three logs on each long wall, and the family's best tapestries brought out to hang above the benches and from the crossbeams. In some districts red paint was used instead of white, bringing a gay note to the drab interior until, grown blacker and blacker from smoke and soot, festival time rolled around and it was time to paint once more.

Sometimes woven coverlets were used on the bed. More often the spread was simply sheepskin, and the mattress straw. Sheets were not used in the poorer homes, though wealthier families might have them. They might even wear imported linen, particularly the outer blouses. The only materials woven at home were coarse sackings and heavy tapestries, and these were made on the simple upright loom used by all primitive peoples.

Carving was the chief way in which the old designs were handed down. It ranged from the finework used on such things as wooden spoons and hunting knives to the massive doorposts which served both as doorframes and as supports for the ends of logs which framed the door. These doorposts are an accurate record of the stages through which Norwegian art passed. Some of them, mainly those

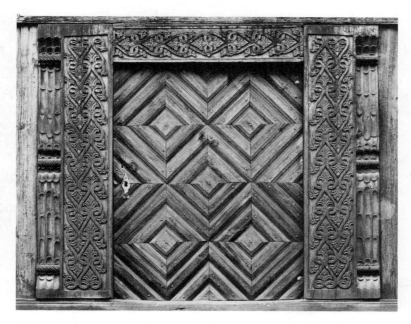

23. Door of the Berdalsloft in Vinje, Telemark. NORSK FOLKEMUSEUM

on the stave churches, show the ancient Viking designs. There are
numerous lofts and houses with the heavy designs of the Romanesque
period, and some have the Gothic-inspired chip carving. Later
periods are abundantly represented on the loft portals from Vest-
Agder to Trøndelag, and from Sogn to the Swedish border.

Ale bowls and tankards were a favorite field for carving skills and
every family was well supplied with them. They had a religious im-
portance as having a part in the ceremony used on holy days and so
were designed with reverent care.

Anything connected with the fire was also sacred, especially in the
dark days before the invention of windows and matches. Even after
the coming of Christianity, the old heathen superstitions haunted the
people, and various charms were used to propitiate the evil spirits.
The rooster with his flashing feathers was thought to have some con-
nection with fire or lightning and was used even on church steeples
as a lightning conductor. The dragon head continued to be a favor-
ite decoration for roof peaks, probably to ward off evil spirits with
its fierce countenance and tongue of painted flame.

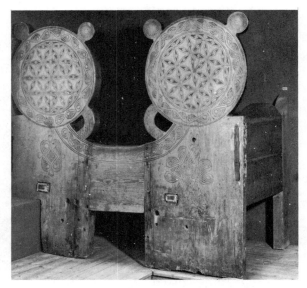

24. Bed from Mo, Telemark, showing Romanesque vine done in Gothic chip carving, Gothic rosette, sunwheel, and knot motifs. NORSK FOLKE-MUSEUM

25. Decorative post on a fire screen from Hardanger. BERGENS MUSEUM

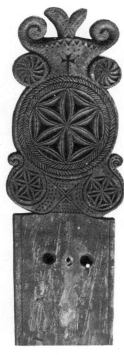

Bedsteads, fire screens, and church pews showed a parallel development in the end designs used on their vertical planks. The earliest ones were surmounted by Romanesque animal heads. These were followed by Romanesque leaf designs, and finally by the intricate Gothic rosette. Sometimes the carving was in the shape of a man's head, probably intended to be a saint, or even the pagan god Thor, and as such a protection for the household.

From all this, one might think that the old Norwegian lived in a dark and fearsome world, and no doubt fear did play a big part in his life. But it had its gay side too, and the social get-togethers, particularly at Christmas and weddings, were often boisterous affairs. The drinking was heavy. After all, hadn't God grown the grain and graced the brewing? It was certainly one's duty, then, to show one's appreciation for God's goodness.

There were dances on the green, brightly wild affairs with the high, weird music of the zither-like *langeleik* or the fiddle setting the pace. Contests and song and food, more food, all this going on for days, a gay patch in the dull day-to-day existence. Then back to the realities of a harsh life, the festive costumes put away, the tapestries returned to their chests, ale bowls to their shelf, and the fare a simple one of bread and meat again.

The big advance in housing came with the introduction of the

chimney. A large hood and wooden chimney, supported on huge wooden beams above the open hearth had been used in Germany all through the Middle Ages. As late as the eighteenth century, wooden chimneys were in use in the cities, for at that time, Bergen found it necessary to make a law against them as a preventive for the fires that periodically raged through the town.

From a chimney supported on pillars or beams in the center of the room to one in the corner where the smoke passage could be built in the wall was a natural step, particularly in stone buildings. Sogn was one of the few places in Norway where a chimneyed fireplace for cooking was used in combination with a *røkovn*. This may have been due to the fact that Sogn houses were frequently built with at least one wall of stone.

While the *røkovn* had already begun to replace the open hearth in the Vestland districts in the Middle Ages, it was later than that when a new kind of fireplace appeared in eastern Norway. Because wood was more plentiful than in western Norway, the fuel-saving *røkovn* was unnecessary. Instead there was a low hearth in the corner with stone sides at the back and a stone hood and chimney to carry the smoke directly outside. It passed through various transitions, finally evolving as the *peis* or corner fireplace in use from the seventeenth century to the present day.

The *peis* is usually placed in the corner opposite the door, a little distance from the walls. It has its own stone foundation which rests

26. Common type of *peis*. NORSK FOLKE-MUSEUM

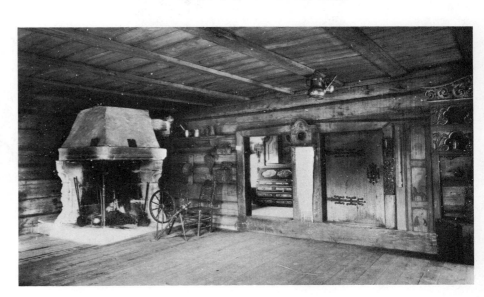

on the ground. The hearth consists of one or two large flat stones, and the two walls which form the back are also of stone or brick. These walls, together with an iron post at the front corner, support the bridge stones or beams above which the sloping hood and chimney are built. Sometimes the hood is constructed of boulders, but more often of flat stones, plastered over to a smooth white surface. In Nordmøre a metal hood is often used. This type of fireplace has the advantage of being able to throw off heat from two sides, and of allowing more people to gather around it at one time. The space behind the *peis* may be used for drying wood, clothes, and grain.

In some districts, such as Romerike, where city influence was strong, the corner fireplace was supplanted by a *mur*, similar to the ordinary type of wall fireplace but not so enclosed, and with its mantel and hood supported by two iron posts at the front corners. It was usually built of grey cobblestones and left unplastered.

The introduction of the chimney brought great changes and improvements in house design. The main advantage was, of course, the clearer air and hence the opportunity to use the gable area for rooms. Some houses could be provided with lofts or half lofts simply by building in an upper floor. Others had to be rebuilt, with higher

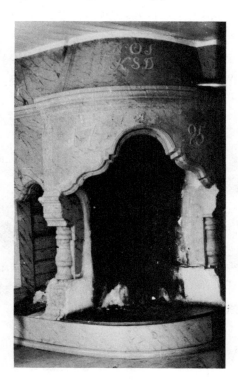

27. Baroque *peis* from Søndre Atneosen, Østerdal. NORSK FOLKEMUSEUM

roofs. This rebuilding was something of a mass phenomenon within the various districts. When social and economic conditions made it feasible the whole district rebuilt its houses—not by necessity but simply because everyone was doing it.

The smoke hole in the roof was replaced by small windows cut into the walls to furnish light and air. Until the introduction of glass, window panes were of animal membrane, but by the eighteenth century, glass windows were becoming common and the owner of a machine to make the lead frames was a busy man. Dirt floors were no longer used and the dirt-filled benches along the wall unnecessary. The house could now be lifted from the ground and placed on a foundation. The whole design of the house and its furnishings became lighter and more flexible.

The floor plan had changed. The fireplace at the left of the door had been replaced by the *peis* in the corner opposite. Often an extra

28. *Peisestue*, Søndre Atneosen, Østerdal. The *peis*, or fireplace, is in the opposite corner, out of the picture. This house, with its baroque furnishings, was on a wealthy farm in eastern Norway. NORSK FOLKEMUSEUM

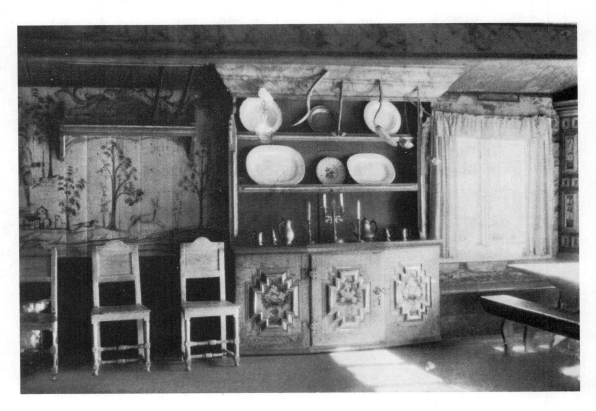

room was added, either at the end or partitioned off the long side of the main room. A long table with benches around three sides still formed the eating area, but the room was dressed up with a fancy corner cupboard in the high-seat corner and a *fremskap* or dish cupboard of the break-front type near the door. These two were the family show pieces and reflected the decorative trends of the day, through the Gothic, Renaissance, baroque, and rococo periods, and with all the individuality of the local districts and their artists thrown in.

Carving, either plain or polychromed, decorated the earliest cupboards. Their form was quite simple, evolving from an open shelf arrangement to which doors were added, first below and later to the upper section as well. The corner cupboard or *roskap* was for the exclusive use of the man of the house. It might be a single shelf affair, with a three-sided front, the door in the center section, or it might have two shelves, with a door in each level. Most often it hung in the corner above the high-seat and the adjoining bench. In later styles after chairs came into common use, it was an elaborate panelled structure, standing on the floor, its crown touching the rafters. The upper and lower sections were separated by an open area where some family treasure might be displayed.

For the use of the woman of the house, there was the *fremskap*. It was much larger than the *roskap* but usually in the same general style, with the same type of decorations and the same crown. Earlier ones had open shelves above a closed cupboard base which was divided into three sections, with a door in the center. They were frequently decorated with beautiful flat carving in fifteenth century Gothic, and were used to display the fine tankards or dishes and candlesticks.

Medieval plank construction was replaced by Renaissance panelling in the seventeenth century. The upper part of the cupboard was closed and panelled in three or four sections, with one to three doors.

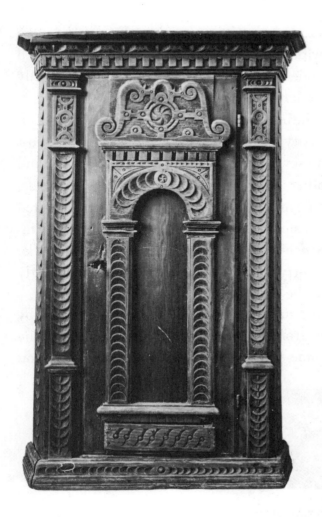

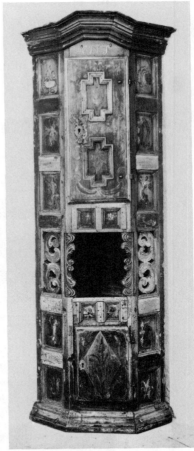

29. Renaissance corner cupboard from Sogn, 17th century. BERGENS MUSEUM

30. Baroque corner cupboard from Telemark. NORSK FOLKE-MUSEUM

Carving became more and more intricate, passing through baroque and rococo styles, until with the Empire period simplicity returned and the design consisted chiefly of restrained panelling, a gracefully curving crown, and simple floral or pastoral painting.

Rosemaling or floral painting found its first and favorite field on the panelling of the various types of cupboards, and was used almost without exception from the seventeenth century on. As the walls and ceilings were made smoother and later panelled with wide boards, the bright flower and leaf forms spread. The room became a painted garden with flowering vines sprawling luxuriantly over door and window frames, cupboards, benches, beds, walls and ceilings, ale bowls, and chests. Even the country churches were supplied abundantly with *rosemaling*, surely to the distraction of the congregation.

A carry-over from Viking days was the built-in bed, supported by two vertical planks at the front and the log wall at the back. The front supports ended in some sort of carved design, depending upon

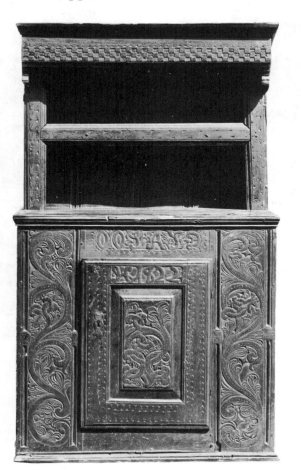

31. Breakfront cupboard from Telemark, 1822, combines Gothic styling and flat carving with Renaissance panelling and rococo swirls. NORSK FOLKE-MUSEUM

32. Part of a Vest-Agder room
from the 1800's.

the period, and were at first almost the only decoration in the house. By any standards, these built-in beds were extremely short. For modern methods of sleeping they would be quite impossible. But in medieval Norway people slept in a semisitting position, propped up on pillows, so a four- or five-foot bed was quite adequate. This method of sleeping must have been in use even in Telemark until the nineteenth century for the date on one such bed in that district is 1750. In more backward districts it lasted still longer.

The canopied bed had come into use in some places toward the close of the Middle Ages. A wooden canopy was supported on pillars, the sides hung with woven curtains. Usually the bed was built high off the floor so that it was necessary to use steps to climb into it. The space underneath might be utilized for storage. Generally the bed was decorated with *rosemaling,* sometimes in connection with carving.

Cupboard beds afforded an unusually large field for the artist's talents, for here the curtains were replaced by doors which were closed during the day, and in cold weather, even at night. In most cases the craftsman both built the bed and decorated it. Thus the

piece was designed with a certain type of decoration in mind, resulting in the highest degree of unity and harmony.

Invariably there was at least one bed in the main room of the house, sometimes two, and there might be more in a side room or in other buildings of the farm. The bed was a wonderful place to display the products of the loom for it needed both draw curtains and a spread. In addition it might be piled with feather pillows, each encased in a beautifully woven woolen cover. Biblical scenes were favorite subjects for weaving, though geometric and floral designs were also much used.

The loom was set up right after Christmas and from then until spring it was always busy. Besides the display pieces, all the material used by the family had to be woven by hand from thread which had first been grown, prepared, and spun at home. As if it were not enough to do all this, each garment after it was sewn, was embroidered with beautiful drawn work or beadwork or other decoration. Most care was lavished on the festival dress, though everyday wear received its share.

The two-story houses that developed with the introduction of the chimney were of various types. In some cases the second story was the same size as the floor below, in others only half as large. It might be placed along either the end or the length of the house and its stairs could be inside or out. Most often they were located in the *sval*, a sort of porch which acted as weather buffer, storeroom, and military protection and was built of vertical planks, enclosed in a heavy log frame. The *sval* might appear at one or both levels of the house and sometimes extended along three sides, ending in a privy. Particularly on the second-story level, the *sval* served as a fortification with fancy carved loopholes through which the defenders could shoot their long bows and later their muskets, in the oft-recurring wars with which Norway was plagued.

In many of these two-story houses or half-loft houses, the only fireplace was the *peis*, located on the first floor. Some warmth might

find its way through the floor boards of the upper story, but one can imagine that it would be rather cold sleeping. In some houses there was a small *peis* in the second story too, usually having a common chimney with the first story fireplace.

Furnishings for the second story consisted chiefly of a bed or two, a chest, perhaps a chair or bench, and sundry small items that found storage there. Probably as newer types of furniture came into use around the middle of the eighteenth century some of the "old-fashioned" pieces were relegated to the upstairs. At any rate, the new "parlor" or "front room" received the modern furniture while the "everyday room" retained its old character.

The upstairs room was often winter quarters for the girls of the farm, but when summer came they moved out to the loft, a combination storage and sleeping building which was, next to the main house or *stue*, the most important building on the farm. In these two buildings all the activities of daily living were carried on, generation after generation, so that they came to have a sentimental and even superstitious value. The *stue* was the location of the hearth, a holy spot in itself, and the whole house took on a religious significance from it. In the loft lay all the food and other supplies for the year, besides the family valuables, hence its importance was almost as great as that of the house.

All the buildings received some attention, decoratively speaking, but it was on the main house and the loft that the greatest care was lavished. These became the show places of the farm and were an indication of the prosperity of the farmer since he often hired artists to do his carving and painting for him. To be sure, many houses were decorated by their owners, probably all of them at first, but as prosperity grew it became the vogue to have the job done by professionals. Some of these artists were local men with an artistic heritage generations old. Others hailed from the poorer districts and consequently had to seek their fortune away from home.

In remote districts where the population was too sparse to warrant

building a church, traveling monks and priests brought religion to the people, and some art as well. But itinerant artists were mainly responsible for brightening these out-of-the-way farms. As they trudged their stony way over the pathless mountains they were the newspapers, the art schools, even the Montgomery Ward of the back-woods. Besides painting supplies their knapsacks held letters, needles, spices, and sundry items to brighten and ease the lives of their pa-trons. When they packed up to leave after a stay of perhaps several weeks, their hosts would have supplied them with choice foods, per-

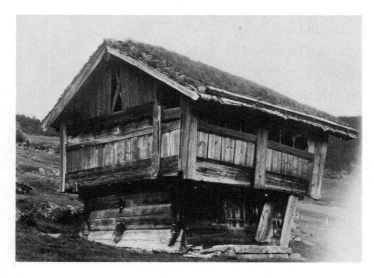

33. Medieval-type loft from Rygnestad, Setesdal. NORSK FOLKEMUSEUM

haps bits of handwork, new ideas, and news to carry to the next farm, so although the interchange was very slow, the influence of each district was felt by every other district, and Norwegian folk art became the delightfully varied yet homogeneous thing we now know.

At first the loft was a one-story affair, set right on the ground, and was used for food storage. But as the number of rats in the country began to increase, around the fifteenth or sixteenth century, the people began to build their storehouses on ratproof "stilts", huge chunks of logs, sometimes nicely turned. The addition of a second story gave the loft its quaint and characteristic appearance. It was built to ex-

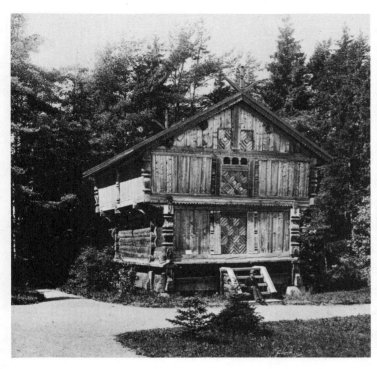

34. Loft from Berdal, Vinje, in Telemark. FOT. O. VÆRING

tend out over the lower level, with a special corner construction to prevent thieves from climbing to the "treasure room." Often the only access to this room was by a ladder to an opening in the outer wall.

All the art styles from the fifteenth century on are reflected in the various lofts which are now standing. Some are of simple Romanesque. Others show late Romanesque or Gothic character, and many are Renaissance types. The massive corner posts and large

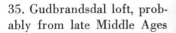

35. Gudbrandsdal loft, probably from late Middle Ages

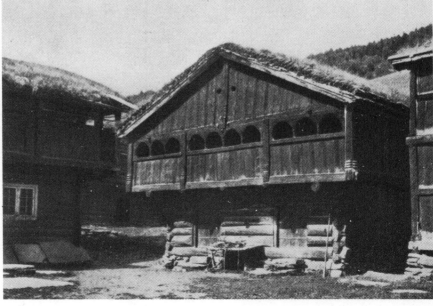

upright timbers which formed part of the framework for the *sval* received the most attention. The door, the facing boards on the gable, and the gable ornaments were also favorite places for artistic display.

Carving and some ironwork were used almost exclusively. Carved parts might be painted in different colors, but were usually left plain. The key to the loft was, quite understandably, a most important item, and it was huge and elaborately decorated. It must have been very impressive as it hung from the housewife's belt, among the other and lesser keys of the farm.

With the introduction of two-story lofts, the food such as stacks of flatbread, dried meats, grain, and flour was stored on the first floor, while seldom-used clothing, extra bedclothes, dowry chests, and various household treasures were kept on the second. There would also be one or more built-in beds for guests, or for the girls of the house to use in the summertime. It was most certainly colorful with all the bright costumes, the painted chests and beds, the woven coverlets and wall hangings. In early days it was a more cheerful place than the house because of its quite open *sval* which let in more light than was possible in the old *røkstue*. Often the womenfolk set up their looms in this building, partly for the light, and partly, we can imagine, so that small fingers would not undo some of the intricate weaving.

Though the *stue* and the loft were the most interesting buildings on the farm, they were by no means the only ones. The number might run as high as thirty or more. On the wealthier farms there was a building for every kind of animal, for men servants, for women servants, for bathing, for weaving, and for brewing. There were various types of storage buildings, hayloft, woodshed, mill, drying house, a saeter house up in the mountains where the dairy maid took the cattle to graze through the summer, occasionally even a chapel and buildings for a family parson.

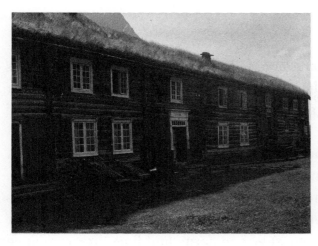

36. Manor house at Løken, Sunndal built in 1823. This type of multiple unit dwelling is common in Møre and Trøndelag. MITTET AND CO. A/S

Particularly in the fertile valley of Gudbrandsdal, this affluence reached an extreme. Houses were extravagantly decorated and the *bønder*, the well-to-do farmers, imitated the Spanish court dress in their festival clothes. There was a real aristocracy here, and an easier life than befell the Sogning or the Nordlending or any other inhabitant of the mountainous coastal districts.

Conditions in Glomdal were equally good. Partly because of its prosperity and partly because of the stream of new ideas coming in from Sweden, Trondheim, and Oslo, Glomdal developed a modern type of house as early as the late 1700's. Walls and ceiling were panelled, baroque and rococo furniture introduced, and the bed moved out of the *stue*. In accordance with city styles, pictorial painting decorated wall panels, chests, cupboards, and doors. The exterior of the house took on a Georgian appearance with an impressive doorway in the center of the long wall and precise rows of windows at both levels. The structure might still be of logs or it might have vertical siding.

The most striking thing about Østerdal or Glomdal houses is their consistently good proportion, particularly in the older examples. Window size and shape is chosen with the whole house in mind, and the windows are placed in careful relationship to the roof, the door, and each other. The roof pitch is quite low, the facing boards along the edge of the gable wide, which helps to bring down the apparent

height of the house. Some houses have an open *sval* at both levels the full length of the house. Farm buildings may be separate or combined. Often they are arranged in a rectangle, similar to the Trøndelag plan.

The long two-story house is also used in Nordmøre and Trøndelag. There may be two entrances or even three on one side of the house, as well as twelve to sixteen double windows. This type of house is actually a row house, with two or three sets of living quarters under one roof. Occasionally the *stue* and farm buildings are combined under the same roof, but without a direct connection.

These row houses, originally single story affairs, were rebuilt in the 1800's to add sleeping rooms on the second floor. Thus it was possible to remove the beds from the *stue* which then became a kitchen. This transition was contemporary with a like development in eastern Norway and along the southern coast.

By the mid-eighteenth century, builders in southern Norway were substituting board siding for logs. This change was instituted largely through the efforts of the conservationists who were also responsible for the next innovation, plastered walls. At first plaster was used only on the exterior, later on interior walls as well. Such measures, along with the use of stone or tile for roofs, effectively reduced the amount of lumber used in a new house. But it backfired in such areas as Gudbrandsdal, Trøndelag, and Glomdal. In the drive for modernization, wood panelling was added both inside and outside the old log houses, increasing rather than decreasing lumber consumption in these districts.

Siding was applied horizontally in most of western and southern Norway, vertically in eastern Norway, Trøndelag, Nordmøre, and neighboring areas. With siding came the use of paint. The walls might be painted red, yellow, dark blue, grey, or white. Window frames on log houses were usually white and doorways white, natural wood, or as in Sunndal, polychromed.

It can be seen from the foregoing that while there is a definite relationship between the house types used in the various parts of Norway, the buildings were by no means stereotyped. Circumstances varied from district to district and from family to family. On the mountainous west coast, where tillable land was scarce, the houses were built on the lower slopes of the mountains, leaving the valley free for cultivation. Several families' houses stood in a row on one side of the "street", their sleeping and storage houses on the other. The farm land was parceled out and rotated each year, so that with little incentive for land improvement, the soil became depleted and the economy ruined. Poverty was not receptive to art, and so there was little of the lavish display characteristic of the more prosperous districts.

In Setesdal people kept a tenacious hold on the past. The *aarestue* with its open hearth was the only house form until around 1750 and even now is used as a summerhouse. Many of the medieval-type lofts built in the eighteenth and nineteenth centuries are still in use. Here and in Telemark, where the farm buildings were not so numerous, they were often put end to end, with a common wall between each section. This was also true of Romerike and various other sections of the country.

37. Restored house at Store-Hvam in Romerike. Hayloft, storehouse, and dwelling units were combined in this house of southeastern Norway.

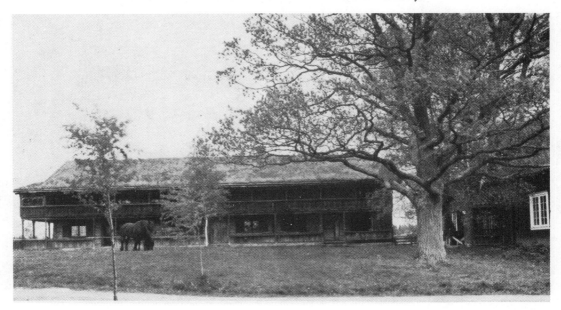

In view of the diverse geographical, economic, and social conditions within Norway and the obstacles to communication, it is all the more remarkable that there has been so much similarity in house construction and furnishing. The variations from district to district only serve to make the pattern more evident. This similarity indicates a common heritage from antiquity and a way of life developed through the centuries to suit the particular conditions of Norway and her people. These conditions are not the same as those of Switzerland or the Black Forest, though like Norway, both places have log houses and people of Germanic descent. Differences in custom, religion, climate, and divers other factors have made Norway's dwellings uniquely Norwegian.

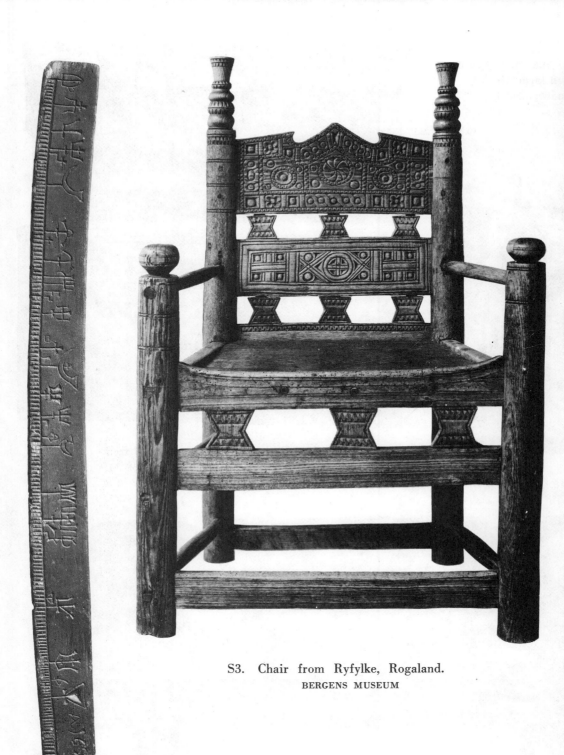

S3. Chair from Ryfylke, Rogaland.
BERGENS MUSEUM

S1. Calendar stick from Hardanger,
winter side. This is for the period
September 29 (Michaelmas) to
April 13. The drinking horn be-
low middle stands for
Christmas.

S2. Same stick, summer side. The
first symbol is a birch tree, signi-
fying the coming of summer,
April 14. Many of the signs stand
for saints' days. BERGENS
MUSEUM

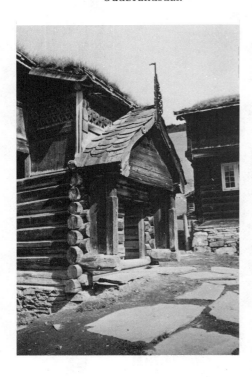

S4. Entrance to the main house at Bjølstad farm, Heidal, Gudbrandsdal.

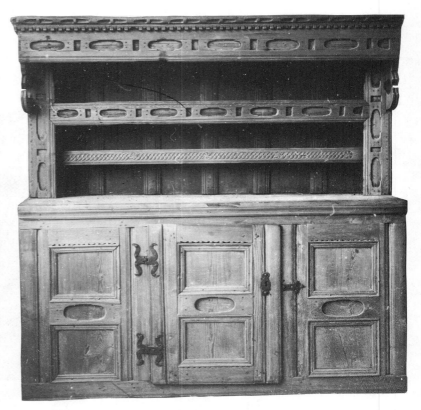

S5. Early Renaissance cupboard from Hallingdal. BERGENS MUSEUM

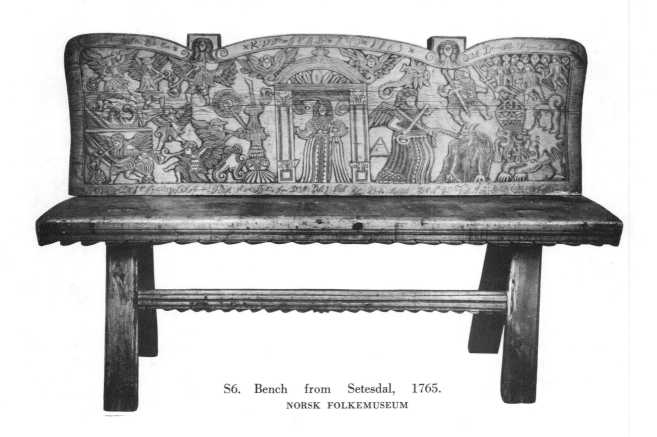

S6. Bench from Setesdal, 1765.
NORSK FOLKEMUSEUM

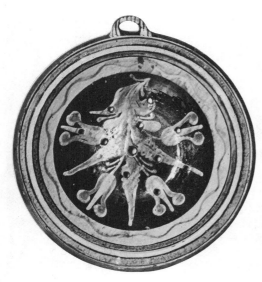

S7. Earthenware dish from Nordfjord. Very little pottery work was done in Norway, mainly in Trøndelag. BERGENS MUSEUM

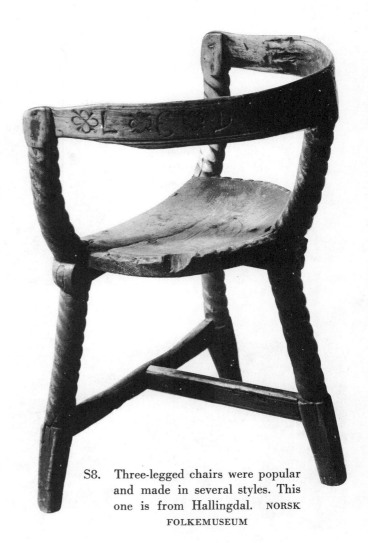

S8. Three-legged chairs were popular and made in several styles. This one is from Hallingdal. NORSK FOLKEMUSEUM

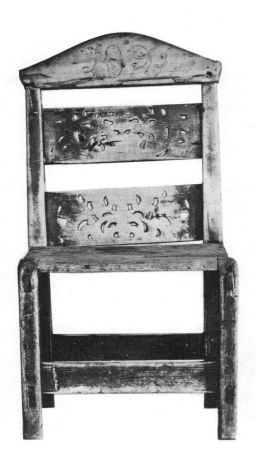

S9. Chair from Tuddal, Telemark. Probably 18th century. BERGENS MUSEUM

S10. Food basket, made of birch root. From Gloppen, Nordfjord. NORSK FOLKEMUSEUM

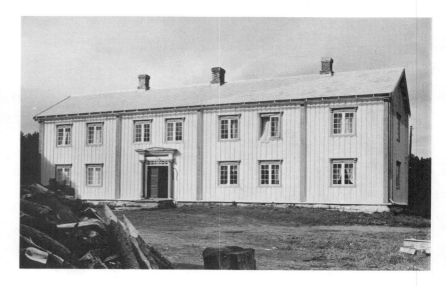

S11. House from Aakerli, Soknedal, Sør Trønde-lag. Vertical board siding often covered old log construction. NORSK FOLKEMUSEUM

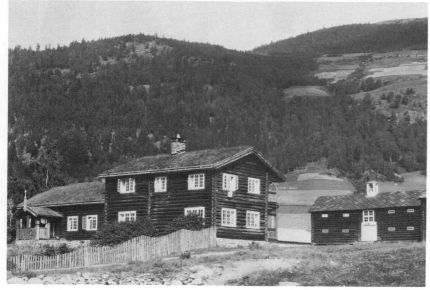

S12. A farm in Gudbrands-dal. Note the *sval* at both levels of the house. NORSK FOLKEMUSEUM

S13. Rauland House, an *aarestue* from Nume-dal, built about A.D. 1300. Now at the Norsk Folkemuseum. NORSK FOLKEMUSEUM

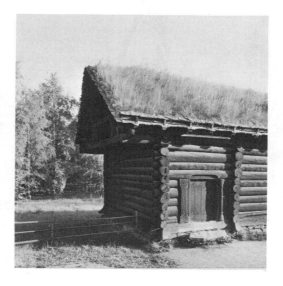

Carving

3

WE HAVE SEEN in Chapter One how the living, moving, heathen art of the Vikings gradually became Christianized after the year 1000. As the Norwegian slowly gained reassurance from and respect for Christian precepts, his art became more calm. He began to feel a closer bond with Rome through the Roman church which had more than regained its influence after the Dark Ages. He found the grape-vine, a Christian symbol, quite adaptable to his mobile ornamentation. The acanthus leaf with its undulating outline fitted admirably into his northern style of art.

Later, in the thirteenth and fourteeth centuries, he accepted such restrained motifs as the Gothic rosette and by that time the old facility was gone. Perhaps it was because Christianity forced him to earn his own way instead of stealing the results of others' labors. Maybe the resultant lack of wealth and time caused the curtailment of the old carving, or maybe it was just that the descendant of Vik-

55

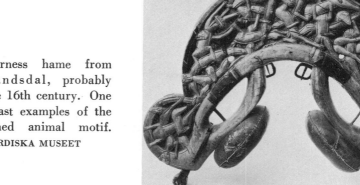

38. Harness hame from Gudbrandsdal, probably from the 16th century. One of the last examples of the intertwined animal motif.
NORDISKA MUSEET

ings no longer understood nor felt the love of life and power that moved his ancestors. At any rate, it was not until the seventeenth and eighteenth centuries when *rosemaling* appeared to revive the old lively traditions that anything like the vital art of the Vikings was seen in Norway.

The beloved animal motifs were not immediately displaced by the Romanesque vine but were used in conjunction with it. Throughout Europe the Crusaders brought home the lion and the eagle, Oriental symbols of sovereignty, to be used on heraldic emblems. These, together with the dragon, were presented allegorically in church art, and in Norway continued to guard important doorways as late as the

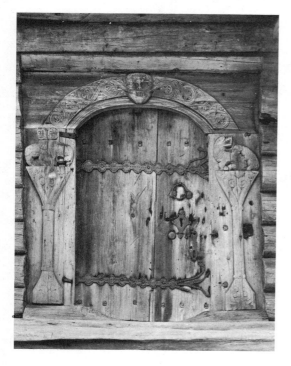

39. Door from a medieval loft in Telemark. NORSK FOLKEMUSEUM

eighteenth century. Usually the lion is shown in battle with the dragon who with the passing of time becomes more and more vegetable and less animal. In the end, the dragon is little more than a crescent on which the lion stands triumphant.

The interlaced ribbon motif was just as important as the animal figures and was used all over the country without district variations so that it was really a national art. Such plaited motifs provided a firm basis for the French-inspired ribbon work of the rococo period. Royal monograms done in this technique were very popular on loft

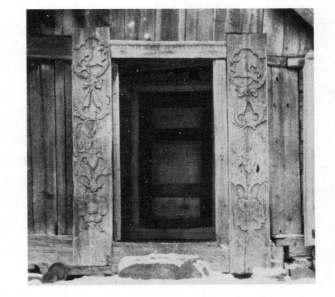

40. House door in Numedal with Renaissance-type carving. NORSK FOLKEMUSEUM

portals and silver brooches in the eighteenth and nineteenth centuries. All these Romanesque patterns, the vine, the animals, and the intertwined ribbons, became so firmly established in Norwegian folk art that Gothic styles gained very little foothold.

The plainly geometric character of the Gothic rosette and leaf motifs led to chip carving, a strong and simple method of decoration. It was used to some extent on furniture but for the most part was employed in decorating portals, small boxes, mangle boards, knife handles, and similar items, particularly after the beginning of

the sixteenth century. On Setesdal doorways it is found in combination with Romanesque vine forms as a popular local development. Its fan-shaped sections look remarkably like the palmetto motif and may have been influenced by it. Conservative Setesdal never really discarded this medieval style of ornamentation.

While Romanesque and Gothic styles were flourishing side by side in Norway, the Renaissance was gaining momentum in Europe. It pretty well covered the continent during the sixteenth century and finally in the seventeenth reached Norway. Here its effects were as rapidly felt and as far-reaching as they had been on the continent. The new method of furniture construction, the use of panelling to replace slab doors, quickly spread through all but the most backward districts.

Solidly carved decorations were replaced by panels of more and more complex outline. The egg-and-dart took its monotonous way around the tops of the cupboards and the cupboard crown itself became strongly profiled. Instead of being carved out of solid wood, decorations were often glued to door panels and surfaces were broken up into small areas. Half pillars plastered to cupboard corners and a round arch across the door between bore evidence to the strong preoccupation with architectural motifs.

About this time, *rosemaling* came into the picture. It replaced much of the plastic ornamentation because it was more suited to the now lighter character of the furniture.

The first of the Renaissance carving, as influenced by the German flat carving, was the spiral motif and a spindly type of naturalistic vine which sprawled over the backs of benches or on wooden chests. At first the vine was supplied with clover leaves on close-lying stems. It went through several variations, sometimes being used singly and sometimes in pairs, but in a dry and unreal fashion until the acanthus arrived to give it new life. Various of the classical motifs such as the twined ribbon and the coin laid scale-fashion were a part of the Nor-

wegian Renaissance and there was some carry-over from medieval carving, if not in ornament then in spirit.

As in the rest of Europe the Renaissance in Norway was inevitably followed by the baroque and rococo styles which were in most respects far more suited to Norwegian life and temperament than any of the preceding styles since the Viking. Baroque panelling and carving with its sometimes grotesque lines and deep modelling was much easier to see in the often still dimly lighted homes of the country districts. Furthermore its power and spirit was more in accord with the Norwegian nature than the calm, controlled art of the Renaissance. The gaiety of the Norwegian rococo was yet more welcome. It never entirely replaced the highly modelled baroque carving because it was so contrary to the structure of wood, but it came to full flower in *rosemaling*.

In Gudbrandsdal the Renaissance vine, with the introduction of the baroque acanthus leaf, developed into the luxuriant *døleskurd*, a highly modelled and uniquely Norwegian type of carving. In the local churches it was painted in rich greens and blues with gold and red as brilliant accents. On smaller areas, such as drinking bowls, it was usually left unpainted.

Turned pillars were one of the most prominent features of baroque woodworking. They were used as supports and as decoration on cupboards and the spindled backs of the three-legged chairs. Broken cornices and irregular panelling, heavy-handed use of the acanthus leaf, particularly in church carving, and in general a monumental effect were the characteristics of the baroque woodworking. This style lasted well into recent times.

Rococo styles as used in France came into Norway around 1760. There was no general movement to discard the previous art styles. Renaissance, baroque, and even medieval forms continued to exist along with the rococo. Furthermore, local eclecticism resulted in a composite art that reflected past ages through the skill of the indi-

vidual artist. The craftsman had the advantage of the experience of centuries of craftsmen before him but he was free to choose and combine according to his own pleasure. In this way folk art becomes a highly individual thing, confined only by the artist's own skill and ingenuity.

In the case of rococo carving, the artist was at first influenced by French example to use the shell and the repeated c-motif. However he soon found that his beloved leaf designs could easily be used in the French manner, and this he did with all his inherent enthusiasm for swirling decoration. On cupboard crowns the leaf pattern was broken through, or pierced. Door panels were carved in moderate relief, the leaves handled in elegant fashion. Outlines curving and sharply recurving were characteristic of the tastes of the day. They were particularly adaptable to the gracefully designed sleighs, less suitable for cupboard corners for which they were all too frequently used.

Gudbrandsdal resisted rococo carving in favor of the baroque acanthus leaf which had been so effectively developed in the district. In Telemark, however, the Renaissance vine on which had been grafted the baroque acanthus leaf, began to sprout rococo flowers and leaves to the end that it became a kind of carved *rosemaling*. Contemporary work in Trøndelag showed vines that were broad and strong but lacked some of the life that flowed through the carved foliage of Gudbrandsdal and Telemark.

With simplified furniture styles this type of carving continued to be used on the wealth of small objects that were such an essential part of living. There were the *mangletrær*, the long, flat, and highly decorated boards with a single handle, used to roll the wrinkles from linen cloth which had been wound on a round stick. There were the butter boxes and pudding boxes in which were transported gifts of food to relatives and friends on important occasions. There was a large variety of wooden drinking vessels—bowls, tankards, dippers

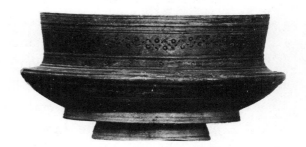

41. Ale bowl from Voss.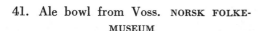

—with as many variations as there were districts in Norway. Spoons and knives, carding combs and weaving accessories, all were decorated with love and understanding if not with perfect skill. These things were as much a part of the Norwegian home as were the linens and were for the most part the products of the owner's hands. They were more local in style and hold more interest for the modern observer than do the all-important cupboards whose design is so obviously borrowed from a foreign milieu.

The woodworking equipment available in the Middle Ages and even into the eighteenth century was extremely limited. An ax and a broadax sufficed for constructing furniture, a drawknife for smoothing the wood. The plane came into use after the Reformation, that is, after the beginning of the seventeenth century, the saw about the same time. Drinking bowls and *trau*, hollowed out rectangles of wood in which to prepare and serve food, were made with the above implements plus a bowed ax called a *teksle*. Finishing was done with the *skjøve*, a curved gouging iron with one or two handles. The *svarvestol*, a primitive type of lathe, was of immeasurable help in making bowls and was in use on some farms perhaps even in the Middle Ages.

Various types of knives and routers were used in carving and special curved rabbeting planes made possible the abundance of moldings so popular after the Renaissance. There were simple types of

calipers and compasses and ingenious lathe tools, designed for the most part to the user's specifications. All in all the equipment available was of limited scope and to the extent of its limitations had to be augmented by the worker's own skill.

The skill of a carver was largely dependent upon how much time he could devote to his craft, and that in turn upon his market. In eastern Norway where there was a more or less stable economy, the man with a bent for craftwork could find enough paying customers to be able to support himself with his art. The rocky and mountainous fjord area, on the other hand, required so much effort of a man to assure his existence that he had little time to develop his own abilities and no money to hire another's.

SOGN, particularly in its outer areas, is quite representative of all the west coast districts in that its craftwork has a homemade look. Any special trends or individual variations were eclipsed by the crudeness of the work. The designs chosen were simple ones, geometrical in character, that required little more of the maker than the ability to use a compass and ruler. The rosette was the overwhelming favorite, usually as an isolated motif but sometimes multiplied many times in a delicate, cobweb-like pattern. The ring chain was another stand-by. It was made up of a series of line-carved rings, laced together with a ribbon or by extensions on the rings themselves. Various arrangements of triangles and repeated lines served as fill-ins.

This type of carving was far better suited to the medieval plank-constructed furniture than to the thinly panelled type of the Renaissance. With the introduction of the new styles into Sogn, carving was of necessity relegated to the smaller objects of the home, things such as clothes chests and household utensils. The effect of the Renaissance was so strong and so long-lasting that except in the parts of the district lying closest to Gudbrandsdal, Valdres, and Hallingdal, baroque and rococo trends were ignored.

The reasons for this were threefold. First, the houses were dark and sooty, not a suitable foil for luxuriant carving. Medieval-type houses were not replaced in much of the outer area until around 1800 when classical panelling, chimneys, and iron stoves were introduced from Bergen. Second, the west coast folk were too poor to purchase the new art or to support district craftsmen. And third, they were not skilled enough to master the new techniques themselves. These factors were operative in outer Møre and Nordhordland as well as the islands, all of whose art development runs quite parallel. The inner part of the district really belonged to the inland culture group, partly because it was able to import craftsmen from the other districts by virtue of its more fortunate financial position.

Sogn, like most of the rest of Norway, was abundantly supplied with drinking vessels. Here, however, there was even greater variety. Ale bowls, which had started with the universal low, open form of the Renaissance, developed into richly turned forms with low foot and high vertical collar. Because of their small size and complex profile they were more simply decorated than the Østland type, an inscription or vine border sufficing. Similar bowls are found in all of Vestland.

Related to the turned bowls are the *kjenger* which are also made from a solid block of wood but must be carved by hand. They are

42. Sogn drinking vessel *(kjenge)*. BERGENS MUSEUM

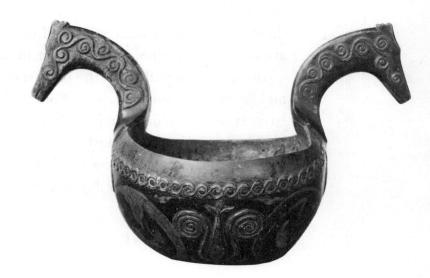

oval in shape with a slight inward curve at the top. The two handles
may be carved in the shape of horse heads, of writhing snakes, or in
abstract form with doves perched on top. Surface carving, if any, is
quite simple. There may be some painted decoration. The *kjenge* is
common to parts of Hardanger and Voss as well as inner Sogn, but is
not found in the eastern part of the country except as an importation.

Another characteristically west-Norwegian drinking vessel is the
staup. It may also be used to hold butter or cheese. Its stave con-
struction is related to barrel making, a home industry in the fishing
districts along the coast. The staves are grooved at the bottom to fit

43. Sogn stave-type drink-
ing vessel *(staup)*. BERGENS
MUSEUM

the circular wood base. Roots bound around the bottom and at the
handle level serve to hold the staves together. The handles, two of
them, are the most interesting and unique features of the *staup* and
are usually indicative of the district in which it was made.

Horse head handles are the most common, are found in outer and
middle Sogn, Sunnfjord, and Nordhordland, and are probably the
basic type. In some examples they have become so stylized as to be
almost unrecognizable. Surface carving is kept to a minimum, wood
burning and stamping being the favored type of decoration. In these,
dot and circle designs are burned or stamped into the wood in more

or less geometric fashion. The technique is a development from the Renaissance method of texturing lower surfaces in flat carving. In the more expertly done examples these designs effectively point up the simplicity of the container and bold curve of the handles.

Of the various other types of drinking vessels found in Sogn, perhaps the most interesting is the wooden beer mug, made to resemble the baroque silver mugs or steins. It is an interesting carry-over from metal to wood, also evident in certain chalice-shaped cups. The steins were turned from birch root, had a single handle, hinged lid, and very short legs. Decorations were restricted mainly to simple fluting around the lid and shallow gouging or line carving around the base, on the lid, and on the handle. The hinge was shaped like a rosette and the knob with which to lift the lid took various forms from the plant and animal world. Actually this particular item was not native to Sogn at all, but was a product of itinerant woodworkers from Valdres who plied their trade along the fjordways in the late 1700's. The elegance of these wooden steins gained immediate favor among the Sognings. Because of wide and thorough distribution they became as much a part of Sogn life as the locally made bowls.

VEST-AGDER, because of its contacts with the continent, more readily incorporated the new styles into its art than did the Vestland districts. It welcomed Renaissance and baroque and to some extent the rococo styles into its furniture-making. There were chairs aplenty and richly profiled cupboard crowns and beds. Much of it is Dutch baroque.

The early carving from this district is like Setesdal carving, with two or more Romanesque vines intertwined as though knitted. Later the braid motif became popular and knotted ribbons were often carved on ladle handles. The latest carving was completely naturalistic. It was contemporary with and an imitation of *rosemaling*. Some

of it may have been done by Telemark carvers, who were no less able than their *rosemaling* colleagues.

As a rule, the carving used on the small household containers was the large-patterned, deeply cut carving of the late Middle Ages. Used on the underside of butterbox lids, it left a patterned imprint on the

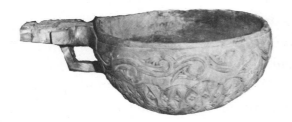

44. Chip-carved dipper in Setesdal style. From Fyresdal, Telemark. Dated 1691. Now in Fylkesmuseet for Telemark og Grenland.

DEAN MADDEN

butter, a fancy touch for a company table. All the most attractive containers were brought out when there were guests in the house. Footed cheese and *lefse* stands, large wooden troughs or bowls with flat horizontal handles for soup and meat, carved ladles and spoons and fine candlesticks bedecked the table. And if the family owned a large fowl-shaped ale bowl in which to float small individual "ale-geese" they could be very proud. That, of course, had the place of honor.

Aside from the articles mentioned there were the usual travel chests and treasure boxes, lunch boxes for the herdsmen and pudding boxes in which to carry food to a sick neighbor. All were suitably decorated. Burning and stamping were used for the stave-type articles here as in other districts.

45. Ale hen from Telemark. NORSK
FOLKEMUSEUM

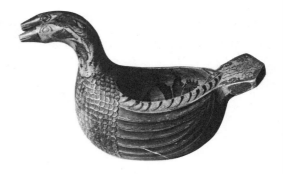

In spite of its proximity to the continent and its favorable material circumstances, Setesdal with unbelievable conservatism ignored anything that developed in decorative carving after the Renaissance. Its most popular motifs stemmed from Romanesque times, the most outstanding one being two parallel vines, sometimes interlaced, with Gothic-type chip carving in a fan shape between. This motif is found over and over again on door posts and chests, and is used in modified form on ale bowls and boxes.

The Romanesque leaf form when done in Gothic technique becomes ax-shaped. In Setesdal this similarity is carried further in one line of development until the motifs are definitely double-bladed axes, pointing out to the four corners of the design area, from a

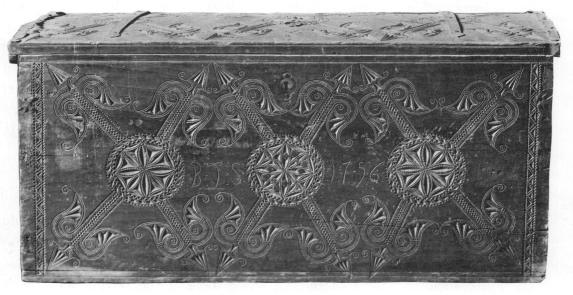

46. Chest from Valle dated 1756 showing typical Setesdal chip carving. NORSK FOLKEMUSEUM

rosette or sun-wheel in the center. Another variation of the vine becomes a chain or knit motif and still another the familiar interlaced ribbon motif used almost universally.

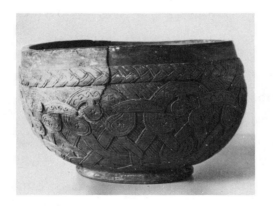

47. Setesdal ale bowl dated 1765.
BERGENS MUSEUM

Although there was some of the most interesting early medieval carving of Norway in the district (Hylestad portal, Chapter One), the carving of Setesdal was little affected by it. If there is any carry-over at all, it must lie in the use of the Romanesque vine and the strongly medieval human figures. There are numerous examples of figure carving in the district, particularly on ale bowls and bench backs. The carving is in low relief, naïve in form, but with a strength and directness characteristic of all Setesdal craft work.

Furniture construction in the district was governed by Renaissance forms from the introduction of the first Renaissance cupboards around 1700 until the influx of Empire styles in the 1830's. An occasional chair with baroque or rococo crosspieces and a certain amount of *rosemaling* are the only evidence that Setesdal had anything to do with the rest of the country in the intervening period. And this work was probably imported.

The small articles of the house were much the same as in Vest-Agder, at least in so far as the dominant form is concerned. Simple borders and bands were burned on the thinner utensils. A few examples have quite elaborate burned designs, showing the effect of *rosemaling*. Some of the ale bowls were of the broad, open, east-Norwegian type, others smaller and more compact, with an upstanding collar, related to those of Sogn.

An interesting custom of the district concerned the drink handed to the new bride by her mother-in-law upon their return from the church. Before she dismounted from her horse she was given a

drink in a small carved bowl called "the bride's bowl." After she had drained it, the bride was supposed to toss the bowl backward over the roof of the house. She could have three tries. If she failed to get it over it boded ill for her marriage. The danger could be somewhat allayed if, upon entering the house, the new bridegroom went immediately to the fireplace and made three slashes in the wooden horse head that surmounted the pole on which the pothooks hung. The specific purpose of this good luck rite was to protect the house from burning.

The horse's head, as well as the sun-wheel, was used all over Europe as a fire symbol. The rooster, too, with his fiery plumage was a symbol of fire demons and lightning, and figured prominently in the luck ceremonies of which there were many. Superstition long played a part in the selection of decorative motifs in Norway. Even when the symbols had lost any real meaning, they were retained in traditional ornament. An example of this is the cock weather-vane.

IN AN AREA about the size of Connecticut, Telemark has at least six distinct cultural districts. Variations occur in art and architecture not only from mountain to valley but from east to west and north to south. Far from being backward, the mountain areas, particularly those toward the west and hence closer to the west coast cities, were the first to pick up the new trends. As these innovations were passed on to the valleys where economic conditions made possible a greater specialization, they were developed and improved. Thus the valley art, though it had a later start, became much more refined than that of the poorer mountain districts. There are exceptions, particularly in the case of *rosemaling* which is a relatively inexpensive form of decoration. Where material cost was a factor as in silverwork and carving, the richer districts had the advantage.

The severe mountain district in northeast Telemark clung to Romanesque motifs as late as 1779. By this time, however, they

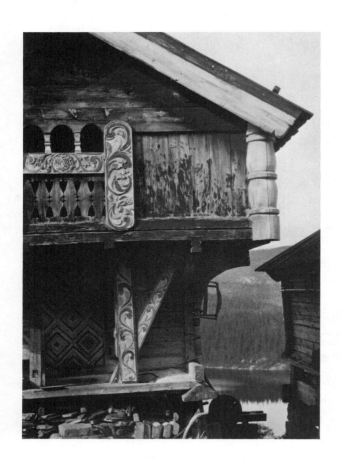

48. Telemark loft built in 1832, in Bondalen, Tuddal

had been combined with Renaissance and baroque styles. Carving progressed from carved c-waves to pierced leaf forms to rococo intricacy. As a rule the carving is unpainted. The background is often crosshatched to make the design stand out.

Pictorial representation was more commonly used in the Hjartdal part of Telemark than in any other area. Boldly carved lions surmount the doorposts of some of the oldest lofts. Bedposts and church doors are embellished with various imaginatively done animals and some human figures. Around 1720 a Gothic-influenced flat carving comes in with weakly curving vine and clover-like leaves on short stems. Later carving includes rose and vine forms, sometimes line-carved and the grooves filled with lamp black, sometimes burned on.

In one home a rather lengthy carved inscription runs completely around the room, along the food cupboard, the bed, to the long shelf

over the doors, and finally the *peis*. Translated, it reads, "God protect this house from fire and thieves: House and goods are inherited from parents but a good wife comes from the Lord: But Sirach says that she is the man's support: but Solomon says that man is her helpmate: Walk not like the foolish virgins but like the wise who have oil in their lamps: Paid by me H.O.S. and T.O.D. Dmn MDCCCV." Inscriptions were at first in simple Latin letters, later in large cursive letters and by 1840 in small cursive letters with large ones as initials.

Chip carving and flat carving had a particularly long reign in the level districts of Telemark. Typical of loft decoration from 1700 is a Romanesque flat carving with the stylized leaves similar to those from Setesdal. The next development is a Gothic rosette framed by a line-carved circle. Around 1750 a luxuriant flat-carved vine makes its appearance and lasts at least until 1800. There is no acanthus element in it. It is simply an embellished Romanesque vine. Around 1780 the strongly modelled carving that is found on doorposts in all parts of Telemark appears.

49. Storage buildings in Lærdal, Telemark. NORSK FOLKEMUSEUM

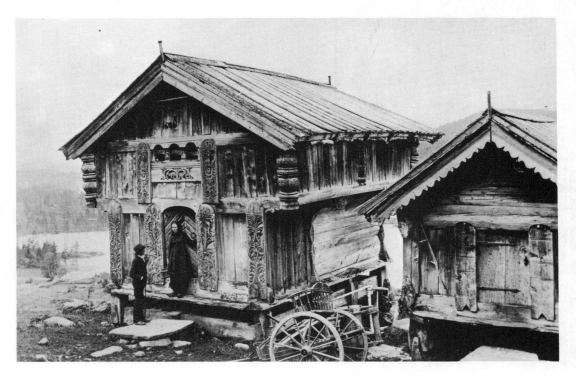

Central Telemark seems to have taken a rather standard path in its carving. From Romanesque vine carving, to Gothic vine and animal carving, Gothic geometric or flower carving and finally Renaissance flat carving, its development has been quite ordinary. There was an unusually close tie between the *bonde* and the official families in this district. This may explain the rapid spread of continental trends in the eighteenth century. After 1800 *rosemaling* has a very evident effect on the local carving.

The Vinje and Rauland area in the high mountains of west Telemark was the first part of Norway to use a Gothic-tinged naturalistic flat carving. This clover-leaf Renaissance vine is used on a loft in Midgard from 1591. The Gothic rosette is retained past 1700 but at the same time the Renaissance vine is developing into the scrolled vine carving that later appears on all the lofts. Four definite types of carving appear in this district, often at the same time, sometimes on the same structure. Line or groove carving, *geisfuss*, is one of the simplest and often most effective, particularly for monograms. *Skulpesnitt* is a gouge carving in which the wood is scooped out in

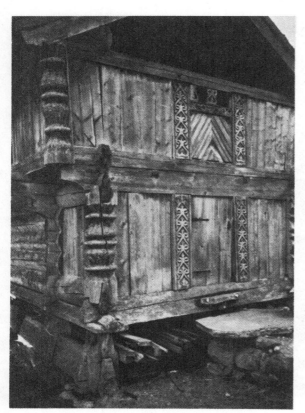

50. Loft in Rauland, Telemark.

parallel rows. The leaf chain, common in Setesdal, is a combination of chip carving and naturalistic flat carving. The fourth type is a billowing vine and leaf carving in high relief over a hollow-cut ground. The richly modelled baroque carving has little effect here.

The lumber industry upon which southern Telemark was so dependent was taken over by coastal cities in the eighteenth century, leaving this area almost depopulated. It is not surprising that Romanesque elements lasted until about 1750. The Renaissance had been introduced to the district by German miners in the early part of the century but it advanced slowly. The clover-leaf vine and tulip imposed upon the local strapwork finally developed into a good Renaissance carving by the 1770's. In the next few decades baroque and rococo tendencies grew rather rapidly so that by 1800 the district had nearly caught up with its neighbors in carving. In the field of home construction, however, southern Telemark lagged almost a century behind. It was not until 1840 that the first rebuilding started.

It is clear from the above that Telemark in its various sections has fostered virtually every type of carving ever used in Norway. It is a most unusual district and one that has excelled not only in craftwork but in music and literature as well.

Two FACTORS were operative in keeping the medieval traditions alive in Numedal up to the eighteenth century. The first was, as is the case in so many other parts of Norway, the inaccessibility of the district. The only means of communication with the outside world was by footpath over the mountains that rise abruptly from the valley floor, or along the troublesome riding paths that wound through the forests and rocky slopes of the valley bottom.

A result of this isolation (and another factor in preserving the old traditions) was the continued existence of several buildings from the Middle Ages. One is the very interesting Raulandstuen, now in Norsk

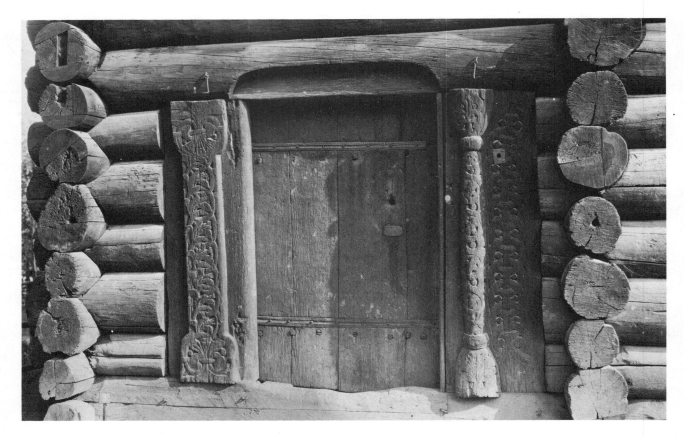

51. Door in the Rauland house from Numedal built about 1350. Romanesque carving on the door posts; runic writing over the door. NORSK FOLKEMUSEUM

Folkemuseum at Bygdø. It is the usual type of medieval log building but with some exceptionally rich Romanesque carving at either side of the door. One panel contains a laced ring motif and next to that a half-column of plant or snake motifs executed with the pierced-work quality of the Byzantine stone columns. The other panel is less well done and rather flat but with the same intertwined snakes or vines. From the runic writing above the door the building is assumed to have been built around 1350. Two movable table supports with carved animal heads were saved in the building and were probably made about the same time.

Other medieval buildings remaining in the district include the stave churches of Nore and Opdal built in the fourteenth and fifteenth

centuries and the numerous lofts which were still being constructed in medieval style long after the introduction of the chimneyed *peisestuer* in the middle of the eighteenth century. Medieval lofts have continued in use in Numedal almost to the present day and the many examples remaining afford excellent opportunity for studying the development of carving.

Gothic carving seems to have affected Numedal much less than it did Setesdal and the west coast districts. This may have been due to the high degree of artistic ability of the Kraviks, the leading family in the district for five hundred years. Because of their exceptional craftsmanship they did not need the security of geometrical form and were able to carve plants and animals and even human figures with remarkable understanding of artistic values. Hence the naturalism and proportioning of the Renaissance meant little more to Numedal carving than a revamping of design areas.

The small objects of the Numedal household were much the same as those of other districts. There was, however, less carving than for example in Gudbrandsdal, and more woodburning. The main form of the object was kept simple for easy cleaning, the burning

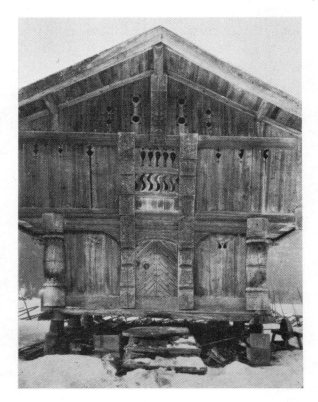

52. Loft in Rollag, Numedal dated 1725. NORSK FOLKE-MUSEUM

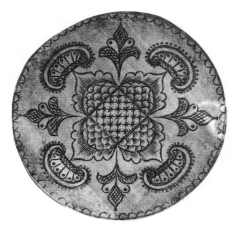

53. Cover of a box from Telemark, decorated by wood burning. NORSK FOLKEMUSEUM

technique chosen to stand up under generations of scouring. Consistent with Numedal tradition, the burned designs utilized not only the common geometrical patterns but also imaginative plant and animal motifs.

Carving was in rather low relief, in contrast to Gudbrandsdal's highly modelled work, and included human figures as well as the other decorative forms. Rather unusual is the scratch carving used on the *grøtspann* (pudding dish) shown in fig. 54.

The relatively late introduction of the *peisestue* (Chapter Two) to Numedal meant that the old dirt-filled wall benches, the open shelf cupboard slanted back at the top with the angle of the rafters, and the simply bold decoration were in use as late as 1770. The Norwegian Renaissance was well over by the time Numedal houses were

54. Pudding dish from Romerike, decorated with scratch carving. NORSK FOLKE-MUSEUM

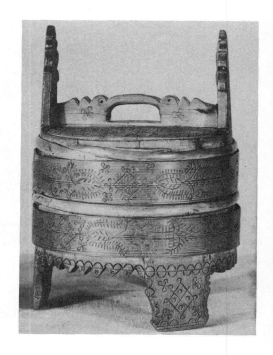

being rebuilt and the concurrent change in furniture styles jumped directly into baroque. Flat-crowned cupboards, in keeping with the ceilinged rooms, were made with baroque profiling and panels, and the new movable chairs had baroque carving. Angel heads carved into the panels, graceful vinework cut through thick facing boards, and short bowed legs were used in one of the better cupboards. Stars carved into the crownpiece and later made of molding glued on appear on several of the Numedal pieces.

There was not much rococo furniture in northern Numedal and that in the southern part of the district was strongly influenced by continental styles which had been brought to the city of Kongsberg. Pastoral scenes quite foreign to the Norwegian landscape appeared on cupboard doors, though the coloring was true to Norwegian tradition. Later rococo pieces showed a deplorable lack of understanding of the values of restraint. Bars, stars, diamonds, wreaths, and ribbons are glued on in such confusion that the structure of the cupboard is lost beneath a welter of half-rounds and wooden naturalism. Even *rosemaling* finds no place. It may be significant that the man who achieved these monstrosities found it impossible to make a living in Norway and moved to America in 1842.

Telemark and Hallingdal men took over more and more of the Numedal craftwork from 1850 on. The simplicity of the Empire style was a distinct relief after the rococo excess. Such features as the straight latticework crown spread over most of the country and the gap between European and Norwegian furniture styles closed rapidly.

THE YEARS between 1740 and 1780 are of greatest significance in Gudbrandsdal carving for it was during this time that the renowned *døleskurd* was developed. Gudbrandsdal, like the rest of Norway, had experienced a period of fumbling uncertainty after the decline and disappearance of Gothic carving. Crude, simple flowers and

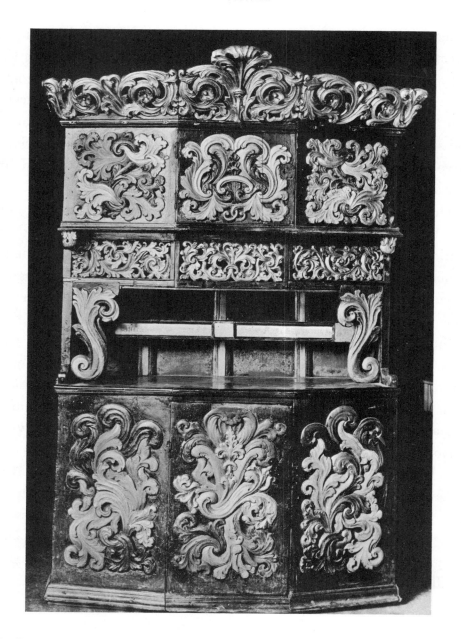

55. Baroque cupboard from Skjaak in Gudbrandsdal, 1783. KUNSTINDUSTRIMUSEET
I OSLO

leaves were attached to stiffly curving vines. Naïvely done biblical
and historical scenes on household objects and a little chip carving
on door posts were representative of the art of the day.

The first sign of a reawakened art sense is a slender naturalistic
ornament sometimes reminiscent of Gothic. By 1700 the vine be-
comes thick and ribbon-like with simple, slightly curled leaves inter-
twined in medieval fashion. The leaves are more and more scrolled,
more like the acanthus that overruns church *décor*, culminating in
the rich baroque type of carving, the *døleskurd*, that is retained in

56. Rococo cupboard from eastern Norway. NORSK FOLKEMUSEUM

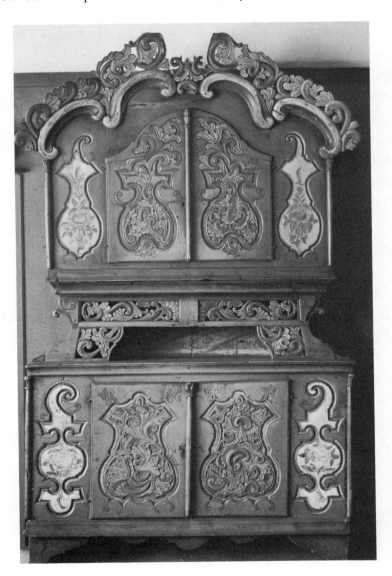

57. Travel box from Gudbrandsdal dating from the 1700's. KUNSTIN-DUSTRIMUSEET I OSLO

58. Below and opposite: *Mangletrær* from Gudbrandsdal; about 28 inches long. NORSK FOLKEMUSEUM

Gudbrandsdal through the following periods. An example of this is found in a monumental cupboard from Skjaak in the western part of the valley, fig. 55.

Skjaak and Lom, because they were closer to the west coast whence continental trends arrived in the valley, were the first to develop the new carving. Other parts of Gudbrandsdal eventually had their own excellent woodworking but the credit for the birth of *døleskurd* is conceded to Skjaak.

Gudbrandsdal was a comparatively well-to-do district and its homes were large and well furnished. Even the smaller objects, things such as the *mangletrær* for ironing and *æsker* (boxes of various kinds) were often decorated with the lavish carving characteristic of the district, in contrast to the simple line or chip carving used elsewhere. Individual whim was strongly evident in home furnishings. The windows were sometimes topped with crowns like those used on the cupboards, sometimes with shelves from which hung a carved and painted "beard." Carved posts between the windows and the fact that the windows were high and rather small made curtains superfluous and added to the charm of the interior. Baroque styles were particularly well suited to the almost manorial houses and continued to dominate decorative art even after the introduction of rococo motifs.

Sunndal, in the mountains of eastern Nordmøre, was culturally related to both Gudbrandsdal and Trøndelag. This was due more to terrain, economy, and the travels of individual craftsmen than to communication, for these areas were not connected by important trade routes. Broad, fertile valleys in all three areas made possible a wealthier group of farmers who were able and anxious to keep up with the latest trends. Thus the more recent art styles displaced the older ones.

This is especially noticeable in Sunndal but for a very special reason. Here, between unbelievably steep mountains there are sudden landslides and terrific winds at certain times of the year. These destructive forces have ruined many a farm building, and each time a building was replaced it was in a newer style. This was true of the smaller items such as boxes and ale bowls as well.

Furthermore, this area was a popular retreat for wealthy English people in the nineteenth century, to whom many of the old items were sold. Because of this, there are now very few things left to indicate what kind and quality of art work was done in the district prior to the 1800's.

Most eye-catching of the Sunndal carvings are the elaborate portal-like entrances on the very long two-story houses. A large panelled door is flanked by two narrower panels and topped by a decorative arch. Colorful and highly modelled carving on the arch and the top half of the door and side panels has a most decorative effect against the brown log walls. The carving is markedly similar to the baroque leaf carving of Gudbrandsdal and was probably learned there by one of the Sunndal carvers. The Sunndal work in general differs from Gudbrandsdal carving in that it is relieved by large areas of perfectly plain wood. It is frequently combined with *rosemaling*.

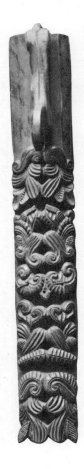

Cupboards remaining in Sunndal are nearly all in baroque style. Most have an arched crown, sometimes with winglike projections at each side. Grotesquely outlined panels in both upper and lower

cupboard doors of the more extreme examples detract somewhat from the massive grace of the cupboard as a whole and from the expertly carved mid-section and crown. Other cupboards from about the same period are flat-crowned and panelled in simple rectangles with *rosemaling* for decoration. Leaf-carved tankard lids, boxes, and spoons, as well as harness hames, are among the many small items that were decorated by Sunndal carvers. Probably there was a substantial amount of burning, stamping, and chip carving at one time. Now there are just a few examples in the district.

Turned ale bowls found in Sunndal are shaped much like those of Sogn, though broader and lower. They have the same vertical collar above a horizontal ridge and the same type of low foot. *Rosemaling* provides the decoration. Turned plates were in common use all over the country but were rarely decorated. The *rosemaling* used on a set of twelve such plates found in the district makes it an unusual and valuable find. Footed stands for cheese or *lefse* were also turned and sometimes stamped or carved in a simple design.

The neighboring area of Opdal in southern Trøndelag fostered a rich baroque leaf-carving very similar to that of Gudbrandsdal. As in *døleskurd* there is no vine stem, but rather a series of c-motifs from which the curling, lobate leaf forms fan out to fill the design. Unfortunately much of the larger Opdal work lacks the unity and harmony of Gudbrandsdal carving because of the introduction of incongruous motifs, and because the surface is broken up into too many areas. Smaller items and specific areas on the larger pieces show a finished talent among Opdal carvers of the 1800's.

GLOMDAL, which includes several valleys in eastern Norway, showed a diversity in its woodworking quite consistent with its size. The northern part of the district, particularly Foldal, was strongly affected by Gudbrandsdal artists who often worked in the district. The native vine-carving was not as deeply modelled as that of Gudbrandsdal and

not quite as well done, though much of it had a graceful charm.

The strong point of this northern area lay in its unfailing sense of proportion. Not only was the decoration scaled to the furniture but the furniture was in proportion to the room. The very large rooms required large furniture, the furniture needed massive decoration and of course baroque was the answer. From about 1740, the rectangular panelling of the Renaissance, of which there had been an abundance, even on chests, was replaced by the angular panelling of the baroque style. There was an infinite variety of highly profiled moldings. Chairs, used mainly by the church previous to 1800, were produced in great numbers for ordinary people, and the style was almost invariably baroque. One kind, used all over the district, had a rectangularly panelled back and a rounded top, with a baroque carved stretcher between the front legs.

North Glomdal carvers made effective use of the play of light on wood, not only in the moldings and smoothly planed surfaces but also in diagonal panelling and grooving. For the most part they avoided pettiness of detail and excessive decoration. When a piece was to be *rosemalt* the carving and panelling were kept to a minimum. This applied to ale bowls as well as to furniture.

Much of the rococo furniture that began to appear in Glomdal around 1790 was done by Gudbrandsdal workers. Characteristic of the work were asymmetric chair backs and elegant coloring. The very popular bookshelves were decorated in gold leaf, usually in combination with other colors. Black and gold chairs were popular. And of course *rosemaling* played a prominent part. Secret drawers and cupboards were in great demand. Simplicity was still the keynote for everything but clocks. These new and wonderful monuments to progress received unstinted embellishment and were accorded a place of honor between the gable windows.

In southern Glomdal household articles were treated quite matter-of-factly. Many of the smaller stavework objects were left perfectly

plain with only the birchroot bindings to divide the area. If decorations were used on everyday items they were often the burned or stamped kind. Ceremonial utensils might be carved in a sure, slender vine decoration similar to Gudbrandsdal's but with open background around it.

Another popular procedure was the chip carving of articles which had been stained reddish brown with alder bark. Carving exposed the white wood beneath, resulting in a design of clean contrasts and pleasing effect. In southern Glomdal chip carving was the accepted technique for nearly all carving, not only on stained wood but on ordinary wood as well.

Woodturning seems to have been a specialty of this area. Whereas in northern Glomdal candlesticks were usually of metal, in the southern part they were of turned wood. Probably they were done at the spinning wheel maker's. Turned ale mugs were made from birch wood and delicately carved, with reclining lions for the base. Ale bowls were quite plain and open, with a little *rosemaling* for color.

Furniture styles in this area took the usual path. The cupboard, for example, went from the straight top type with open plate shelves to the kind with closed sections above and below, to one with a curved top which becomes more and more complicated, and finally to a secretary. Curving corners and c-curved crowns were characteristic of south Glomdal cupboards around 1800. Fortunately the cabinetmakers were satisfied to restrict their bid for elegance to the outline. The surface area was kept quite simple.

ROMERIKE, a flat, open district lying just northeast of Oslo, is also on a centuries-old travel route to Sweden. These two factors had a strong modernizing effect on the district, and the constant bombardment of outside influences destroyed any really individual or unique form of art that Romerike may have had. Furniture and other articles remaining in the district are rarely as old as the eighteenth

century and are of a very ordinary design. Their main claim to fame is in their expert workmanship.

During the 1800's Romerike cabinetmakers carried on a profitable business with Oslo furniture merchants, making cupboards, tables, and the like according to the buyers' specifications. The articles were delivered unfinished so that the buyer could better see the quality of the wood. Such a close relationship between craftsman and dealer had a beneficial effect on quality of construction but tended to standardize design.

Carving was also done in quantity. Carved heads and human figures are more numerous in Romerike than in other districts and are found on harness hames, newel posts, tankards, rococo table legs,

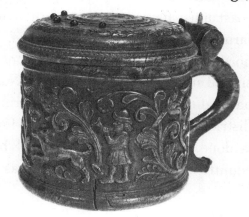

59. Beer mug made of wood; typical of the flower and figure carving of Romerike. NORSK FOLKEMUSEUM

and the like. Baroque and rococo flowers and vines were used on these same articles, and as a rule were executed in an artistic but not particularly unique manner.

If there is any connection between the folk art of Romerike and that of any other district, it must be with that of Glomdal. Both districts show a fondness for scenery and human representation, particularly in painting, and both used a great deal of panelling. Probably at one time Romerike, like southern Glomdal, had a quantity of chip carving and stave articles, but there is little or nothing left now.

When one considers the perishability of wooden articles and the powerful drive toward modernism in the last century, one marvels at the number of historical objects that have been saved in Norway. Probably the things that are left, the lofts, furniture, bowls, and treasure boxes, are representative of what Norwegian farms once harbored. But infinitely more, perhaps better, things must have disappeared.

This tantalizing thought is spurring still more Norwegian scholars to collect and record information from the parts of Norway which have not yet been studied. It is perfectly conceivable that their search may turn up new and different art styles and even a different way of life. Certainly the wind-swept, wave-dashed islands off the northwest coast must have a culture of their own in which fishing rather than farming is the dominant influence. The art of the Lapps in the far north differs sharply from that of southern Norway and perhaps should not rightly be considered Norwegian at all. However, it must have affected the art of neighboring Norwegian districts and these districts have yet to be explored for art publication. When all this is done, Norwegian folk art will be outstanding among European countries for its diversity as well as its excellence.

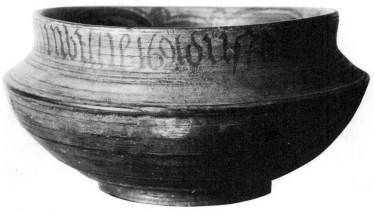

S14. Ale bowl from Sogn, 1691. Typi-
cal small, high collared bowl of
the west coast. BERGENS MUSEUM

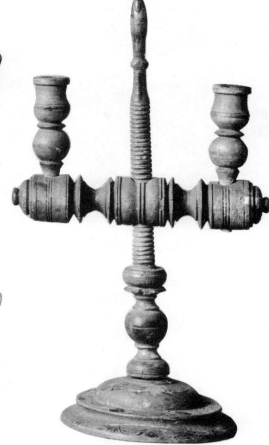

S15. Turned candleholder from Aal,
Hallingdal. NORSK
FOLKEMUSEUM

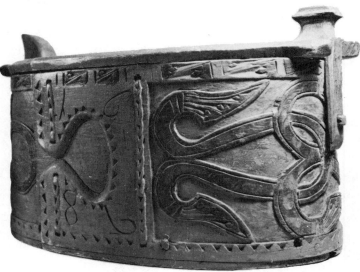

S16. Two views of a box (*tine*) from
Setesdal, 1686. BERGENS
MUSEUM

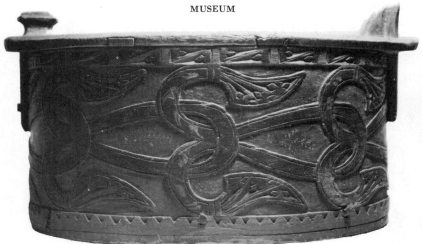

S17. Setesdal ale bowl, probably 17th
century. NORSK FOLKEMUSEUM

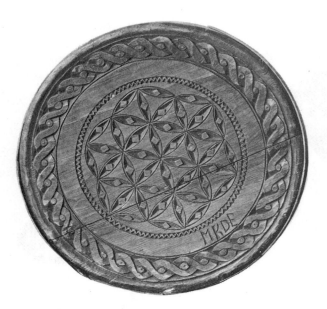

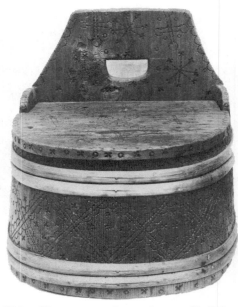

S18. Chipcarved lid for a bentwood box, from Vest-Agder. NORSK FOLKEMUSEUM

S19. Flour container from Sigdal, Buskerud. Decorated by stamping. NORSK FOLKEMUSEUM

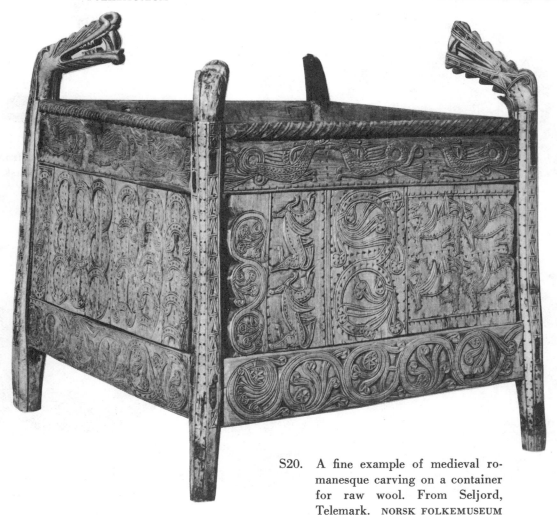

S20. A fine example of medieval romanesque carving on a container for raw wool. From Seljord, Telemark. NORSK FOLKEMUSEUM

S21. Bentwood box with dome lid, from Romsdal. Scratch-carved through color. NORSK FOLKEMUSEUM

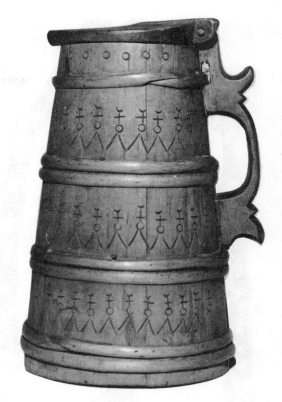

S22. Stavework tankard. NORWEGIAN-AMERICAN MUSEUM

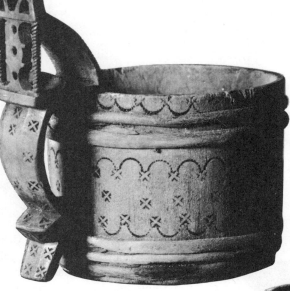

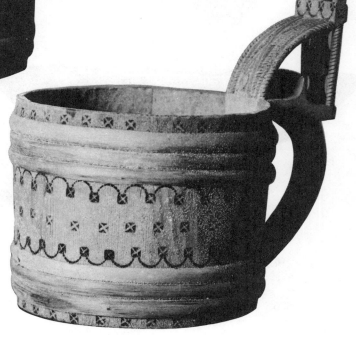

S23. Butter containers from Sunnfjord. BERGENS MUSEUM

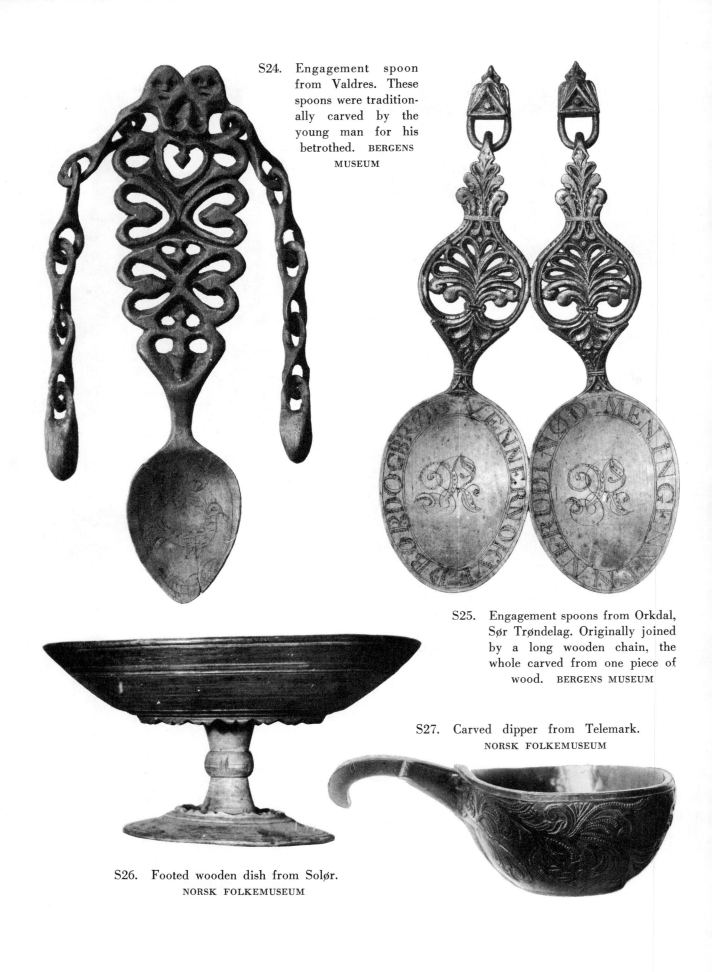

S24. Engagement spoon from Valdres. These spoons were traditionally carved by the young man for his betrothed. BERGENS MUSEUM

S25. Engagement spoons from Orkdal, Sør Trøndelag. Originally joined by a long wooden chain, the whole carved from one piece of wood. BERGENS MUSEUM

S27. Carved dipper from Telemark. NORSK FOLKEMUSEUM

S26. Footed wooden dish from Solør. NORSK FOLKEMUSEUM

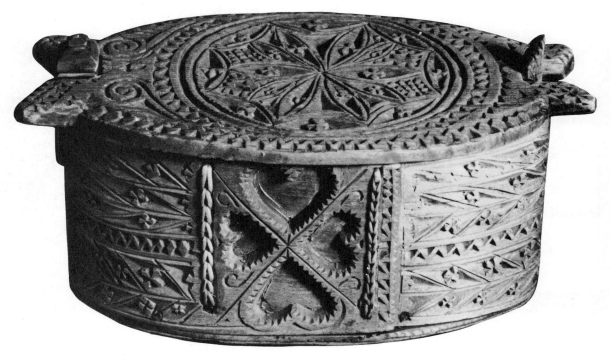

S28. Carved *tine* from Valle, Aust Agder. Bentwood boxes were sewed together with birch root. This one is unusual in the depth of its design. NORSK FOLKEMUSEUM

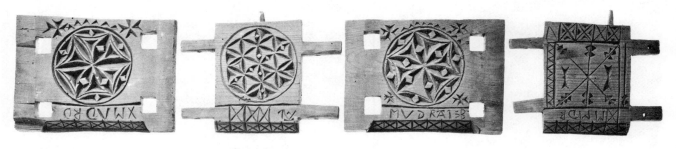

S29. Butter molds. These pieces fit together to form a box, usually with a pyramidal lid. Upper from Nordfjord, lower from Sunn-hordland. BERGENS MUSEUM

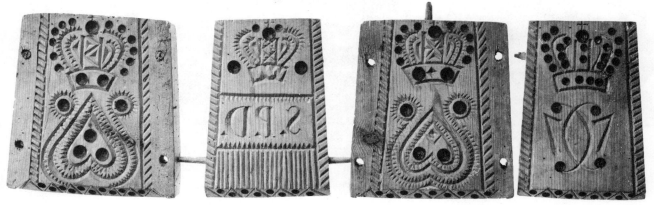

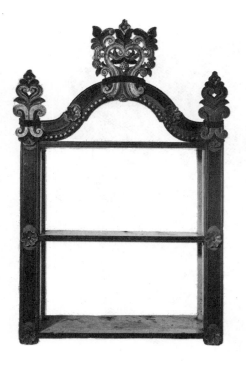

S30. Carved and painted shelf from Selbu, Sør Trøndelag. NORSK FOLKEMUSEUM

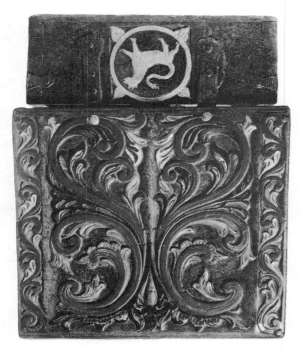

S31. Lid and back of a travel box from Bø, Telemark. Polychromed carving. NORSK FOLKEMUSEUM

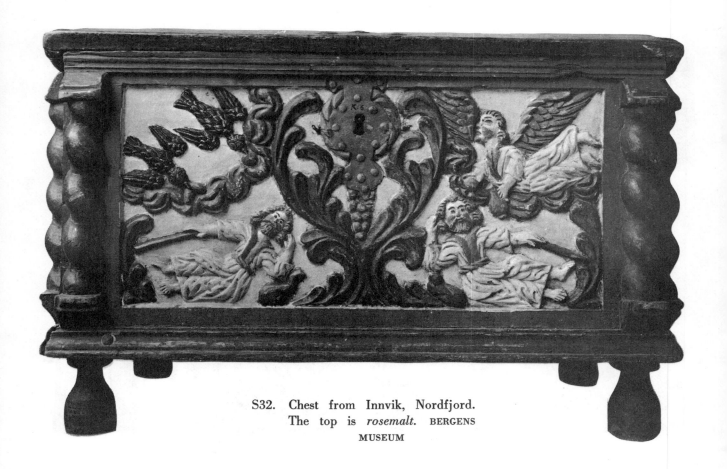

S32. Chest from Innvik, Nordfjord. The top is *rosemalt*. BERGENS MUSEUM

Rosemaling

4

ROSEMALING, or literally, "rose painting," is a term covering a wide variety of Norwegian painted motifs. It has a counterpart in the Swedish *blomstermålning* (flower painting), in the decorative painting of Russia, and in Pennsylvania Dutch art, but it is distinct from all of these. It also varies from district to district within the country, with here some picture painting similar to that used in Sweden, there tulip motifs from the Dutch and German baroque, and in another place, the scroll-like motifs from French rococo, but always the designs have a strongly Norwegian air.

Rosemaling is the most recent of the Norwegian peasant crafts. Whereas carving dates back to prehistoric times, and in the Middle Ages was sometimes enhanced with color, the decorative painting on a flat surface did not begin in Norway until about 1700. The first districts to take up the new art were those in the central and south-western sections of Norway, notably Hallingdal, Numedal, Telemark,

Setesdal, and Vest-Agder. Telemark and Hallingdal seem to have had the most prolific painters, though men from Gudbrandsdal and Trøndelag also turned out a quantity of this painting.

In most districts certain families began to specialize in *rosemaling,* as other families or men specialized in the other crafts, and "schools" of painting developed within the districts. This makes it comparatively easy to determine from which district a bit of *rosemaling* comes, when as is usually the case, the piece is unsigned. Sometimes it is the choice of colors which identifies the locale. For example, in Hallingdal the colors are bright, with a predominance of red. Glomdal is particularly fond of blue-green.

Sometimes the design itself is the distinguishing characteristic. Thus Telemark painting is recognized by its graceful, elongated leaf forms, and dainty flowers on long stems. Gudbrandsdal makes extensive use of a luxuriant acanthus motif. In Numedal the designs often include tulips because a German painter was one of the first in the district, and German decorations nearly always contained the tulip motif.

Of course there is much overlapping and the painted articles found in a certain locality may not belong to the art of that district at all. Artists from the poorer parts of the country, such as Telemark and Hallingdal, often had to find more prosperous areas in which to make a living. Because of this, Telemark painting appears in Numedal, Setesdal, and Rogaland, Halling painted pieces in Gudbrandsdal, Numedal and Valdres, and so on.

Even in cases where the artists themselves were not imported, their work might be brought in as a market product or a gift, or as part of the dowry equipment of a bride. These new pieces were often the basis for a more or less minor change in the local styles. Thus we find Setesdal painting influenced by Vest-Agder work, Glomdal decorations with a definite Swedish look, and a metropolitan air in the art of the more urban coastal districts.

Diversification developed fairly fast, in less than a hundred years. Since this new art style came in during or soon after the Renaissance, the first pieces were, naturally, quite simple and rational, almost cold. City-made ale bowls seem to have been the point of embarkation; for these, done in the late 1600's, have been found in nearly all the districts.

The Renaissance conception of the treatment of space seems not to have disturbed the rural artist too much. He was willing to be more or less symmetrical, at least for a time. But a lack of imagination was something he could not tolerate. Fanciful carvings of the medieval period were still to be seen here and there about the country, and the eighteenth century painter seemed to feel a closer kinship to the heathen artists through the centuries and his own land than to the "enlightened" artists of ancient Greece and Rome.

He liked to stretch the truth a little. Pure naturalism was never very popular with him and neither was imitation. He used his own fantasy in forming wonderfully complicated leaves and vines, and flowers that might look like butterflies to one person and partly husked walnuts to another. Baroque and rococo were much more to his liking than Renaissance, the one because it was earthy, the other because of its lack of restraint. For this reason, Renaissance examples are few, while baroque and rococo elements are still being used today.

The baroque vine is the starting point for almost all *rosemaling,* and most pieces show elements of flower baroque too. However some pictorial painting can be found, particularly in the eastern districts. The designs are quite stiff and stylized but unquestionably decorative. They are interesting in that they show the mental disposition of the day in which they were painted. Many of the scenes are Biblical, some are from the then-popular nature study books, others from legends. Animals such as the dragon, griffon, unicorn, and sea horse were depicted here and there. Folk scenes, particularly of wed-

ding parties, appeared frequently, with greatest popularity in Tele-mark, Setesdal, and Vest-Agder.

Every design was different in some respect from every other, and it is difficult to find two pieces with even a close identity. To be sure, the various things produced by one artist would have enough points of similarity to make it possible to determine their origin with a fair degree of accuracy. However it was a point of pride to be original; straight repetition was frowned upon.

There was very little mass production. In Nordmøre two of the most prominent artists made use of stencils in blocking in the main areas in their design, which was always symmetrical. Details were put in freehand and were varied from piece to piece. This procedure was used after the 1840's as the crafts fell into a decline; it could never have been used in the freely placed, intertwining designs from other parts of Norway.

While we may have no trouble in appreciating the design of the eighteenth and nineteenth century *rosemaling*, the color is a different matter. One who has been schooled in monochromatic costumes with "just a touch" of color contrast, and in houses with "muted" or "sophisticated" color schemes will find it difficult to understand, and like, the flamboyant and the somber in the old Norwegian decorative painting.

At one extreme the background may be a dull teal blue and the design a combination of darker and lighter shades of the same color with a few touches of a subdued brick red and perhaps a little pale ochre and some black for accents. At the other extreme we find pieces with, for example, a raw green ground, framed in yellow with a red molding, and the design a raucous combination of reds and yel-lows with shades of green and touches of blue, and perhaps both white and black outlining and high lights. In the one case we get a feeling of depression, the other we may find too stimulating, too bald.

Both are quite unsophisticated. And in that they reflect truthfully the spirit of those who made them and of the homes they enriched.

There are, however, many examples in a middle group which come closer to the twentieth century conception of colors. In this class belong the decorated white panels of Glomdal and other eastern valley districts bordering on more sophisticated Sweden, and various of the moderate-toned pieces found in all areas which show a more restrained though still beautiful choice of colors and interesting contrasts.

Virtually every shade of every color and every combination of colors has been used at some time in some part of Norway. Even purple, which has had very few supporters, and gold, which is much more at home on Russian-made objects, are to be found on a few Norwegian pieces. For the most part though, dull blues and blue-greens, dull reds and red-oranges have covered the backgrounds, while moderate greens, reds, yellows, whites, and some blue have formed the design. Yellow ochre was rather more popular than pure yellow, and was much used for lining. Black lines and accents are very important in the old *rosemaling*, giving the design character and serving to set off colors which are often very nearly the same value. White serves the same purpose and is also used for high lighting.

An artist's ability can be judged by his adeptness in the use of white and black or sometimes yellow to set off his design. It requires a steady hand and a sure eye to vary the strength and delicacy of the lines at just the right point in the design and with just the right gradation. The curve of a sweeping stroke must be perfectly executed and in harmony with all the other curves of the design. Small commas of black or flecks of white must be located for the best effect, their size and number selected with care. Certain artists were noted

for the proficiency of their brush stroke, and they can always be identified by it.

Another attribute of the better artists was their skill in blending colors. This was effected by laying a contrasting streak of color on top of a wet area, or by carrying two colors on the brush at one time so as to give the proper shading and contrasts without a muddied effect. Care in preparing their paints, in grinding the pigment and mixing it with oil was the secret of their durability, and it took a lot of time. A painter in Nordmøre in the mid-1800's wrote:

To make chrome yellow: Take ½ oz. of the best English white and rub it on the painter's stone in as little water as possible, place in an earthenware bowl that can hold two or three times as much. Then take 1½ oz. oil of vitriol (sulphuric acid) and mix it with enough water so that it covers the white; stir it well immediately and let it stand for a day, then pour the liquid off; take 1¼ oz. potassium chromate, crush it dry on the stone, place in a fine earthenware cup; pour over it a little more than half a cup of water and when it is well dissolved, pour it on the English white stirring steadily; when it has stood some minutes it is stirred well again. This is repeated several times, after which it should stand for 3 days; then pour the water off, pour more water on, stir it well and let stand until it settles. Pour the water off. This is repeated several times until the water is quite clear; finally pour off all liquid, spread out thinly on an earthenware dish and let it dry in the air or place on a warm stove and stir.*

All this work was required just to prepare the pigment. At this point it had not even been mixed with oil or varnish. The preparation of varnish was nearly as onerous and time-consuming. Crushed clear lac, mixed with crushed glass was shaken with alcohol in a bottle until the lac dissolved. The bottle was laid on a shelf on its side and shaken occasionally. Resin was added, the shaking process repeated. After being allowed to settle and clear, the varnish was decanted into another bottle and the desired coloring added. Good recipes for colors or varnish were highly prized tools of the trade and were carefully preserved.

* Tora Sandal, *Fra en Rosemalers Verksted paa Nordmøre*

Scrupulous workers allowed their wood to dry two or three years during which time any shrinking or "bleeding" would have taken place. Prepared thus, the wood afforded the best possible surface for painting, and the finish lasted for generations. Pine was a favorite material. Previous to the Renaissance, furniture was not painted at all, just "white-scoured," and even after the idea of painted furniture spread, it was mainly the cupboards and chests and some beds that received such treatment. Chairs, tables, and benches were still, for the most part, bare wood. And so were the floors.

Ale bowls, boxes of various kinds, and chests constitute the greater part of the remaining examples of *rosemaling*. The bowls are most frequently decorated inside, with just a border or an inscription around the outside edge. Biblical quotations appear frequently, and almost always there are the initials of the owner, sometimes of the artist, and the date. One such inscription states:

> *I al din gjerning bør Guds ære*
> *det første og det siste være.*
> In all your deeds should God's glory
> the first and the last be.

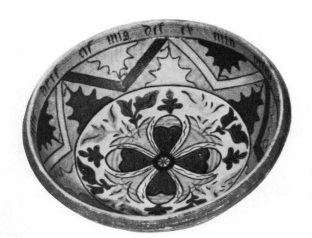

60. Renaissance-type ale bowls from Setesdal, 1700's. Left: Border is red and blue on yellow background. Center flower is on white background. Diameter about 10 inches. NORSK FOLKEMUSEUM Below: NORDISKA MUSEET

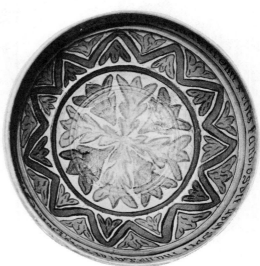

Another from 1658 reads:

> *Hvo lidet kan avle og meget vil drikke,*
> *en rig mand saa bliver han ikke.*
> Who little can raise (crops) and much will drink,
> a rich man will never be.

Two legends in a lighter vein are these:

> *Den farge som er satt—er rø og blaa—*
> *Aarsagen er nu den—de vilde ikke skure og tvaa.*
> The color that is used—is red and blue—
> Now the reason is this—they don't want to scour
> and wash.

> *Tap i bollen saa du er holden min kjære ven.*
> *Du ølet finder, om tønden rinder, i kjelderen.*
> Fill the bowl so you will have enough my dear friend.
> You will find the beer, if the barrel will run, in
> the cellar.

One amusing inscription, found on the cross beam of a house in Hallingdal, uses pictures to replace the nouns. It states, "I would rather live with lions and dragons than with an evil woman."

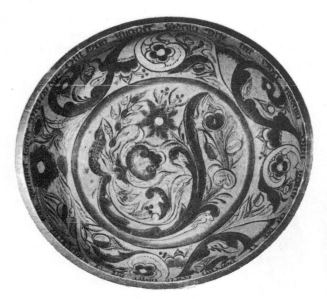

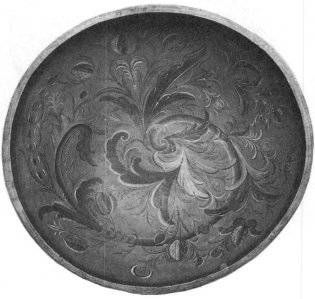

61. Left: Baroque ale bowl from Setesdal, 1824. Blue, green, and red flowers on yellow background. Outside is brown with yellow border. Diameter about 18 inches. NORSK FOLKEMUSEUM Below: Rococo ale bowl from Setesdal, 1846. NORDISKA MUSEET

GLOMDAL, lying next to Sweden along Norway's eastern border, has for centuries been an important link between northern and southern Norway and between Norway and Sweden. Its many rivers and large lakes carried small boats along on their summer journeys or provided a natural highway for sledges of lumber in the winter. Where the river was too swift or too closely pressed by mountains, travelers took to the heavily forested ridges and followed prehistoric paths to their destination.

The destination of many of these travelers was Grunnset. This market town, almost in the center of Glomdal, was the locale of large scale trading operations for at least three hundred years. Every year on the first Thursday of March people from all the neighboring districts and Sweden brought their homemade and homegrown wares to sell or trade for the luxury goods offered for sale by the merchants from Oslo or Drammen or Trondheim. Swedish weavings found their way into Norwegian hands at Grunnset and Norwegian grain or horses were carried back to Sweden. Fish from the west coast could be exchanged for butter from Østerdal, and large lumber contracts were drawn up and signed at this country fair. Nearly every family was represented. New ideas filtered back into the widely separated settlements with surprising promptness, making Glomdal one of the most up-to-date of all Norwegian districts.

The northern part of the valley was not settled until about 1644, after the opening of the copper mines. For this reason its handwork cannot be followed back to the Middle Ages as in other districts. The lower end of the valley, around Elverum, was a lumber trading center and a military post during the Danish period. The varied contacts with foreign and city traders and officers produced a more cosmopolitan culture and offered better opportunity for artistic development. By the eighteenth century Stor-Elvdal had become a noted handcraft center with high artistic standards.

Much of the Glomdal *rosemaling* is similar to that of Sweden, but

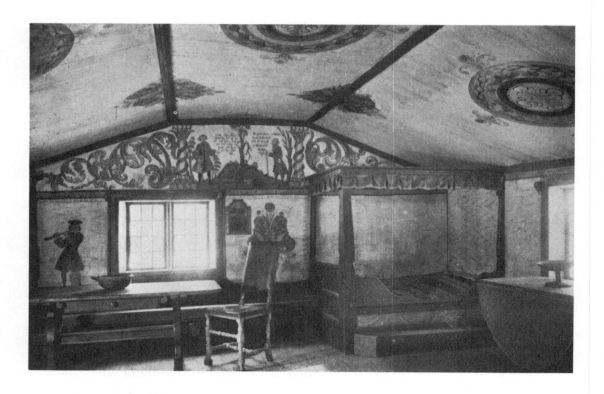

62. Synnviss house from Narjordet in Glomdal. Baroque decorations and figure painting typical of eastern Norway. FOT. NORMANN

it may also show a strong Gudbrandsdal influence, particularly in the more northern districts. The ale bowls have Renaissance-type designs, geometric patterns or simple leaf forms, such as are found in the Renaissance painting of Trøndelag. Chests and wall decorations from about 1740 to 1800 show late Renaissance flower vases, human figures, houses, and scenery. Trees, particularly pine trees, play a big part in Glomdal painting. There is much less of the typical flower and vine painting except in areas where Gudbrandsdal painters moved into the district.

Blue is a favorite color in this eastern district. It was used extensively here in the monochromatic painting popular in various countries in the eighteenth century, or in blue and white scenes such as appeared on blue willowware. It was also a favorite background color for polychrome decorations. Marbleizing was used in such

combinations as black on red or blue on white and various combinations might be used in the same room. Reddish-brown teamed with blue-gray was especially popular in the northern part of the valley.

Walls and ceiling were panelled, making them easy to decorate. Sometimes the entire wall was covered with scenery, and the ceiling with clouds! By the early 1800's the severe Empire style had ruled out so much decoration and the walls were painted in a solid color, with just a little frieze up under the gable.

ROMERIKE had a substantial amount of *rosemaling* but it was not outstanding. Some of it was flower baroque in which tulips are always naturalistic, other flowers of indefinite style. Far in the majority are the pictorial paintings. Some are landscapes, influenced by the French *chinoiserie*. Some are simply-drawn trees. Many are Biblical and allegorical scenes in which the figures are no better and no worse than those of other folk painting.

None of the Romerike painting is particularly subtle and the colors are dark. Blue and green grounds are here, as in Glomdal, the ranking favorites. One example has a drab, dark green frame and brownish colors. A dull blue chest has copper bands, brownish-rose flowers and drapery, and a dull green cartouche. Dark green frames the painted panels on a cupboard for which the background color is a dull blue-green, the design a combination of white, dark green, and brownish red. A reddish molding separates the panel from the frame.

Picture painting is used mainly on cupboard and room doors, sometimes on chests. Several chests have only a decorative cartouche at each side of the front on which initials and a date are inscribed. But inside the lid there may be a flowing vine motif or scenery with trees and flowers. Romerike painting fell far short of the standards reached in its carving and lost its popularity early. It was too much in the stream of travel to develop a good local character.

THE TERRITORY covered by the name Gudbrandsdal includes some of the highest mountains and the most fertile valleys of Norway. It takes up a big part of central Norway, and touches Glomdal on the east, Valdres on the south, Nordfjord, Sunnmøre, and Romsdal on the west. Even though mountains make communication with these districts somewhat difficult, Gudbrandsdal has for centuries been an important passage between west and east. The southeast, that is, Romerike and Oslo, is easily reached by way of the great water route, Laagen river and Lake Mjøsa. Roads and railroads now run the length of the valley, up to Romsdal and Trøndelag, but side roads are still few. Through the centuries it has been a prosperous district, very receptive to art. *Rosemaling* and carving have been developed fully here and the familiar vine motif has a definite Gudbrandsdal character.

Around 1600 all the churches in Gudbrandsdal received new decorations. This was the starting point of the Renaissance. Pictures and vines were painted on the wall, acanthus leaves later bordered the pictures top and bottom. German, Dutch, and Danish influences appear because Norwegian artists had gone to the continent to study. The Renaissance movement was strongest in Skjaak and Lom in northwestern Gudbrandsdal. In this same area rococo as a break from tradition came in strongly early in the eighteenth cen-

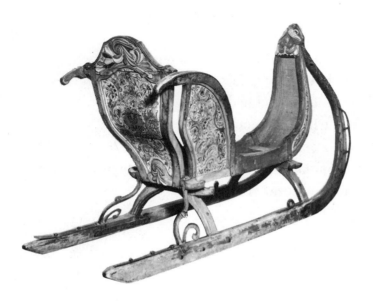

63. Sled from eastern Norway.
NORSK FOLKEMUSEUM

tury, whereas in southern Gudbrandsdal, easily reached by European trends, it was virtually ignored until about 1760.

Lom and Skjaak show a combination of the forces from western and eastern Norway that have flowed in through the years. Back in the twelfth and thirteenth centuries artists of the eastern valleys employed animal motifs almost exclusively. At the same time western Norway was concentrating on plant designs. A blending of these two appears in the Lom church where we find a carved winged dragon handled in a vinelike manner.

Carving in this little area of Lom quite eclipses its *rosemaling*. Here carved pieces were also painted though only a few colors were used. Red in the depths, yellow for high lights, blue or green ground, blue or gold lines—these sufficed for the pattern. For the frame, blue was sometimes used, with red molding and gold lines to give a touch of elegance. When *rosemaling* came it was executed like carving in form and movement, and with just as few colors. Most often the artist used shades of the background color, with high lights to strengthen the movement. Simple, stylized roses and tulips peeked out here and there in the leafwork. Such color decorations harmonized perfectly with the carving.

Painting reached its peak in the Vaagaa area between 1750 and 1790. The lines and modelling were executed boldly and with fine feeling. Duller colors were used at first—blue-gray, brown, and so forth. Later, lighter colors came into favor along with a more elegant handling of forms. The background might be a light red, with green, blue, and yellow in the design. Often it was stippled or splattered. Door panels might be light to contrast with the design, and the rest of the cupboard brown. The moldings were usually in a contrasting color, sometimes gold.

Around 1800 one popular painter in Gudbrandsdal used four distinct styles of painting: a completely ornamental type with the acanthus vine as the main motif, decorative figure painting, *rose-*

maling with natural designs, and the Chinese manner—gold and silver landscapes and buildings on a black ground.

Lesja and Dovre were far ahead of the rest of Gudbrandsdal in *rosemaling*. Painters from here worked in Lom, Skjaak, and Vaagaa before these districts had developed their own painters, and in famine years they migrated to Romsdal in Møre. In the earlier Lesja work the background was completely filled and in its strong architectural sense showed the influence of carving. Dovre's painting combined Lesja's sureness of form with a love of rich decoration. The designs were elegantly drawn, over an open background, and showed a naturalistic tendency. As in weaving, green and blue grounds were very popular. After 1800 they were replaced by brown. Green, blue, red, and yellow colored the design. White was often used in door panels with a darker color framing it. One room had green walls, white ceiling, a red-brown door with white panels filled with a vari-colored design. The furniture was decorated to match the door.

City painting in the nineteenth century becomes a study in naturalism with each object decorated as a work of art in itself, not as a part of the room scheme. Around 1850 this tendency reached the Gudbrandsdal districts where lack of tutoring resulted in crude, flat landscapes and naïvely done portraits. It displaced the old confident handling of lines and reliable choice of colors. Imitation of oak on pine by streaking with stains or paint was another indication of *rosemaling's* decline. By 1870 in most Norwegian districts *rosemaling* had died out completely.

TELEMARK, a culturally rich district in south central Norway, has fostered a number of capable *rosemalers*. Though their own district was economically unable to support many artists, they found eager patrons in the adjacent districts of Numedal, Setesdal, and Rogaland. Their urge to create and to beautify must have been unusually strong,

for the barriers between their home district and their neighbors were tremendous. Mountains cover all but the coastal region, and swift-running streams and huge lakes are too numerous to count. To reach any other part of Norway from Telemark it was necessary to go on foot over the mountains, and often over not just one range but several. Even now there are only a very limited number of roads through the district and just a few miles of railroad.

A combination of Renaissance naturalism in flower forms and the baroque vine was the basis for the early Telemark painting. The vine or leaf forms in some variation carried through the whole

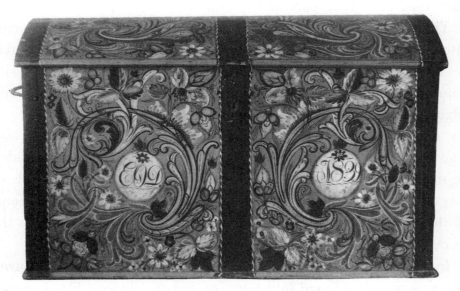

64. Chest from Fyresdal, Telemark. Red background, black painted iron bands, polychrome decoration, 1839; about 3½ feet long. NORSK FOLKEMUSEUM

rosemaling period with rococo line play increasingly evident in the later years. Flower motifs continued to be used but in such imaginatively decorative form that their prototypes would be impossible to find.

Nearly all Telemark painting had a definite formula that made for strength and sureness and a confident treatment. It avoided the pitfalls of experimentation, yet was flexible enough to allow for a wide variety of results. This pattern consisted of a root, main stem, broad c-shaped leaves, and flowers on long graceful stems. These were supplemented by abundant line play skillfully arranged to fill the entire area. Telemark *rosemalers* were experts at achieving this in a natural way. With the root in the center of the design as a starting place they were able to swirl any number of leaves, stems, or decorative lines out over the surface in any direction, the curves and counter-curves crossing under or over each other as they swept out to cover their own particular part of the design.

Though the flowers were not naturalistic, certain types recurred often enough to permit classification in a very general way. A three-petaled motif appears frequently in various forms, nearly always with pointed tips but varied as to centers and with scalloped or plain edges. Another favorite is a more or less round flower with five or six petals, sometimes very irregular, but more often symmetrical. And finally, there is a wide variety of flowers made up of any number or size of ovals, overlapping or fanned out, with a center, petals or calyxes serving to hold them together in a pseudoflower form. Some of these look rather shell-like and were probably suggested by the rococo shell motif of the Louis XV period.

In Telemark's early *rosemaling*, from about 1760 to 1790, furniture was usually painted in yellow and red on a brownish red ground with moldings in green and white. Chests were blue-gray or green with light gray-green, red, white, and black in the design. Later color preferences turned to the lighter, brighter shades. White or light red served as background colors for many Telemark pieces, and various shades of gray-blue or gray-green constituted the greater part of the design. Brick red and light yellow or yellow-ochre were used as accents and black or white for outlining; sometimes both. All in

all, the Telemark *rosemaling* is most pleasing and it is easy to see why it found such favor in the surrounding districts.

HALLINGDAL, too, was a rich area culturally but incapable of supporting all its talented sons at home. Like Telemark it was very mountainous and its painters also went to other districts to work. South of Hallingdal was Numedal and to the west lay Sogn and Hordaland. These three districts contain many examples of Halling art work and their own crafts show the effect of their contacts with these "outsiders."

Whereas Telemark painting was distinguished by its clean, sure brush strokes and organic design, Hallingdal lay claim to fame for its color. The Halling *rosemaler* loved the blazing contrast of red and yellow and he was an expert in the fortunate combination of the most difficult shades. Though not as controlled as the Telemark painting, Halling decorations showed more imagination. They were unrestricted as to make-up and consequently we find a wider variety of forms and treatment.

Characteristic of Halling decoration were the real roses that bloomed profusely over the work. Though the Renaissance, baroque, and rococo were all used together, the baroque vine was not as strong here as in Telemark. For the most part, Halling painters avoided the petty handling of detail that began to smother all types of craft work in the nineteenth century and contributed to their decline. This factor, along with the vital use of color, resulted in a strength and bounce unequalled in the painting of any other district of Norway.

Indicative of the uninhibited use of color is a cupboard done by Torstein Sand of Hol. The cupboard itself is painted a soft green. But this is the only restrained thing about it. The panels are red, with blue, yellow, white, and black *rosemaling*. Bright yellow frames around the panels are filled with light vinework in blue, red, and black. Picture this cupboard in a room with blue walls and sienna

red dado, wall benches, and table and you have an idea of the crashing effect enjoyed by these Hallingdal painters.

GEOGRAPHICALLY, Numedal lies between Hallingdal and Telemark. Though it too is in a mountainous district, it was more prosperous than its neighbors due to the fact that it had excellent and extensive mountain pastures, comparatively easily accessible, as well as more favorable conditions for lumbering. So while the men of Numedal farmed or cut timber, the artists of the neighboring districts brought their talents into the valley and made their living as decorators. This was especially true after about 1830.

In the late 1700's Numedal had its own share of able *rosemalers*, particularly the men from the Kravik family. The first of these spent some time with the grenadiers in Oslo or Kongsberg and when he returned home in 1770, he brought with him a late baroque or early rococo love of color. He had also picked up the city artists' inclination toward naturalism, but he avoided direct copying in favor of a decorative treatment. He did a blue door in the Uvdal church, decorated in shades of blue, white, and sienna red. The design consisted of graceful vines and tendrils and fat five-petaled flowers, their centers filled with a hatchwork of lines.

This meshed line detail is characteristic of a great deal of the Norwegian decoration, but by no means all of it. In some districts a spiral line fills the flower centers and in many cases an effect is achieved by the simple addition of two or more contour lines. Short parallel lines crossing a slender flower stem appear here and there and serve to give an illusion of strength. In some cases they are used to fill in or strengthen part of the design, for an undecorated space or a naked line was anathema to many *rosemalers*, particularly the less talented ones, and simplicity was to them a sign of weakness.

Another feature brought to Numedal by this first Kravik was the

use of figures and mottoes in wall decoration. His Biblical scenes contained characters in plumed hats, knee breeches, and many-buttoned waistcoats, and the inscriptions with which he provided his murals were quite essential to their understanding.

Blue or blue-green was used on most of the Numedal furniture. Red frames around cream-white or light green panels were favorite combinations in both the southern and northern parts of Numedal. Vermilion or brown with white panels were also used, and sometimes the background color was black. A variety of colors appeared in the designs—red, vermilion, yellow ochre, violet, and blue-green.

One of the painters in southern Numedal had evidently come to Norway from Germany, for in his painting he used the tulip motif frequently, along with realistic roses, five-petaled white flowers, and Germanic inscriptions. A student of his made use of reverse c's and s's, a continental innovation, and favored formal balance in his design. There is a good deal of this in the districts which have been affected more strongly by the continent. Landscapes and vases full of flowers were designs of city origin and perhaps should not be included in the term *rosemaling*. Certainly they lacked the imaginative handling and the design skill that were needed for the free-flowing vine and flower motifs of such places as Gudbrandsdal and Telemark.

Around 1800 one of the later Kraviks began to use various forms of the acanthus leaf and to drop naturalism to some extent. He started a turn to the mechanical and schematic shaping of leaves which was carried further by the painters of Tinn, in Telemark. It may be, then, that Telemark *rosemaling* really began in Numedal.

Having such close connections with the city of Kongsberg which received all the continental fashions, Numedal craftwork inevitably passed into the Empire period, along with the rest of Europe. It was true in this district to a greater extent than in some of the others, partly because of its proximity to the source of the new styles, but

perhaps also because the more stubborn or more conservative of other parts of Norway realized that baroque and rococo were ideally suited to the native temperament and way of living, whereas the new styles were not.

SOUTH AND west of Telemark lies Setesdal. It is a mountainous district much smaller in area than the others of which we have been speaking. Lying off the regular travel routes, it has managed to stay several centuries behind the rest of Norway in almost every respect. Its people were, at least until the twentieth century, a suspicious, ultra-conservative clan, noted for their propensity for fighting. They were something less than hospitable to the officials sent there by the government, and in that respect as well as their backwardness, they might be compared to the people of the Ozark mountains in the United States.

A difference in language and customs intensified the problem of establishing rapport with them, and though the church and its ministers had the best opportunity to influence them, even they had trouble. A couple of parsons are said to have been killed by irate Setesdalers. As late as 1840 people of Setesdal were living a medieval existence, in houses with open hearths and no chimneys.

No doubt the medieval type of house with its smoky walls had something to do with the fact that *rosemaling* began here very late. Although there was some painting of small objects such as chests and ale bowls in the 1700's, it was not until the 1850's that Setesdal people began to paint their household furnishings. This was at least one hundred years later than in the rest of Norway. Except for an occasional picture, no painting was done on the walls. This in spite of the fact that the white-painted log walls of Bykle church in the upper reaches of the valley fairly swarmed with *rosemaling*.

Here as elsewhere in Norway, imported ale bowls from the sixteenth and seventeenth centuries seem to have been the inspiration

for *rosemaling*. The first locally made bowls from the first half of
the seventeenth century used the same fine Renaissance painting
found on the early imported examples. They contained simple geo-
metric center designs and many had zigzag borders. The *casette*
motif such as was used in church carving from the 1620's was also
used in painting.

From 1760 to 1790 acanthus and tulip designs were most com-
mon, though rather unrecognizable. In this, Setesdal painting was
like west Telemark painting and doubtless Telemark men were work-
ing in Setesdal at that time. Around 1800 Setesdal painting was
strongly affected by Vest-Agder, its neighbor to the west. Vest-Agder
made use of the same motifs as Telemark but used a broader brush.
In picture painting bridal scenes were much used, scenes such as the
bridal party approaching the church on horseback, the parson wait-
ing at the door.

In the 1840's and 50's several Telemark painters came to the
upper Setesdal districts and gave the local painting the stimulus it
needed to reinvigorate itself. Probably this was the last stand of the
long line of professional *rosemalers*, for after about 1870 and until
its revival by craft groups in the twentieth century *rosemaling* along
with most other craftwork was a dead art.

On the whole, Setesdal *rosemaling* was not as good as its carving.
It started late, and for the most part borrowed its ideas from the other
districts. On the other hand, its colors are good, strong, and fresh,
showing the mental disposition of the people.

VEST-AGDER, the southernmost district of Norway, was a flourishing
trading area from most ancient times. Its port towns of Mandal and
Kristiansand were the base for trade with Holland and many of the
people from the coastal area went to Holland to work for varying
periods of time. When they returned they brought Dutch ideas; even
their clothes being like the Hollanders'. Dutch engravings formed

the basis for their art work and so the flower baroque became even more popular here than elsewhere in Norway. This was true particularly of the coastal regions where there was a strong city influence. Back in the mountains the people were far enough removed to be able to develop their own art.

The rococo never had much effect in Vest-Agder. Baroque flowers and vines held sway from the first popularization of *rosemaling* in the district until its disappearance in 1880. For some reason the painters of this region seem to have lost their originality after 1800.

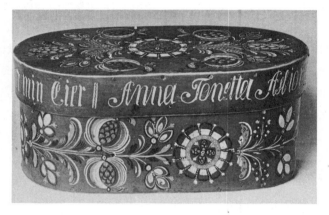

65. Church box from Fjotland, Vest-Agder. Dull blue background with brick red, green, and yellow decorations, and white accents; about 15 inches long. NORSK FOLKEMUSEUM

They began to use the same motifs and the same colors over and over so that their work acquired a dry and stereotyped appearance. Their colors became more and more ugly and lacked harmony. Some painters put altogether too much into their designs, filling every space, and their work suffered from this excess.

There were, however, some capable artists in the region before 1800 whose originality and fresh sense of color compared favorably with any in the rest of Norway. They, as well as later painters, used dark ground colors almost exclusively, but they managed to give their work life through the play of light and dark shades in the

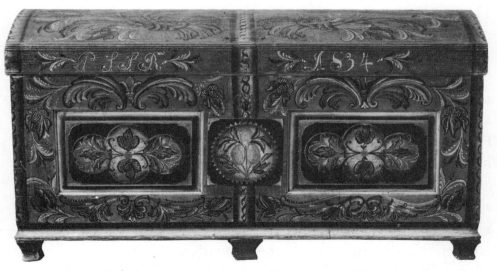

66. Chest from Tonstad, Vest-Agder. NORSK FOLKEMUSEUM.

design. One of their favorite subjects was the bridal party scene and they used it most frequently on ale bowls. Biblical scenes and quotations were popular here as elsewhere.

Vest-Agder chests were nearly always painted with a contrasting band of color down the center. On each side were framed initials and date. Leaves, feather-like sprays, and various types of flowers constituted the *rosemaling*. These chests were, for the most part, from the years after 1830. Earlier ones displayed more carving.

It should be emphasized that excess in decoration was a weakness particularly of Vest-Agder for it reached the point where everything that could be called flat was caught up in a whirlwind of flowers and color.

ROGALAND, lying to the west of Vest-Agder, and having a common border with Setesdal in Aust-Agder and a bit of Telemark as well, shows evidence of a cultural exchange with all three. In addition there was a Hallingdal painter or two in the district. With such a mixture it is not strange that Rogaland has no really characteristic type of *rosemaling*.

The Dutch flower baroque, the vase forms, are similar to Vest-

Agder's work and doubtless were gathered to some extent by Rogaland's own travelers to the continent. A very capable *rosemaler* named Eilert Førland worked in the southern part of the district around Egersund in the 1820's and 30's. Though he used a tulip-like motif and round-petaled flowers such as those used in Vest-Adger, he was not at all confined by their natural forms. His imagination allowed him to develop flower and leaf shapes such as were never seen on earth, and his design gains by it. He was an expert in fitting his designs into difficult places and had an excellent sense of proportion. He sometimes used a heart motif, usually with a hatchwork of lines in the center.

A great deal of Rogaland's painting seems to have been concentrated in the inner fjord area, around Sand, Suldal, and Jelsa. It was in this part of the district that men from Telemark, Setesdal, and Hallingdal came to seek their fortune as artists. Characteristic of the Telemark work here is the type of fine linework with tiny detail, almost like saw teeth, that is used throughout the design. There is also some of the basic pattern used by Telemark painters, that is, the root, long thick leaves, and long-stemmed flowers. A brick red background is common, with dull blues and greens and some white in the design. Another popular background is a dull blue-green. With this we find shades of yellow ochre, dull red and white, and sometimes gray or beige. Very few backgrounds are in the lighter shades.

Sogn did no better with its *rosemaling* than with its carving. In the outer districts painting was chiefly confined to ale bowls, with just a simple flower motif in the center of the bowl and perhaps a slender vine around the upper edge. For the most part the designs lack any great degree of originality or character and are homemade in the most basic sense of the word.

The one exception lies in the work of the "Sogndal painter," so-called to distinguish him from the Halling painters who came into the district after 1750. He was without a parallel in Norway, either in pattern or color, and in fact his work lies closer to some of the imported Russian bowls. His colors were richly combined, in sharp contrast to the ground color, most often a soft blue-green. Red and yellow dominate the design with various greens and white and black to complement them. The designs are quite symmetrical rosettes and vines, but the drawing is done with a lively, almost nervous brush stroke.

This painter worked all over Sogn and must then have been a rugged traveler, for Sogn is a region of fjords with forbidding rock

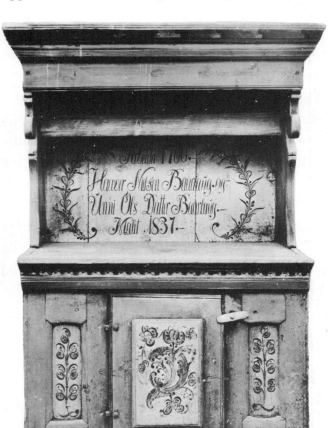

67. Cupboard from Baar-log in Feios, Sogn. NORSK FOLKEMUSEUM

walls, of rocky islands and dangerous waterways, of steep mountains
and narrow tortuous valleys. Its transportation facilities even now
are of the most primitive kind, and the Sogn fjord is still the main
highway as it was long ago.

Even in Sogn, as was mentioned in Chapter Three, material cir-
cumstances influenced the development of art. The outer districts
were extremely poor and they belonged to the island culture group
which never got beyond the Renaissance in its art. Living conditions
were too harsh for aesthetic growth, and its people never became
skilled enough to master baroque's rich leaf-carving and rococo's
intricate scroll painting.

The inner districts, on the other hand, were richly forested and
even contained a few profitable fruit and tobacco farms. This region
was culturally related to that of Gudbrandsdal, Valdres, and Halling-
dal. It was richer artistically than any other west coast district.
Though Bergen, a flourishing port town, was relatively close, it was
never of very great influence on the people of Sogn. Because of a
difference in their dialect and in dress, they were ridiculed in the city
and the continental trends which so soon appeared in Bergen had a
long and roundabout path to take before they reached the Sogning
homes.

MØRE, between Sogn and Trøndelag on the west coast, depended
heavily on Gudbrandsdal and Trøndelag artists for its painting. Its
own artists were distinguished mainly by their love of symmetry and
simple, straightforward presentation. There is very little elegant line-
play in the Møre work, and little shading. Four- or five-petaled
flowers and wreathlike vines with leaf sprays are the most common
motifs.

Colors are few and bold but well chosen. The backgrounds are
very dark, almost black, with a green or blue cast. In almost every

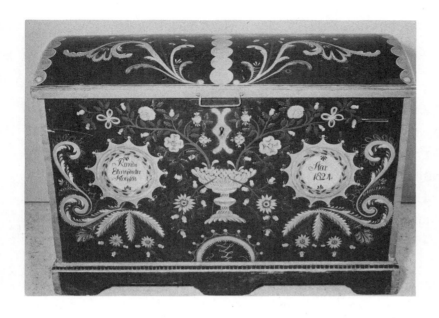

68. Chest from Mogstad, Surnadal, Nordmøre. Red lid, black sides, with polychrome decoration; about 3½ feet long. NORSK FOLKE-MUSEUM

69. Chest from Heggen, Rindal, Nordmøre. Black background, red banding with white outlining; about 3½ feet long. NORSK FOLKE-MUSEUM

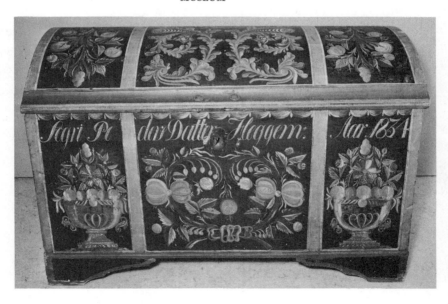

pattern there are shades of reddish brown or brick red, with some yellow and gray-blue. White and black are used sparingly.

In the work of certain painters, those who had worked or trained elsewhere, there is better design and better technique. Such *rosemaling* may show some traits of other districts but at the same time demonstrates the artist's individuality.

Much of the painting found in Nordmøre is the work of Trøndelag artists. Opdal was the *rosemaling* center of southern Trøndelag and Lønset was a close rival. Here in the late 1700's a school of painting developed in which c- and s-curves are the framework for the design of three-lobed leaf forms. Four-petaled flowers provide the center of interest. The colors are brownish shades of yellow, green, and red, with some Prussian blue and white. Black outlines each part of the design and hairline brush strokes supply shading. The designs are formally balanced, often symmetrical.

Before the middle of the nineteenth century Trøndelag painters had turned to classical urns and shell-like bowls filled with stiffly arranged naturalistic bouquets. Some painters experimented with informal balance while still depending on c-motifs to keep the design under control. Colors became brighter with more white used in the background or design and with blue tones replacing brown.

This comparatively early change to the Empire type of decorative art was doubtless due to influences arriving from Trondheim. Oslo, Bergen, Stavanger, Mandal, Trondheim, all the cities played an important part for Norwegian folk art. They siphoned off the most significant decorative trends from the continent and passed them on to the inland towns and districts where they became Norwegianized and a part of Norse culture.

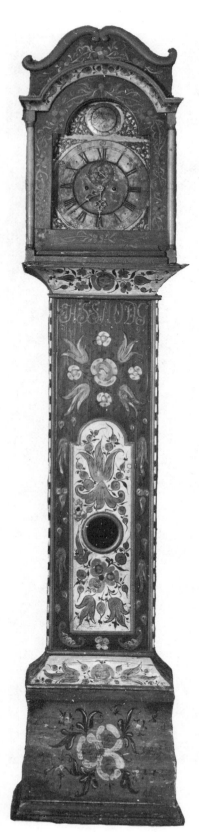

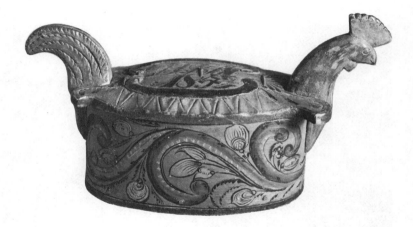

S34. *Tine* (box) from Bykle, Aust Agder, 1852.

S35. Ale bowl typical of western Norway. The inscription reads, "1827 Takker Herren Først Drikker Eders Tørst" (Thank the Lord first, [then] quench your thirst.)

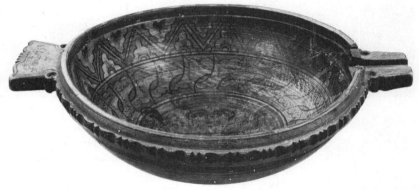

S33. *Rosemalt* clock from Sigdal, Buskerud.
NORSK FOLKEMUSEUM

S36. Ale bowl with pouring spout, 1759. BERGENS MUSEUM

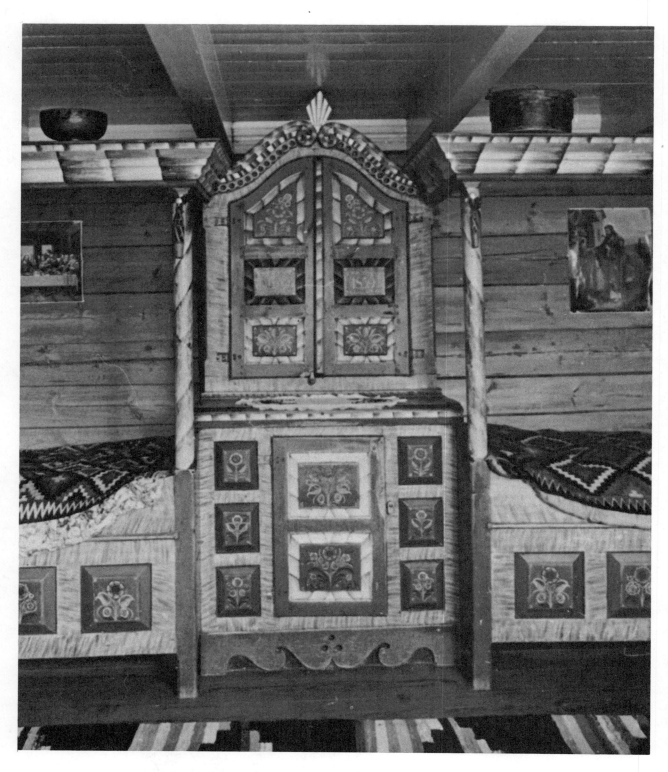

S37. Vest Agder guest room. Note the
marbling technique used on bed
posts and borders. Sometimes
done with a feather.

Metalwork

5

PROBABLY MORE than any other Norwegian peasant craft, metal-working was a job for specialists. Carving and *rosemaling* might be attempted by anybody, and weaving and embroidery were not particularly difficult in their simpler forms. But metalwork required a certain know-how that presupposed at least a little training, an apprenticeship, with an older craftsman within the district or with city masters. Some even went out of the country, to Germany or elsewhere on the continent, and brought home not only the latest techniques but also the latest styles. These innovations arrived with imported German workers as well, so that there was a definite German flavor to much of the early metalwork, particularly of the late medieval and Renaissance periods.

There had, of course, been metalworkers in Norway for many centuries before the German influx. Norway's Bronze Age began in 1500 B.C. and the Iron Age in 500 B.C. Many interesting relics from

115

these and successive periods have been and are still being found, the greatest number from the Viking Age or later. The relationship between the Viking finds, for example, and later medieval and post-medieval metalwork is not very striking. One may however discover a certain congruity of purpose and expression, and even in some cases of form, that marks the later work as being of early Scandinavian lineage.

Actually both the early and the later Scandinavians received inspiration from the same quarters, either directly or indirectly. Byzantine art, whether it came directly to Norway and Sweden with Viking chieftains or indirectly through Rome and Celtic Ireland or by way of the later trade routes, carried an Oriental feeling that reappeared in the remote Scandinavian countries as a strangely exotic and exciting form of decorative art, particularly in the field of jewelry. The mysticism of the East found kindred ground in the heathenism of Norway and continued to thrive in its new environment for many centuries.

Even after the triumph of the Church, superstition, the illegitimate offspring of heathenism and Christianity, provided the support which was needed to assure the continuance of the old art. The Church itself astutely transformed the familiar pagan symbols and charms into Christian amulets and medals, making the transition less painful. Thus pagan containers for magical substances became Christian reliquaries, in locket form. It is interesting to find that after the Reformation, when Norway was no longer Catholic, these same lockets or their later adaptations were used to hold perfume or smelling salts.

In spite of such a long tradition of metalworking, the number of rural metal-craftsmen was not imposing before the Renaissance. These craftsmen supplied the farms with decorative hinges and keys, large kettles, and anything that required special equipment or skill. Nearly every farm had a smithy but it was used mainly by the land-

owner himself for the ordinary items a farm requires and seldom for
any artistic work. Iron was obtainable in the rather numerous iron
bogs and the farmer did his own smelting. This method was not
conducive to large-scale iron production and failed to capture the
interest of commercial miners. There were however profitable iron
mines in various of the mountain areas.

Around Røros rich copper mines were opened in the 1600's,
attracting hundreds of German mineworkers, "mountain men" as
they were called. Among these workers were men skilled in all
phases of metalwork and from them the workers of nearby districts
received valuable training. Many craftsmen of northern Gudbrands-
dal and Østerdal and southern Trøndelag developed into expert iron
and brass workers. This area continued to produce highly decorative
metalwork well into the nineteenth century.

The same thing was true in other parts of Norway. The fabulously
rich silver mines at Kongsberg at one time employed four thousand
workers, many of whom came from Germany. Telemark men learned
of the Renaissance from these foreign craftsmen and carried the new
styles, as well as a considerable amount of bootlegged silver, back
home. As in other kinds of art work, Telemark excelled in metal-
smithing, and especially in jewelry-making. Setesdal was not far
behind.

Most noteworthy of rural ironwork is its door hardware. On the
medieval type of door which is made of vertical planks banded to-
gether with straps of iron, the ironwork is of necessity very prominent.
The better of the old ironworkers took advantage of this to design
strap hinges that were not only useful but beautiful. With the com-
ing of the Renaissance, plank doors were replaced by panelled doors.
This meant that hinges no longer needed to bind the door together,
nor did they need to be so strong. They were simply a means of
hanging the door to the jamb. By stages they were shortened,
widened, made of thinner material, and decorated by chasing or

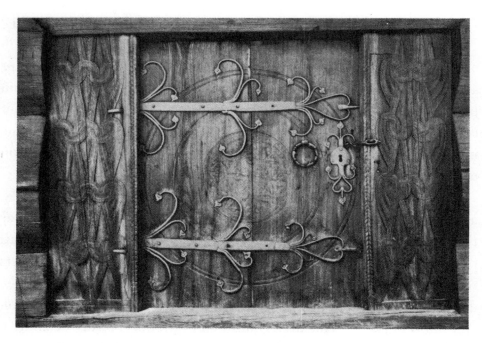

70. Door of the Oseloft from Setesdal; restored. NORSK FOLKEMUSEUM

piercing. Latches and latch handles replaced bolts and door rings.
The door had completely changed character.

One of the most striking examples of medieval ironwork is the
door of the Oseloft from Setesdal, now in restored form at the Norsk
Folkemuseum at Bygdøy. The long strap hinges are enhanced by
graceful Gothic stems which end in hearts or arrowheads instead of
clover leaves. There are three groups of opposing stems. The lower
pair of each group curve out and down, the upper pair up and in.
Two stems at the end of each hinge curve toward each other to form
a heart. The design of the key plate is in keeping with that of the
hinges. A ring serves as a door handle. Seen with its underlayer of
Gothic carving, a rosette, and the chain carving on each doorpost,
this door is one of the most beautiful in Norway.

Another good example of Setesdal ironwork is the door on a store-
house at Sordal. Strap hinges extend completely across the door.
The curled iron strips that border these hinges are much cruder than
those of the Oseloft. A ring serves as handle here too, as on all old

doors in Setesdal. The most interesting feature of the door is the series of small iron loops that hang side by side the length of each hinge. Their purpose was to frighten away evil spirits and incidentally to give warning if a thief tried to enter.

These iron loops were used along with shallow concave disks on cow and horse collars of iron, again for protection. Curls and rings jangled on the long iron pothooks that hung above the open hearth fire. In time such charms came to be mere decorations, carried on by tradition. Such is the case with the door rings, at one time a symbol related to sun worship. One such ring is made of iron twisted like a willow band and is called "Stefan's work," apparently after Stefan Stalledreng who was supposed to be descended from the sun-gods.

Vest-Agder's medieval ironwork is quite similar to that of Setesdal, though not always as well done. Twisting of iron seems to have been utilized more in this district and the curving or curling stems are actually part of the hinge rather than added strips. The door rings are very like those of Setesdal. Legend says that one of these rings once hung in a goblin's ear.

Later ironwork in Vest-Agder was predominantly city-made. Neither Setesdal nor Vest-Agder craftsmen did much with chasing or engraving of door hardware. They were at their best when forging the sturdy strap hinges necessary for the medieval plank-type door.

Telemark, on the other hand, used surface decoration even on medieval hinges. Some were scratched with runic inscriptions. Others had stamped designs—curves, crosses, circles. Occasionally there was a Gothic-type leaf design, apparently cut into the warm iron. A simple sword-shaped strap hinge was used frequently. As a modification of this there is the snake hinge, a simple strap which folds back on itself at the eye end in the form of a snake's head. The opposite end is sometimes split to look like two snake tails, sometimes ends abruptly. The edges are usually filed and may be tongued. A center groove holds the pyramid-forged rivets.

In another variation the sword hinge acquires flower stems or spirals. This was a favorite device and was used everywhere. Numedal, for instance, has a hinge that separates into two branches at the end to form a wreath. One of the Glomdal doors has spirals and tulip blossoms branching out from its spearlike hinges and a rosette as a door ring or knocker.

When the Renaissance panelling came in, some districts used just the branching part of the hinge, much shortened, while others used just the sword part. The branches were at first coiled and forked like writhing dragons. Later they were simplified and eventually given an acanthus character. By this time the hinge had become a short broad plate and had lost to the latch plate and handle much of its importance.

There was some chasing and much engraving of door hardware in the eighteenth and nineteenth centuries but most popular was the pierced work. This type of ironwork was especially well used in Gudbrandsdal where red or white cloth or a contrasting metal was laid underneath to accent the design. The plates were cut of quite thick iron; the edges filed to soften the outline. Prominent rivet heads, sometimes tinned, were used as part of the decoration.

Whatever the technique, the designs used for local metalcraft repeated the design preference of other crafts of the area. Gudbrandsdal metalwork, like its painting, became another form of *døleskurd*, the luxuriant leaf-carving of the region. Telemark *rosemaling* provided the blueprint for its carving and metalwork. Districts within the trade area of cities such as Bergen, Trondheim, and Oslo early showed city influence. Unfortunately, some of these areas soon succumbed to city-made products and let their own metalcrafts industry die out.

There was not much chasing of iron door hardware. Brass, on the other hand, was easily hammered and its possibilities were fully explored in Gudbrandsdal and Østerdal. Some Telemark trunks had

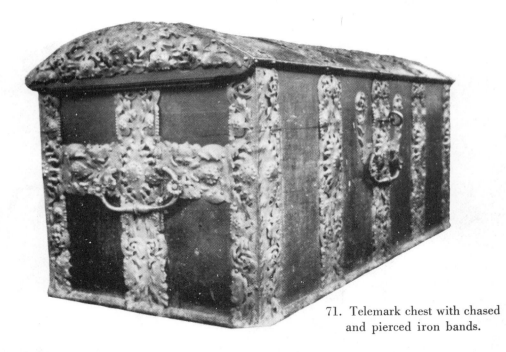

71. Telemark chest with chased
and pierced iron bands.

metal bands that were both pierced and hammered, resulting in a
strongly modelled design. The internal hardware was not ham-
mered but pierced and highly polished. This type of work is sup-
posed to have been done in Kongsberg or copied from Kongsberg
products. The city had an important effect on the whole country be-
cause of its reputation as the center of artsmithing in the eighteenth
century. Beyond the Kongsberg area trunk bands stayed quite flat,
content with scalloped edges or an open design for interest. Occa-
sionally there is a chest with decorative flower shapes spaced between
the bands. Or as in the case of Setesdal and Vest-Agder chests, almost
no ironwork was showing at all.

Aside from door and chest hardware there are various minor
categories of wrought iron such as candlesticks and the corner sup-
port for the *peis*. The latter is most often twisted but may be treated
in other ways and used as a support for the pothooks as well as for
the hood of the fireplace. Iron candlesticks were made in certain
localities such as inner Sogn and Østerdal, each place with its own
special model. A metal vise might have engraving on the front sec-

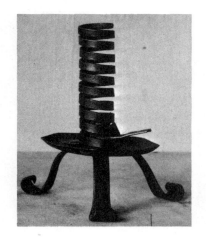

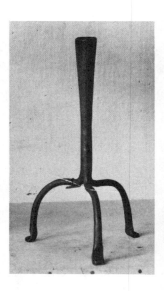

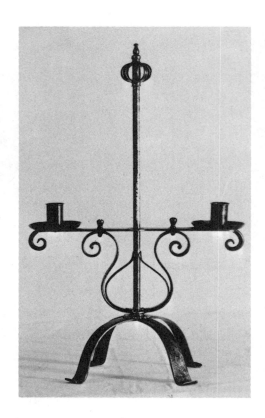

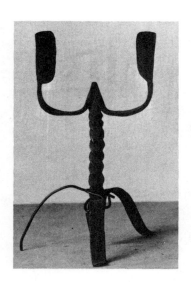

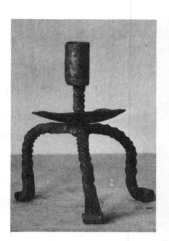

72. Iron candlesticks from (top left to right) Hallingdal, Sør-Trøndelag, Romsdal, (below) Solør, and Østerdal. NORSK FOLKEMUSEUM

tion and a sleigh was an excellent field for decorative ironwork. In Gudbrandsdal there were even wrought-iron grave crosses on which scrolled and leafed designs filled in the area between the four parts of the cross.

Norway's rural ironwork is interesting but its silverwork is even more so, perhaps because it is more personal. Silver played a very important part in the life of the Norwegian peasant. It was treasured for its beauty but there was more to it than that. A new piece of silver jewelry was not worn for the first time to any ordinary affair. The

proper place to first display such a treasure was at church, and this had a consecrating effect. Furthermore, certain types of jewelry had a direct connection with church ceremonies, e.g. bridal crowns and belts and the cross-shaped pendant worn by the groom. Though such pieces might be worn elsewhere for state occasions, particularly the belts, they still had a little of the holy about them and demanded a certain reverence.

Besides, there was superstition. Charms that once produced magical powers were now called upon to exorcise them, and while this seems inconsistent with a belief in Christianity it continued to be a powerful influence even into the nineteenth century.

Rikard Berge writes:

These beliefs follow men from the cradle to the grave. Thus, one should fasten a silver buckle in the baby's swaddling band or sew a consecrated coin in his wrappings so the trolls won't exchange babies. Silver belonging to each person in the house, and heads of grain are laid in water to make consecrated water; a collection of nine kinds of heirloom silver or church silver protects against troll love and pursuit by supernatural beings; heirloom silver or church silver is worn as an amulet, the bridegroom's cross and *agnus dei* . . . are worn against troll forces; silver heals sickness and guards health, cures animals of sudden strange maladies, heals snakebite and sores and quiets the blood, puts greater strength in the produce, in milk and butter and field crops, makes the horses healthy. To get the beer to work or to protect against supernaturally produced winter storms they consecrate silver, etc. With silver buttons or silver bullets they can shoot those whom lead does not harm, even the trolls themselves, the troll king and the troll women. Silver in bell metal gives church bells more power. *

Legends have been handed down with many of the very old silver items. One story is heard again and again in connection with bridal silver. It concerns a girl who is outfitted by the *huldrefolk* (people who live under the mountain) for her wedding to one of their own kind. Suddenly her human suitor appears and carries her off to the

* Rikard Berge, *Norskt Bondesylv*, p. 14

church to be married. The *huldrefolk* beg for the return of their silver but of course are denied. Their silver is, after all, far superior to any made by human hands and cannot be duplicated. Angered by the theft of both girl and silver, the nether-world people place a curse upon the offending parties. Such silver is called *huldre* silver and is passed on from generation to generation.

Because silver was mined in the mountains it was easily connected with the supernatural mountain folk who were believed to be the true owners. Only those favored by the *huldre* could find and keep silver. Others who found it either could not find the spot again or they died before they could tell the location.

It is clear that spiritual as well as decorative values were responsible for the high value placed upon jewelry. As treasures they were handed down from parents to children, adding a little more prestige with each change of ownership. Thus medieval forms were passed on, century after century, with gradual changes in design or use but no abrupt shelving of ancestral ornament. Herein lies conservatism.

There was another factor in the amassing of silver articles. There were no banks, and since all the family needs were supplied by the land and the people's own efforts, there was little to be bought. The money economy of the outer world made itself felt quite early in the rural areas, not so much as a method of exchange but as a means of hoarding. The farmer who had been well paid for his lumber, his produce, or the lease of his land had little else to do with his money but bury it in the ground in huge copper pots. Thieves were fairly common so he chose his spot well—under the manure pile was a favorite place.

There were times when a few silver coins came in handy, on a trip to the city, for example. There one might find some fine silk materials for a daughter's skirts, or a splendid silver tankard, or clock, or a new piece of jewelry. Even without leaving the farm, one could find a use for currency. Peddlers often came by with attractive things

to sell. And there were the local silver workers who needed silver from which to make ornaments for the family costumes. Raw silver was a dangerous thing to have around—it was illegal. Stamped silver was too expensive. So the silversmiths often melted down the farmer's coins and created rings and brooches for the family. Or they used the coins with little or no alteration as pendants or dangles. Coins thus invested in jewelry were still silver—only the form had been changed.

Copper coins as well as silver were used in the making of jewelry and buttons, and raw copper, brass, pewter, and various other alloys were quite commonly employed. The brass and copperworking region centered quite logically around Røros in southern Trøndelag where the large copper mines were located. There was a brass button factory at Toten in Gudbrandsdal and brass purse clasps, chains, and jewelry were more common than silver in this area and in Østerdal.

Gudbrandsdal had a few silversmiths and Numedal a few. Telemark and Setesdal had many. There was a thriving silverworking business in Valdres and Hallingdal and in the west coast districts, although the people of the coastal areas purchased much of their jewelry in the cities where master craftsmen turned out quantities of silver in the *bonde* style. Bergen was the point of origin of much of the west coast silver, its products being carried far into northern Norway for sale to the Finns and the Lapps. Trondheim was another metalcraft center and supplied most of its own district of Trøndelag so that there was never much *bonde*-made silver in that region.

It is often difficult to distinguish between the city-made jewelry designed for rural sale and the *bonde*-made pieces. City products were supposed to be hallmarked but this was not always done, probably because the quality of the silver was not always up to par. Workmanship was no proving point because both city and country silver could be poorly made and both could be exquisite. At any rate,

there was no problem in discerning which jewelry was intended for *bonde* use. It nearly always had flashing, tinkling dangles. Most of the filigree work was country-made. City-made silver was most often cast. Very little table silver was made by rural craftsmen, certain types of drinking vessels being the main exceptions.

Among the country people, brass had been used for jewelry, knife handles, and the like, well through the Middle Ages, whereas the higher classes had had silver even in Viking times. When the Renaissance arrived with its filigree jewelry which by the very nature of the work must be made of silver, nearly everyone began to wear silver ornaments and the brass ones were relegated to everyday wear. For the very poorest people brass was the only type of jewelry even after the Renaissance. Brass buttons and shoe buckles remained popular for all but the most festive dress among all classes, particularly for the men. One factor in the retention of brass ornaments was the financial crisis in the early 1800's when silver was scarce and expensive and when even old heirlooms had to be turned over to the crown to be melted down.

Silver ornaments played a very important part in Norwegian folk dress. On the west coast where silver chains were used to lace the bodice, and brooches were large and numerous, clothing was designed as a foil for jewelry rather than jewelry as a finishing touch for the dress. Even everyday clothes required a certain amount of silver—lacings, elaborate eyelets, brooches, and neckpins. But on festival clothes the display was dazzling.

The bride was the most dazzling of all. In addition to the chains, fancy eyelets, and neckpins, she wore a large oval collar that slipped over the head or fastened on one shoulder and was covered with all kinds of brooches and belt plates in varying sizes. On her head was

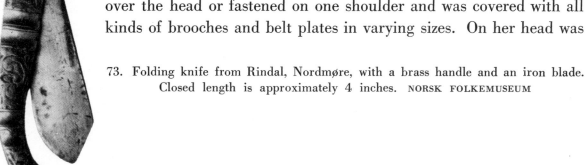

73. Folding knife from Rindal, Nordmøre, with a brass handle and an iron blade. Closed length is approximately 4 inches. NORSK FOLKEMUSEUM

a silver crown, a nightmare of peaks and garlands and dangles, very heavy and very difficult to wear. In some areas the crown was a cloth-covered frame hung with dangles. The Voss type is one of the most attractive. It is a flat B-shaped piece worn horizontally on the head so that the pendants hang down all around. The pendants are heart-shaped and bedangled, a large one at each side in front, smaller ones in back. Beading covers the top of the headpiece. (See fig. 140.)

The bridal belt, an important part of the dress, was a series of metal plates fastened to a cloth base. Chain or cloth streamers with silver ornaments hung down in front. Around her neck the bride wore one or two pendants on rather heavy chains. At least one of them had been given to her as an engagement gift by her fiancé. She might also have several rings. About the only things lacking were earrings and bracelets. Neither had much place in Norwegian peasant dress.

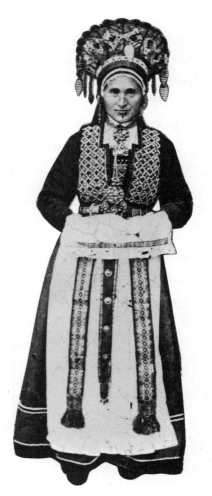

74. Hardanger bridal costume. BERGENS
MUSEUM

The bridal clothes just described belong mainly to the west coast districts. Other areas had somewhat different traditions but all used some sort of crown and bridal belt and all placed heavy emphasis on jewelry.

Men's clothing was not quite so splendid but it still required a remarkable amount of silverwork. Buttons were numerous, both on the vest and the coat and sometimes at the knee. Knee buckles and shoe buckles were usually quite simple but belt buckles were elaborate. The whole belt was strung with silver plates of more or less prominent design. Collar and cuff buttons or links and breast pins very similar to those of the women, but smaller, were also necessary. Knives and knife sheaths, both silver-clad, were hung from the belt during the 1700's. Metal watch chains and fobs came into use in the 1800's. From the foregoing it is clear that the silversmith was one of the most important and busiest men in the district.

Finer techniques such as niello, inlaying of stones, and enamel were almost completely lacking in *bonde* silver. Molding or casting, beating, stamping, and filigree were common and there was some cutwork, mostly in the older examples.

Until about seventy-five years ago the silversmith had to prepare his own metal. This he did by heating lump silver with a little copper in a clay crucible to give a material of the desired hardness. For wirework very little copper was added. The molten metals were poured into a long, narrow form or into a flat pan and pressed into a sheet.

Casting molds were of sand, stone, or clay. Sand molds were made by filling one half of a wooden form with a special kind of moist sand, laying the model in the center and then placing the second half of the form on top. This too was filled with sand. When the whole thing was dry the forms were separated and the model removed. A groove was made from the impression to the outer edge, through which the silver could be poured. Smaller grooves provided for air

holes. The sand mold was then fastened together and heated and the silver poured in. After removal from the mold all little points and unevennesses had to be filed off and smoothed. The silversmith often cast things in several parts and soldered them together. He sometimes bought parts of a design ready-cast in the city.

Beating was done with forms and punches. Chasing was left mostly to the city silversmith although a little chased vinework was done on brooches in the country districts. Bossing required a hollow of the proper size in a wood or brass block and a punch with a rounded end that would just fit the hollow. To make a bowl-shaped dangle a disc of silver was laid over the hollow and the punch hammered into it. Bosses in large pieces of metal were made in the same way. More elaborate forms and punches were used for belt plates and the like and could even be bought in the city. Because it was such impersonal work the rural smiths turned to other methods.

Engraving was sometimes used alone, sometimes in combination with other techniques such as filigree or hammering. It required more in the way of an artistic sense and a steady hand than in equipment, the latter consisting mainly of pointed tools. It was used as early as 1500 on *bonde* silver.

The extreme popularity of filigree jewelry in rural Norway is a comparatively recent development. Filigree came into style all over Europe during the Renaissance and was carried into the most remote districts. Norwegian filigree has its counterparts in other countries, in Byzantine and North German work for instance.

It may be divided into two groups, one in which the base is of wire, the other which has a solid plate for a base and a design of wires and grains. The wires are made from octagonal sticks of silver which are drawn through progressively smaller holes in a die, the material heated several times during the process. The finished wire is then subjected to one of several treatments to give it more interest. One method calls for twisting the wire through a screw die. This

gives the wire a diagonally striped appearance and is more effective on the large diameter wires.

A second method, much used by the *bonde* silversmith, is the twining method. The wire is heated, laid double, and held with tongs at one end while the other end is rolled between two boards. Ordinarily the wire is rolled away from the worker. When it is twisted toward the worker the result is a reverse twist. The two types may be laid side by side to give a braided effect. A method not much used in other countries but popular in modern Norwegian art uses three twisted wires twined together with the fingers. It is evened by rolling between boards.

Tiny coils of wire are used in large quantities on filigree brooches. A fine wire is coiled around a slender rod by rolling on a board. Next the slender coil is wrapped around a coarser rod, heated, and cooked in a tartar solution or dilute sulphuric acid. The whole coil is then clipped into identical rings with a very short-bladed scissors. These rings are soldered to the ornament. When used double, the outer ring is spread at intervals making a series of small curls.

In the center of these wire curls there is always a tiny round ball of silver called a bead or shot, or a squarish, faceted knob called a diamond. The beads are made by heating bits of silver on ground charcoal. Surface tension forms the bits into drops.

When all the curls and beads and wires are ready and the base plate is cut out, they are soldered together. Solder is made from silver, brass, zinc, and borax. It is filed or cut into tiny pieces which are laid on the base plate exactly where curls or wires are to be added. All curls and wires are added at one time, powdered borax sprinkled over them, and the whole thing heated over an oil lamp. A small pipe is used to direct the heat where it is needed by blowing. After soldering, the article is cooked in an acid solution to remove the black color, rinsed well in water, and dried. A fine wire brush is used to brush away the white coating deposited during the cooking.

Now the process begins all over, this time with the beads and dia-
monds. Some articles require several solderings, going through the
complete process each time.

Modern silversmiths do their gold plating by the electrolytic
method. Older craftsmen had to lay gold leaf on the piece to be
plated and burn it on. The piece was then polished with a hand
polishing tool and liquid green soap. This process was used on the
bowl-shaped dangles and in a few other instances. It was under-
standably not as common as ordinary silverwork.

In view of the amount of time and patience it must have taken to
achieve a masterpiece (or monstrosity, as the case may be) in filigree,
the large amount turned out by Norwegian craftsmen, and mostly in
Setesdal and Telemark, is truly remarkable.

ONE OF THE oldest types of peasant jewelry is the pendant. The
bracteate, a gold coinlike amulet from early Viking times, was the
forerunner of the Catholic *Agnus Dei* which appeared in the sixteenth
century. The bracteate was decorated with heathen symbols and was
probably patterned on still earlier pendants. In its earlier forms the
Agnus Dei depicted a lamb (the name means Lamb of God). Later
the name was applied to any round molded pendant hung from a

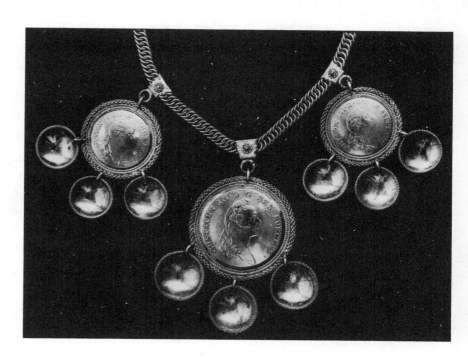

75. Coin-type pendant
(Agnus Dei) with bowl-
type dangles. NORSK
FOLKEMUSEUM

neck chain, and usually with three dangles hanging from its lower edge. Coins were frequently used as pendants, with three smaller coins or hammered rhombic plates as dangles. The number three is important in both heathen and Christian decoration. Cross-shaped dangles were used occasionally and there were many necklaces that had a cross as the main pendant.

Pendants were sometimes covered with filigree and even set with stones, though this indicates city work. Stone setting was used very seldom by the country craftsmen. Many of the pendants were in locket form and were used first as reliquaries, later as coin or perfume containers.

The necklace chain is usually a flat type in which each link is interlaced with two or more links to each side of it. Various other types of chains are used for other purposes, among them the lacing chain. This is made up of long links pinched together in the middle to form a figure eight and then bent double. The links are then slipped into each other, one after another. This is a very strong type of chain and quite flexible. Both silver and brass were used for chain-making, the latter for chains that had to withstand hard usage. Bodice chains were nearly always of brass.

With metal lacings it was necessary to have metal eyelets, *maler*. These were at first plain rings. The rings became more and more elaborate until they looked like decorative buttons with a hole in one side. Finally even the hole was closed up and the resemblance was complete. Lacings were no longer used but the *maler* continued to hold their appointed place along the bodice edges or on the shoulder straps. In Hallingdal and Valdres, Numedal and Tinn, the *maler* were supplied with a hook and eye and were used as clasps, sometimes with as many as four linked together at each side of the opening. Several of these multiple clasps might be used on a garment.

76. Cast eyelets *(maler)* from Numedal and filigree eyelets from Setesdal. NORSK
FOLKEMUSEUM

77. Cast eyelets *(maler)* from Nume-
 dal. NORSK FOLKEMUSEUM

The oldest type of *male* or eyelet was cast, usually of brass or pew-
ter. The fine late Gothic leafwork of the original examples was
replaced by luxuriant Renaissance forms and finally degenerated into
indistinct cast designs. This was true also of many other types of
cast jewelry. Hammered star *maler* with a bossed pattern and leaf-
shaped dangles were popular during the 1600's and 1700's. The
final development was in filigree. A slightly rounded filigree clover
leaf soldered into a ring was a particularly popular type. Other wire-
work designs were used, some with base plates and some without.
Dangles might be added to the *maler* not intended for lacing.

In addition to the above *maler,* all of which were round, there were
square ones with a comblike edging. They were molded in late Gothic
designs and were rather limited in distribution. Eyelets done in the
clipping technique were made in limited numbers and were used
in groups.

Maler were a versatile sort of jewelry. Not only were they used as
lacing rings and clasps but as belt plates and bridal decorations, both
on the headdress and the large collar. They might also be used on
the belt streamers. They differed from buttons in that they lay tight
against the cloth whereas buttons were equipped with shanks.

Another sort of chain fastener was the jacket chain. This was
worn in all the areas where the very short, open jacket was in style.
It consisted of a pair of clasps or bars fastened at either side of the
opening with a multiple strand chain between. There might also be
a center plate. The end clasps or plates and the center ornament
varied greatly in design. They might be rectangular, heart-shaped,

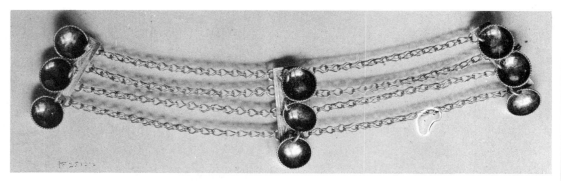

78. Jacket chain. NORSK FOLKEMUSEUM

or round, and decorated with hammered bosses, filigree, or engraving. They might have dangles, usually three.

The clasps used at either end of the jacket chains were most often the much used two-part buckle. This buckle was made in a variety of shapes—most frequently round, heart, leaf, and rosette. A hook was soldered to one side of the clasp, an eye to the other. Sometimes the hook and eye showed, sometimes they were covered with a small round decorative disk or a cast figure, sometimes the plates fitted tightly together to look like a single plate.

One of the oldest clasps is the flat clasp. It has two plates, usually heart- or leaf-shaped, and is engraved or hammered but not filigreed. Another very old type was cast in leaf or medallion form with Gothic figures as part of the main plates or across the middle of the clasp. Crowned monograms were also used in this manner. The better, more striking designs are quite open, with a rather lacy effect.

Filigree clasps are comparatively young and are some of the best of Norwegian silverwork. They have been made mainly in Telemark and Numedal. They are heart-shaped, the opposing hearts pointing

79. Heart-shaped filigree clasp. NORSK FOLKEMUSEUM

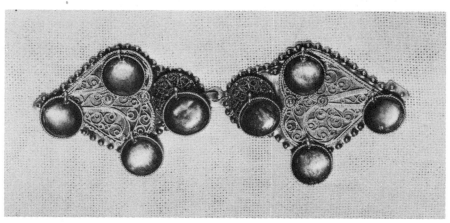

away from each other. A small rosette is attached to each heart, the hook and eye to the rosettes. The whole clasp is beautifully filigreed. A scalloped effect around the edge is achieved by hammering or stamping, occasionally by filigree loops. Dangles are infrequent and are used sparingly. Clasps are used on women's jackets and bodices and on belts. They are found all over the country but are most popular in Valdres, Hallingdal, Telemark, Setesdal, and Hardanger.

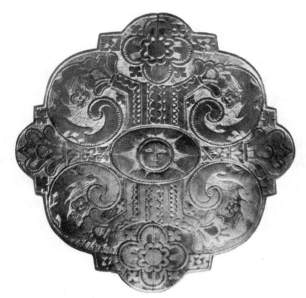

80. Belt buckle from Aal, Hallingdal, which was cast in two pieces and soldered together. NORSK FOLKEMUSEUM

In addition to the above-mentioned types there were several other belt buckles or clasps. One had rectangular plates with a round *male* covering the hook. Another had rectangular plates with hook and eye and a short chain hanging down between. In a third type the hook and eye are hidden behind the plates and a fourth kind utilized a bar with a round knob on the end which hooked into a hole in the opposite plate. Various pronged buckles, similar to the prong type of breast pin, were used. With this type of fastener a decorative silver tip was added to the end of the belt. The belt was extra long so that

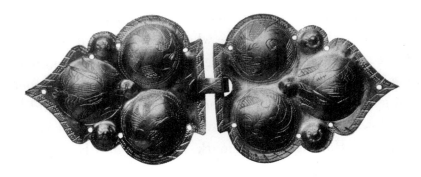

81. Jacket clasp from Aal, Hallingdal. NORSK FOLKEMUSEUM

it hung down from the buckle, and silver disks dangled from the tip.

The really elaborate belts were decorated with metal plates, either threaded on like slides or fastened tightly to a cloth or leather strap by sewing or by lacing them on from the back with a thong. In some cases the plates were linked together or sewed edge to edge. Other times they were spaced. Belt plates might be hammered or engraved but these were usually city-made. They could be round like the *maler*, but the type really designed for belt decoration was rectangular.

There was a wide choice of design in rectangular belt plates. Heathen designs, Gothic masks, lion heads, Renaissance and rococo figures and leaves were just a few of the patterns. One of the most frequently encountered is the tower design, fashioned upon the city seal of Bergen. These plates were of course Bergen-made. Dangles were commonly attached to the lower edge of each belt plate, two to a plate. Some were in the shape of concave disks, some were rings, some were diamond-shaped with hammered rosettes. Or they might be leaf- or star-shaped. Dangles of this sort were extremely popular with the Norwegian *bonde* and his family and were applied to nearly all types of ornament.

Nailhead belts were used mainly as everyday belts for men in the Setesdal to Gudbrandsdal area. They were most often brass-studded, fastened with a brass buckle. A double sheath holding a knife and

a whetstone hung from the belt. The practice of hanging things from the belt was a carry-over from the pocketless Middle Ages and continued into the nineteenth century. From a double sheath to hold two knives or knife and whetstone, it developed into a veritable tool chest with as many as eight compartments. An auger, a jackknife, and an awl helped to fill the extra sections. Both knife and sheath were metal-clad, the metal ornamented with engraving or cutwork. The earliest examples were banded with brass, later ones with silver.

The sheath was held by a two-tined iron piece which pivoted in a decorative metal holder, which was in turn fastened to the belt by a leather or chainlike strip hanging from a metal ring or bar. Thus the sheath swung freely. Keys and sometimes spoons hung from both men's and women's belts. Women also fastened a large, decorative "loose pocket" or reticule to the belt. Heavily decorated belts were more for men than for women. Women wore them chiefly as part of the wedding costume.

By far the most important piece of Norwegian folk jewelry is the breastpin. It was worn daily by everyone in all districts and in vary-

82. Top belt is leather with cast rosettes and silver lace. Remaining belts have pressed belt plates with leaf, ring, and bowl and yarrow dangles. Note Bergen tower design on bottom belt. NORSK FOLKEMUSEUM

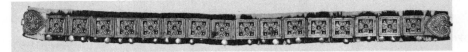

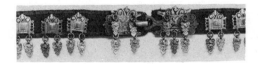

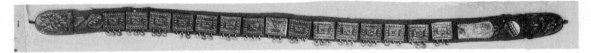

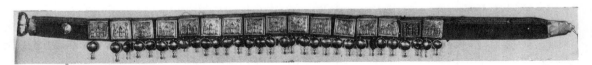

ing quantities. In some districts such as Østerdal and Gudbrands-
dal and along the northwest coast it was a rather small and simple
ring or heart shape. The western districts used more elaborate types
with many dangles. Telemark and Setesdal developed beautifully
filigreed pins which were widely distributed throughout the country.

There were more or less definite rules governing the wearing of
these pins. The smaller, simpler types were for men and were worn
at the shirt opening. Women wore simple pins for everyday, two
or three at a time. For festival dress the larger, more elaborate types
were brought out and worn in quantity, particularly on the bridal
costume. Boys and girls sometimes exchanged pins for fun. It had
no connotation of an engagement, or even of "going steady," and a
really popular boy might collect a whole chest full of pins.

One of the very oldest types is the shield pin, so-called because of
its resemblance to a round shield. It usually is closely perforated
around the edge and may have punched or hammered decorations.
Most examples have a round hole in the center and a single prong.
The point of the prong lies on top of the pin, making it necessary
to pull some cloth through the hole before the prong can be inserted.
This makes the brooch lie close to the cloth but is rather difficult to
fasten. It was not until the 1890's that Norwegian craftsmen began
to put the fasteners on the back.

The *bursølje* is similar to the shield pin but larger and without
perforations. It has a very wide flat prong and hammered decora-
tions, usually rather crude. It was used as a belt buckle.

A derivative of the shield pin is the mask pin. It has six masklike
projections in a petal position around the center ring. Perforations
around the ring and between masks show its connection with the shield
pin and give the pin a somewhat lighter appearance. It is made either
by casting or by hammering. A twisted wire surrounds the center
hole.

Another development from the shield pin and one that has many

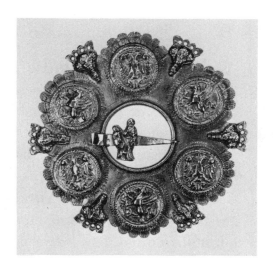

83. *Bolesølje* from Valle, Setesdal.
NORSK FOLKEMUSEUM

variations is the *bolesølje*. It always has six large round projections placed in a circle, may have six smaller ones between. In its original form it is made by casting. The disks are cast separately, then soldered to a base plate, which is cut with a scalloped edge to follow the line of the disks. The design may be an animal (lion, griffon, snake) or a head (saints, cherubs). A circlet of twisted wire is often used to edge the center hole. This type of pin may also be hammered and may have the shallow bowl type of dangles.

The filigree *bolesølje* is a variation produced by the Telemark and Setesdal silversmiths. A scalloped base plate is cut first, with holes cut out where each stud is to come. The studs are made separately of filigree disks soldered to shallow rings, the whole thing soldered to the base plate which is itself covered with filigree, usually in the form of tiny coil flowers with a shot center. This type of brooch is quite large and is worn only by women.

A less elegant pin is one made much like the cast *bolesølje* but with depressions instead of humps. It is smaller in size and quite plain. More elaborate types may have many depressions and a rather stiff sort of filigree. It is called a *skaalesølje* from the shallow bowl-like hollows *(skaaler)*.

Freely flowing filigree vines characterized the *Trandeimsøljer*. The base plate is scalloped as for the *bolesølje* but there are no pro-

jections. Instead, exquisitely curling Gothic vines cover the surface, each branch ending in a tiny silver shot. These pins have not been made for one hundred and fifty years. The later imitations look rather stiff and do not do justice to the original model.

The *rosesølje* is unique in that it was originally designed to be made in filigree but has since been made by casting. The two types are sometimes hard to distinguish. The pin has six kidney-shaped petals formed of double strands of twisted wire. The threads curl in to the center of the petal and have frondlike projections between,

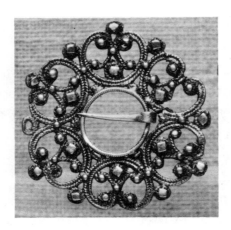

84. *Rosesølje* from Bygland, Setesdal.
NORSK FOLKEMUSEUM

indicating a connection with the palmetto motif. This same design was used on a metal-decorated wooden shield made in the 1100's. After the petals are soldered together where they touch, the whole flower is soldered to a center ring, and curls, diamonds, and shot are added. Sometimes the pin is given an outer ring. There is no base plate; so the design is quite open.

The latest change in the *rosesølje* was the addition of dangles. No other brooch has been so covered with dangles. As many as eighteen disks might be added, each hung with two rings and coil flowers. The basic design becomes completely hidden.

A well-known type of pin is the *slangesølje* which, like so many other pins, originated in Telemark and Setesdal. It is of Gothic

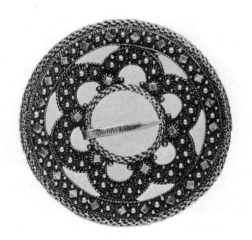

85. Filigree *slangesølje* from Hovind, Telemark. NORSK FOLKEMUSEUM

design and has had few changes. The solid bottom plate is broken through; so it is no longer a base plate but two concentric rings bound together with a rosette of six circle segments. The cutting is left until most of the filigree has been applied. First the round plate is slightly cambered. Twisted wires are then soldered around the inner and outer edges of both rings and heavy twined wire to the outer edge of the pin and around the center hole. Curls and shotwork are added to both the rings and the rosette. Now the base plate is cut, leaving the loops that form the rosette. The final step is to solder twisted wires along the edges of the curved segments. This pin, like the *rosesølje*, has been heavily bedangled.

A variation of the *slangesølje* and various other pins is one which instead of filigree has small points and knobs projecting up from the surface. The pin is cast and the points are burnished to give the sparkling effect which in filigree would be accomplished by shotwork. This type of pin is especially suited to everyday wear. Women wore them as they worked in the fields and particularly while threshing because dust could not hurt them and abrasion only made them brighter.

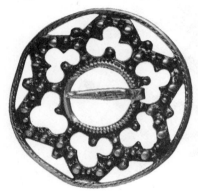

86. *Taggesølje* from Telemark. NORSK FOLKE-MUSEUM

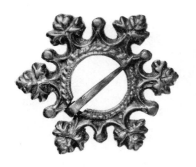

87. Early-type of spur pin from Tinn, Telemark.
NORSK FOLKEMUSEUM

Another type of cast brooch is the spur pin, so-called because of its spur-shaped or palmetto-inspired points which project out from a center ring with an equal number of rudimentary projections between. It looks rather like a snowflake. This pin is common from Gudbrandsdal to Setesdal and from Ryfylke to Sogn.

Mi lisle Gjente, vi du meg have
ska du faa Syja for aakja Dale.
Aa vi du have meg, mi Gjente staut,
ska du faa Syja me aakja Lauv.

My little girl, if you will have me
You shall have a pin worth eighteen dollars.
And if you will have me, my fine girl,
You shall have a pin with eighteen dangles.

So sang the Norwegian suitor. The more dangles a pin had, the more splendid it was. But decoration was not the only purpose, or at least not the original one. In olden times, as was mentioned earlier in the chapter, rings were added to silverwork as a protection against evil spirits or as an oracular device. Even cow collars and

88. Later type of spur pin
from Dagali, Numedal.
NORSK FOLKEMUSEUM

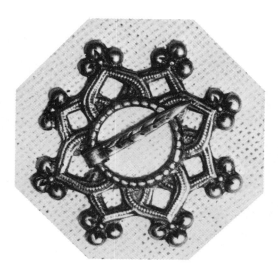

storehouse doors were hung with dangles made of iron. Knife handles, spoons, and drinking cups had silver dangles and jewelry was the most bedangled of all.

One of the first dangles was the leaf, a diamond-shaped or leaf-shaped piece of sheet silver with a bossed or scratched design or simply corrugated. The shallow bowl type of dangle, one which is peculiarly Norwegian, has already been mentioned. A variation of this is the ring which is a bowl dangle with the center cut out. A twisted wire is soldered around the edge. This type is used on wire-work rosettes and may number as high as eighteen on one piece. It was most popular in Hallingdal and Valdres. There is also a ring dangle which is simply a piece of wire soldered into a ring. It is used on smaller pins of the cast type and is popular in Numedal, Tinn, Hallingdal, and Valdres.

The cross dangle, made from sheet silver in the form of a Greek cross is almost unknown outside Norway. All dangles may have smaller dangles added to them, but it is to the cross that the most extras have been added. Strings of dangles from each arm, filigree added to the plate, filigree replacing the arms of the cross, dangles on top of filigree, all obscure the original design and give the pendant a nightmarish quality. When one realizes that several of these pendants might hang from one breastpin he can appreciate the value of simplicity. Used with restraint, dangles provide a unique and charming effect. When overdone they are worthless.

There is a large and popular group of Norwegian brooches that is based on neither a base plate nor a rosette but on a plain ring. One of the best known of this group is the horn ring, a ring to which "horn" pieces have been added at each side of the prong and a rosette to the top and the bottom of the ring. The horn pieces are bars, either cast or cut from sheet silver. The rosettes may also be cast or cut.

The first ones had flat square plates added at both ends of

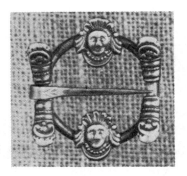

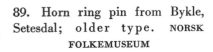
89. Horn ring pin from Bykle, Setesdal; older type. NORSK FOLKEMUSEUM

90. Horn ring pin from Telemark; later type, with hammered cross and yarrow flower dangles. NORSK FOLKEMUSEUM

the prong, with rosettes as the center pieces. Successive ones were much varied. The square plates were replaced by dogs or lambs. Eagles and lion heads were often used. Later there were knights and cherubs and grinning baroque masks. Symbolical placement put the eagle of St. George above the lion, which sometimes had wings and resembled a dragon.

After a time the symbolism was lost and the figures were combined haphazardly—two angel heads on each side of the prong, or two knights, or one of each. Finally any natural semblance disappears and the horn plates become just designs. Then filigree takes over, bringing with it hordes of dangles of the barley grain type, patterned on a prism. The simple charm of the original horn ring is lost under a shower of grain.

Another pin of the ring type is the *sprette*. It is very old and was first simply a ring, unadorned. During the Christian Middle Ages it was formed into a heart and has retained that shape ever since. The earliest ones were cast, later ones cut from a sheet (still with the open center), and finally made in filigree. The heart has a crownlike

top of doves, cherubs, leaf forms, a regular crown, and so forth. Many of the heart pins have holes of some kind around the edge. In early examples Christian symbolism is dominant. Later ones become a symbol of love with cooing doves as the crownpiece. Thus they can have a double meaning.

Shoe buckles and knee buckles, in contrast to breastpins, were fairly simple. They were rectangular or oval, with a prong, usually of silver but occasionally of gold. The shoe buckle was more or less curved to fit the curve of the foot. Many of them were made in the cities, in accordance with eighteenth century English styles. However, buckle shoes were common as early as the 1300's.

Knee buckles were smaller versions of the shoe buckle. They were used either on the knee of the breeches or on a separate knee band of leather. In some places both kinds were worn at once.

It was inevitable that buttons should replace brooches and buckles to a great extent. The many-buttoned frock coats and vests of the rococo and Empire periods were mainly responsible for the change. Eastern Norway in particular used quantities of buttons. There might be as many as twenty-four buttons on a coat, sixteen on a vest and twenty on a pair of breeches. Furthermore a man often wore three or four vests or coats at a time. The short coats of western Norway required fewer buttons but the pants buttons were correspondingly larger. Even the long Empire-style pants of Telemark, Hallingdal, and Setesdal used many buttons, both for the front flap and the ankle placket.

91. *Sprette* (ring pin), from Flaa, Hallingdal; early type.
NORSK FOLKEMUSEUM

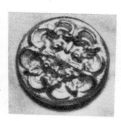

Button-makers of Gudbrandsdal and Østerdal relied mainly on brass for their material. Their buttons were cast in copper molds, some with raised designs, most with a flat or slightly rounded surface and with engraving or thin, ornamentally pierced steel for decoration. Brass, pewter, bell metal, and other alloys were as widely used for buttons as silver and in some places they displaced silver entirely.

The silver button area begins in Valdres and follows westward. Silver buttons are seldom cast. Instead they are hammered or stamped from flat disks, often coins, and may be decorated with engraving. A shank is soldered to the back. Deeply curved buttons might have a flat plate soldered to the back, a twisted wire design to the front. They might also be engraved. Later types acquired elaborate filigree or were made entirely of filigree without a solid base.

Buttons were often linked together and used as collar or cuff links or, when joined by a bar, as cuff buttons. Collar buttons were of any type, single or linked, with or without dangles. For men they were usually without. Dangles included crosses, chains, ring rosettes, filigree balls, plain balls, bowls, cut rosettes, yarrow flower dangles, in any combination and any quantity.

Even finger rings were covered with dangles; some of the rings were like buttons in that the center plate was a disk with filigree and

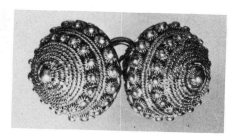

92. Brass buttons, coin-type cuff buttons of silver, and silver filigree collar buttons from Setesdal. NORSK FOLKEMUSEUM

dangles added. Others were cast in Gothic leaf or flower forms or with a center figure medallion. An early type is the serpent ring, a long strip of metal which coils around the finger like a snake, usually ending in a snake head. Later imitations were cast and lost the serpentine characteristics.

Aside from jewelry, a miscellany of other silver items was made by rural Norwegian silversmiths but they are not important enough to warrant a thoroughgoing description here. Perfume containers in the shape of pocket watches, silver-clad wooden snuff boxes, jewelry boxes, and certain types of drinking vessels are among them. Of the latter may be mentioned one shaped like a large silver tumbler, resting on three silver balls. Another is a small round bowl curving in at the top and decorated with acanthus leaves or rococo swirls.

Most interesting are the drinking horns. They may be real animal horns or wooden imitations and may have silver, brass, copper, pewter, lead, or bronze bands. The horn itself may have carved decorations with engraving on the metalwork. Because the horns were chiefly for use at Christmas time, many were inscribed with pious sayings or the names of the Three Kings. Some gave the owner's name and a date. The horns were of three types—without feet, with feet, and with wheels. The first kind was provided with eyes so that it could be hung from the wall. The second had two long feet in front and a short one in back. Or it might have a dwarf as a support.

There were wide metal bands at each end of the horn, some of them decorated with buttons, figures, and the like. One or two middle bands to which feet could be soldered came next. Lengthwise bands, usually four in number, kept the crossbands from slipping off. These bands were often scalloped along the edge according to Gothic patterns. Even drinking horns acquired dangles. Perhaps to ward off intoxicating spirits!

The metalwork of rural Norway is an intriguing chapter in Nor-

93. Cuff buttons from Telemark and Gudbrandsdal. NORSK FOLKEMUSEUM

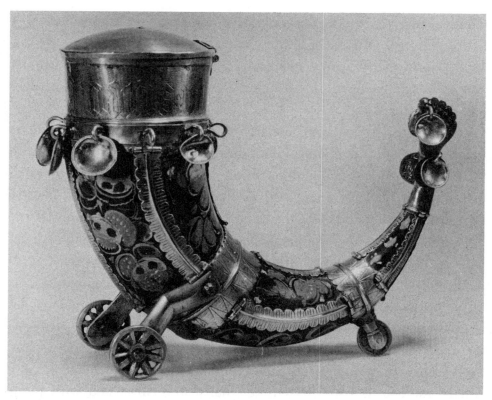

94. Drinking horn from Vinje, Telemark. UNIVERSITETETS OLDSAKSAMLING

wegian art history. Even though much of the inspiration came from
the continent it was reworked by the local craftsmen into a native
expression which was often far superior to any found on the main-
land. Considering the importance given to metalwork and particularly
to jewelry by the Norwegian peasant it is no wonder that there are
so many folk songs concerning it.

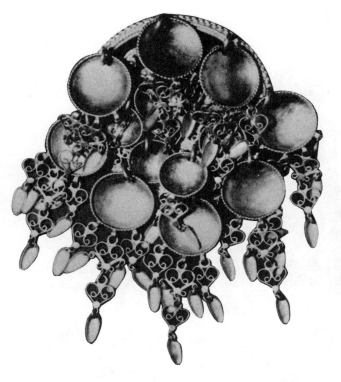

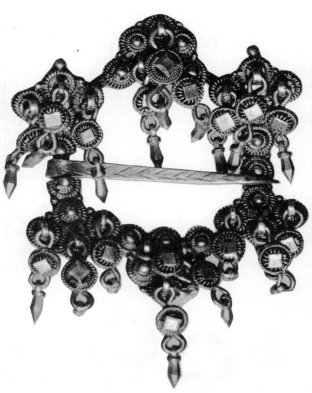

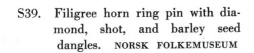

S39. Filigree horn ring pin with dia-
mond, shot, and barley seed
dangles. NORSK FOLKEMUSEUM

S38. *Rosesølje* with bowl and filigree
dangles, from Buskerud. NORSK
FOLKEMUSEUM

S40. *Krumkake iron.* Used for baking
a fragile type of cookie, which is
then rolled on a stick.
NORWEGIAN-AMERICAN MUSEUM

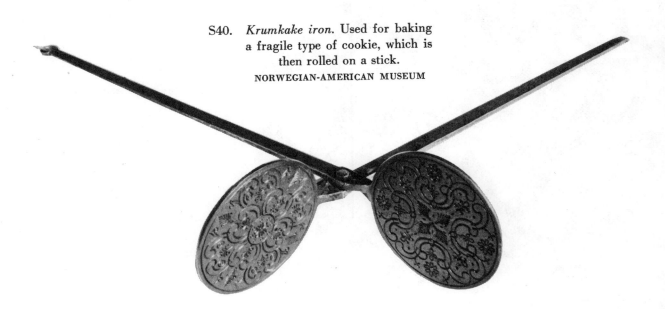

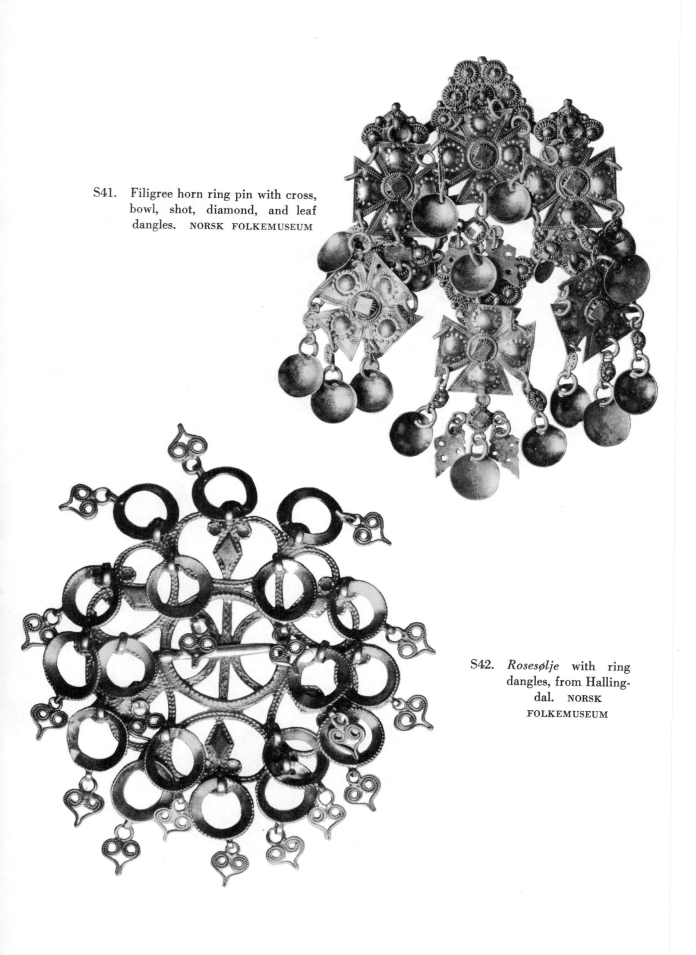

S41. Filigree horn ring pin with cross,
bowl, shot, diamond, and leaf
dangles. NORSK FOLKEMUSEUM

S42. *Rosesølje* with ring
dangles, from Halling-
dal. NORSK
FOLKEMUSEUM

Weaving

6

THERE IS VERY little material upon which to build a comprehensive history of Norwegian weaving. Until about A.D. 1000 there was no writing in Norway, and after its introduction the scribes were far too busy recording Norwegian history to be much concerned with the crafts. Occasionally travelers went home and wrote an account of their observations among the people of the North, but such reports touched very lightly upon home arts. Pictures such as were printed in English and French medieval manuscripts are not to be found in Norway. Only a few actual examples of ancient Norwegian weaving have been recovered, but upon these must be based a deductive knowledge of equipment, methods, and designs.

The remains of the Oseberg ship, as described in the first chapter, contained long strips of tapestry. These were probably done on an upright loom, the design picked in by hand without the use of shuttles or shed sticks. However prehistoric pieces (pre-A.D. 1000) have

149

been found for which apparently several harnesses have been used. On a vertical loom this means a variable number of sticks and loops to raise the various sets of threads. These sticks or rods rested across the loom on pegs when not in use. It was not until about 1750 that the horizontal loom came into general use in Norway. It was equipped with two harnesses at first; more were added later for more complex designs.

In the horizontal type, the lengthwise or warp threads are fastened to a beam at the back of the loom, threaded through wire or cord eyes called heddles in the two or more harness frames, and then through the reed of the beater and fastened to the front beam. The harnesses can be raised separately by means of treadles, thus raising certain threads to form a shed or opening for the passage of the weft. The weft or crosswise threads are carried back and forth by means of shuttles in plain weaving and many pattern weaves, or picked in by hand in others. The beater which beats the weft threads together to form a close, even material is supplied with reeds, vertical strips of metal. Spacing of the reeds determines the number of warp threads to the inch and thus the closeness or openness of the weave. This also regulates the width of the material. Because the warp can be wound up on the back beam and woven material on the front one, the length of the woven piece is theoretically unlimited. On the vertical loom it is usually equal to the height of the loom, although beams on which to roll the material may also be used here.

In threading the loom the Norwegian woman used either linen or wool warp. Both had to be prepared at home from the first planting of the flax seed or shearing of the sheep to the last bit of finishing. In the case of linen the preparation took more than a year. The flax seed was planted in the spring and when it reached its full height it was pulled up by the roots to allow for the longest possible fibers. It was then tied into bundles and hung up to dry. Some of the husks were beaten off, but retting in a stream was left until the following summer.

Eight days of soaking to rot the remaining husks and a few days of drying on a sunny hillside and the flax was ready to be scraped. This meant laying a bundle of flax on a wooden knife to which another knife was hinged jackknife fashion. The upper knife was pressed down on the bundle and the flax drawn through, the husks falling to the ground in the process. It was a primitive method but not unpleasant for it was done in the open air, and with the whole family to help.

After the fibers were ready, the rest of the work was a matter of convenience. Whenever she had some free time the woman combed or carded the flax with spiked boards, straightening the fibers in preparation for spinning them into threads. Spinning was done on a hand spindle or, after the beginning of the seventeenth century, on a spinning wheel.

Hand spinning required a stick about twenty-seven inches long, the distaff, on which a bunch of flax or wool was fastened loosely, and a shorter stick, the spindle, with a round weighted plate in the middle on which the thread was wound. The distaff was fastened in the belt and a wisp of flax pulled out and rolled between the palms of the hands to start it into a thread. This was fastened to the spindle which was then given a quick twist with the hand to twist the thread. The strand thus formed was wound on the spindle and more fibers were twisted. It was fine gossip work and it could be done as one moved about. Saeter maids, watching the cows in their summer pasture on the mountains, found it a good way in which to while away the time.

Wool had fewer steps to go through, but its preparation was less pleasant. After being sheared from the sheep the greasy, smelly wool had to be washed several times before it could be carded and spun. Usually some of the oil or lanolin was left in to smooth down the fibers and facilitate weaving. The finished piece was washed and stamped, a process in which the material was put into a wooden trough or barrel partly filled with water and then literally stamped

with the feet. This served to felt the fibers together and to eliminate any bulges or unevenness in the weaving. It resulted in a tough, long-wearing rug or spread.

Overskjæring was a finishing process in which the surface was clipped or singed to remove any fuzziness. It gave the product a smoothness and sheen. Because it was a job for experts it was not always done.

Much of the charm of the old Norwegian woven pieces is in the soft, skillfully combined colors. Homemade dyes lack the harshness of modern chemical colors and for this reason, home dyeing is being revived along with hand weaving in the present-day Norwegian craft groups. Dyeing involved the extraction of color from roots, bark, or berries, or in later times from imported materials such as indigo and cochineal. The wonderful blue colors used in Norwegian weavings were produced by fermenting urine for use as a mordant. Yarn or finished material was dyed in large iron and copper kettles over an open fire or in some buildings of the farm that had an open hearth. This was usually the *ildhus*, built for baking, corn drying, and so forth.

Not all the yarn was dyed. Some was left in its natural color. The hardy long-haired Norwegian sheep of ancient times came in shades of grey or brown, and coverlets that appear to have been dyed dark are actually the natural color of the wool. In later times the white, short-wooled sheep were brought into Norway, making it possible for the weavers to add white and the lighter dyed shades to their color schemes.

Hemp was used for the coarser materials and was prepared by hand. There were no tools for its husking and scraping. Cotton and silk were imported and less frequently used than wool and flax. Linen in various grades was used for most shirts and underclothing, when they had underclothing, and for sheets in the more prosperous homes. For everyday clothing simple homespun and leather sufficed, but velvet and wool broadcloth were the rule for festive wear.

Weaving was for the most part a home art, but there were also professional weavers, especially in the cities, who wove pictorial tapestries and decorative panels for the embellishment of the churches and the homes of the wealthy. Doubtless most of them had either come from or been trained in Brussels, the weaving center of the continent. They were the means by which new methods such as the Flemish picture weaving and new motifs such as the pomegranate were introduced to Norwegian homes. Their work afforded inspiration to the country weavers.

95. Överhogdal tapestry. Swedish double weaving from the Middle Ages with motifs and symbols very similar to those used in Norwegian weaving of the same period.
FOT. ATA

From the examples remaining it seems that double weaving (*flensvevnad,* from a word meaning "to hang softly") has had a continuous development in Norway from the fifth century or even earlier. This type of weaving depends on the use of two sets of warp and weft threads, woven to form two separate webs, and joined only at the edges of the design units. At intervals these webs change position, that is, the top web becomes the bottom web and vice versa. This is accomplished by passing one set of warp threads through the other, nowadays by means of treadling. The respective wefts change places at the same time. When alternate warp or weft threads are of a contrasting color, the result is a striped surface, with one color in the top web, the other in the bottom one, and the change of color on the surface occurring with the change in the position of the webs.

Fragments of double weaving preserved in Trøndelag indicate that the early wall hanging was a long narrow strip which was hung horizontally around the room below the smoky portion of the wall. Human and animal figures, stylized trees and geometric motifs were combined in all the oldest pieces, apparently with some historical or religious significance. The colors were red, brown, yellow, and sometimes blue.

96. Remnant of horizontal tapestry from Kyrkjebø. Double weaving, probably from the 1600's; about 6 feet long. NORSK FOLKEMUSEUM

97. Horse blanket from Stjør-
dal, Nord-Trøndelag. Double
weaving. NORDENFJELDSKE
KUNSTINDUSTRIMUSEUM

These same colors are found in the later pieces, from the eighteenth
and nineteenth centuries, but the motifs are no longer combined as
above. Instead single elements such as the tree or bird or human
figure are used, sometimes as part of the main design, but more often
as repeat borders. Allover patterns made up of grape clusters, pome-
granates, cross motifs, eight-petaled roses, or feather-shaped branches
deck the main part of the textile. Meander and zigzag borders are
common, as well as a variety of repeated geometric motifs.

These later tapestries were made to hang vertically, the dimensions
approximating a five to eight proportion. They could be hung behind
the high seat, or seat of honor, but were more commonly used as
bedspreads or to cover a coffin. Dates, initials, inscriptions, and
psalm numbers woven into the design and a central cross motif indi-
cate their sacred function. Pillow covers were also woven in double
weave and there are examples of other uses such as a horse blanket
and a triangular kerchief now in the Nordenfjeldske art museum.

Double weaving is still practiced in eastern Trøndelag and still uses the old motifs and the old colors. It has become so bound by geometric regularity that it gives a rather monotonous impression. Such conservatism, and hence the preservation of the medieval tradition, may have been due to the fact that beginning with the Renaissance, Gudbrandsdal picture weaving so eclipsed the Trøndelag weaving that development in double weaving virtually stopped. Arrested thus in a late medieval stage these Trøndelag textiles provide a valuable link in Norwegian textile history.

Picture weaving, done without heddles on a vertical loom, is an ancient and intricate art. It is possible to follow its development in Norway for almost fifteen centuries, from the miniature-like figure weavings of the Migration era through the revival of tapestry weaving by the various Norwegian homecrafts organizations in the late nineteenth century. Outstanding among the earlier examples are the tape-woven figure tapestry from the sixth century which was found at Evebø, the rich ninth century figure weavings of the Oseberg find,

98. Tapestry from Baldishol Church, 12th century; about 6½ feet long. KUNST-INDUSTRIMUSEET I OSLO

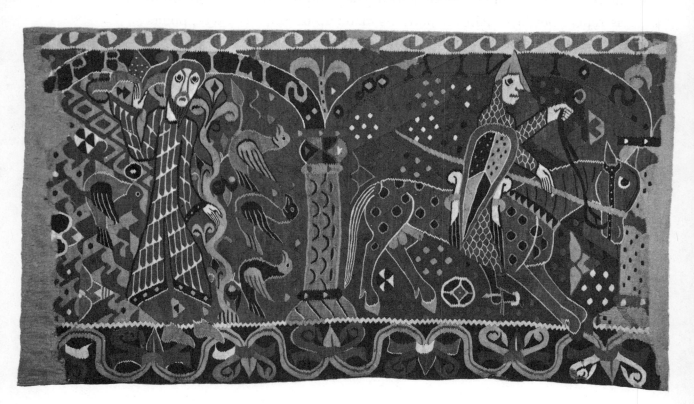

and the Baldishol hanging depicting the months of the year, from the Romanesque period late in the twelfth century.

As in the other crafts, there was a deterioration in the art of weaving between about 1480 and 1550. But with the Renaissance came a heightened awareness, a new conception of beauty which was translated into tapestries in a more naturalistic form, though still with a medieval technique. The weaving shops of Europe were soon humming with greater activity than ever before and their apprentices rapidly spread the new interpretation of art from country to country. Some of them went to Norway and set up shop in the cities where they wove beautiful hangings for the churches and mansions.

Revived interest in picture weaving began to develop throughout the country. But the tradition of medieval simplicity and plane projection was so strong that instead of the Gobelin-type naturalism with all its perspective and shading, the results were stiffly stylized and naïvely flat pictures that to cultured continentals looked crude and childish. Actually they were a strong and pure type of decoration intended not merely to copy nature in cloth but to present an idea or theme in the most direct way. And in this they succeeded.

The first exponents of this new art were located mainly in the coastal districts. Gradually, however, the new ideas were carried inland, where they lasted in local variations until the middle of the seventeenth century. Northern Gudbrandsdal became the center for this national art, its products widely distributed and its designs emulated in other districts. As in carving and painting, certain people began to specialize in weaving. Their particular quirks of design or technique appear repeatedly in the pieces which have been saved. Some of them signed their work, thus giving us another bit of evidence by which to determine the maker.

The technique of picture weaving is more or less that of darning, though the yarn is carried back and forth with a bobbin in the fingers rather than a needle. When heddle rods are used, alternate threads

are automatically raised or lowered, making it possible to simply slip the bunches of yarn directly between the two sets of threads rather than having to weave them in and out. Because the threads cannot be counted out as in geometrical weaving, it is necessary to have a full-size colored pattern behind the loom. For this reason picture weaving is more easily done on a vertical than a horizontal loom.

Each section of the design is built up separately and since the lines are usually curved or slanted it is unnecessary to lock the opposing weft threads to avoid a slit in the fabric except in the occasional vertical lines. Here the joining is usually accomplished by "toothing," that is, by carrying the weft, or design, thread of each section one warp thread into the adjacent section in alternate rows. The use of a linen warp and a woolen weft beat closely together results in a smooth weft surface with all the warp threads covered. Such a piece has unusually good wearing qualities. Furthermore, there are no loose ends on the back of Norwegian figure weavings. The sides are exactly alike, hence reversible.

Heraldic devices such as lions and shields were used frequently in the old Norwegian picture weaving. This was true also of the Oriental motifs. The pomegranate and the Tree of Life came to be just as much at home on the rugs and pillows of Norway as in their own far-off lands. Animals that no Norwegian farmer had ever seen found their way onto hangings and painted walls. The elephant and the unicorn, the strange but real, the familiar but mythical, both caught the fancy of the imaginative Norse men and women. These people were neither more nor less credulous than their contemporaries, but in their minds they endowed all nature with spirits and invented a variety of horrible subhumans for good measure. It was no problem at all to imagine the strange animals of story and song and to translate them into thread.

In spite of and along with this thriving folk belief, Christianity was an active force. By far the greater number of preserved picture

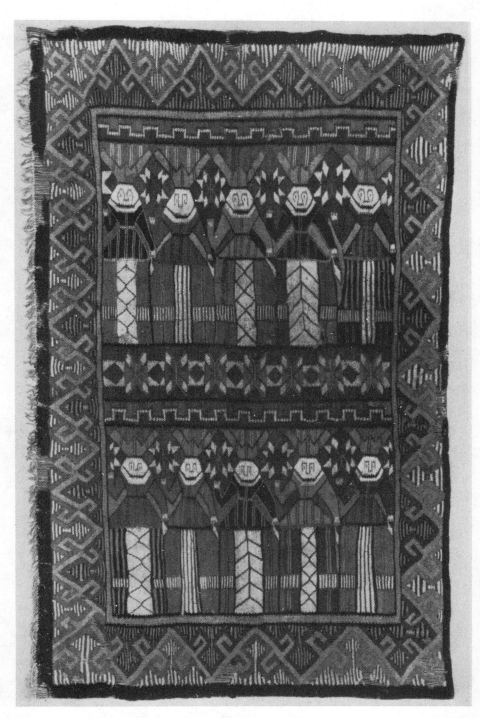

99. Wise and Foolish Virgins tapestry from Sør-Trøndelag, middle of the 17th century. KUNSTINDUSTRIMUSEET I OSLO

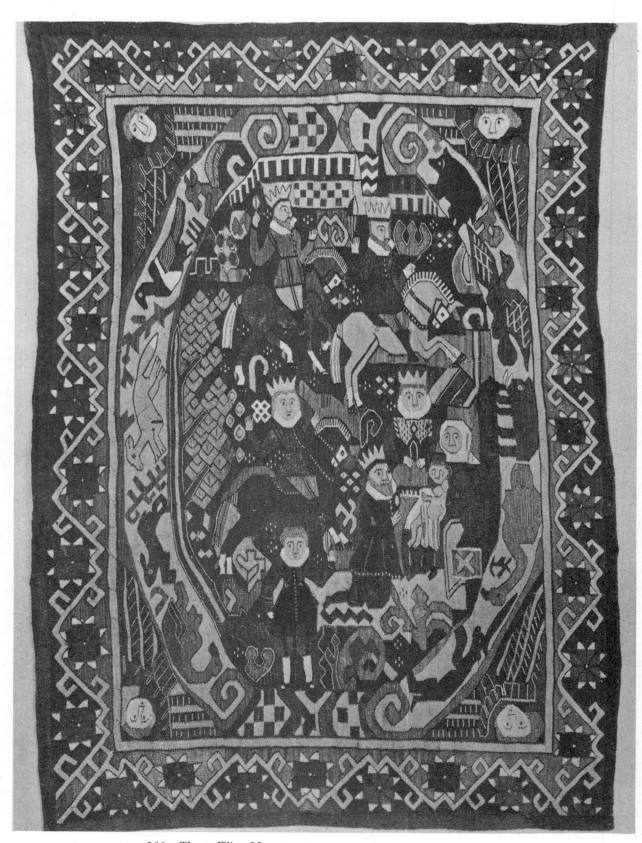

100. Three Wise Men tapestry. KUNSTINDUSTRIMUSEET I OSLO

weavings are of Biblical scenes. The Wise and Foolish Virgins appear again and again, sometimes with six figures in each row instead of five. In some cases a title or quotation accompanies the design. The Three Wise Men is another favorite, quite incongruous in seventeenth century dress. These picture weavings are some of our best sources of information on the attire of the Middle Ages and the Renaissance.

A particularly pleasing design, the *skybragd* pattern, recurs in nearly every district of Norway as well as in Sweden. The term *skybragd* means "cloudwork" and the pattern is sometimes explained as a clouded evening sky with its constantly changing blues and reds. It is a repeat pattern, shaped much like the pomegranate motif and is probably a development from it.

The palmetto, the lily, wreaths of flowers, or borders of animals are much-used designs, most of them coming from Oriental rugs and tapestries, sometimes by way of the Lowlands looms. Two birds or animals facing each other within an octagonal framework constitute a regular formula. Renaissance vases of flowers, while not quite as set in their manner of presentation, are still standardized as to form. Tulips taken over from the Dutch baroque appear in Norwegian weaving along with older and newer motifs, later to be adopted by the *rosemalers*. The spread of unfamiliar motifs to out-of-the-way districts was aided by the wide distribution of pattern books and of botanical and zoological pamphlets. It resulted in a rich choice of design throughout the country.

Weaving experts of western Europe achieved a lifelike modelling through the use of hatchwork and shading lines, whereas the naturalism of Norwegian weaving was much more stylized. A single contrasting line sufficed for shading, the outline served to define the subject. As naturalism gave way to conventionalization, Norwegian motifs became less and less recognizable, particularly in the "square-woven" tapestries where motifs such as the lily and the rose have managed to retain their names only through tradition.

101. Pillow covers from Gudbrandsdal; above: *Skybragd* pattern; below: Lily
pattern. KUNSTINDUSTRIMUSEET I OSLO

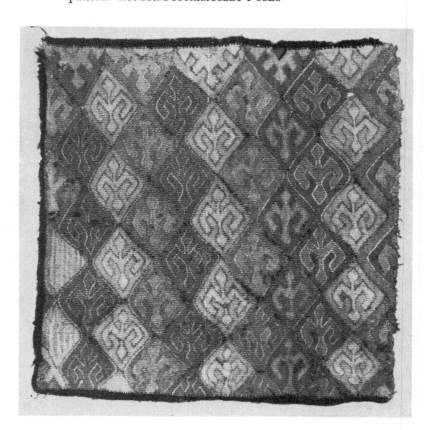

Although the making of large tapestries began to decline in the late seventeenth and early eighteenth centuries, the more remote districts continued to use picture weaving for pillow tops and bench covers for another hundred years. Gudbrandsdal weavers still provided inspiration to other districts, especially to Trøndelag and Valdres, the former specializing in variations of the pomegranate motif, the latter in the Virgin motif. Because picture weaving was so intricate and time-consuming this work was not for everyman to own. For purposes of utility it was far more practical to use the horizontal loom with one of the treadled weaves that could be worked up in a hurry. But for a touch of elegance, for sheer luxury, a bit of picture weaving if only enough for a pillow top was unequalled, and to own such a piece was the desire of every woman who could aim even a little higher than the necessities of life.

Through many centuries the *aaklæ* has been a most useful and highly decorative part of the Norwegian home. It is a colorful square-weave tapestry used for coverlets, carriage robes, bench covers, pillows, rugs, and a myriad of other items. As appropriate to the modern as the medieval home, it was not allowed to drop out of use. Its richest development was during the 1700's when it was turned out in great quantity in all parts of southern Norway, but particularly in the west coast districts. It was more characteristic of home weaving than were the picture tapestries, for professional skill and artistic training were quite unnecessary. Because of its geometrical character, it could be done on a horizontal loom, with harnesses to form the shed for the passage of the weft. As in picture weaving, the warp is of linen and the weft of wool, resulting in a rep surface with the warp completely covered.

Rather than build up one section at a time, the threads for each color area are carried from right to left, with a twist around the thread of the adjacent area to avoid a slit in the fabric. By changing the relative position of the harnesses the warp threads also change

places, and the design threads are fed back through the new shed, this time from left to right. In Norwegian square-weaving of the seventeenth century the pattern threads were twisted or "locked" around each other only in alternate rows. In the second row then the threads were simply slipped through their own section of the warp without being linked to the adjacent color. This method allows for use of diagonal lines and makes for a more supple textile than the double-locked type. The latter was used in Sweden and in Norway in the eighteenth and nineteenth centuries. It requires the locking of weft threads each time they meet, that is, in every row, and works perfectly well for square patterns but not so well for diagonals. Slanted lines must proceed in step fashion, each step being the width of two weft threads.

The pattern and coloring of the *aaklær* are identical on both sides, and this together with the long-wearing materials and sturdy weave assure their use for a very long time.

West Norwegian square-weaves are in a group by themselves. They include some of the best and most artistic pieces among Norwegian home weavings, though the majority of them are not as pleasing as the picture weavings. The typical west coast color scheme includes red, blue, yellow, white, and black. Brown or red-violet patterns used on the south coast make the *aaklær* look very dark, even when they are worked on a yellow and white ground. This combination is the old heraldic rule of color on metal or vice versa, the "metal" in this case being the yellow and white ground.

The development of square-weaving parallels that of chip carving in locale, time, and even motifs. Both are products of the Middle Ages, particularly the late Gothic period. The eight-petaled rose is found in each field and is used again and again. In the older woven pieces it is framed by square or octagonal borders in which the rose colors are repeated. Angled areas as in the octagonal borders are usually a series of diagonally placed squares. A majority of the most

common patterns make use of this scheme to form their lilies, roses, knots, and other equally unrecognizable motifs.

Sometimes the main part of the tapestry is pure square-weave (*rutevev*) while the border is a series of zigzag lines. It is as though the weaver allowed herself to escape from the confines of geometry only at the top and bottom of each piece, as though she brought a personal touch to a piece which was otherwise a docile imitation of the designs and colors of countless women before her. It is interesting to note that she didn't feel impelled to keep the borders in formal balance even though the rest of the piece was. Top and bottom borders frequently differed in depth as well as in design. Even the center area of the tapestry sometimes shows an incomprehensible inconsistency in color, although the pattern itself is usually quite regular.

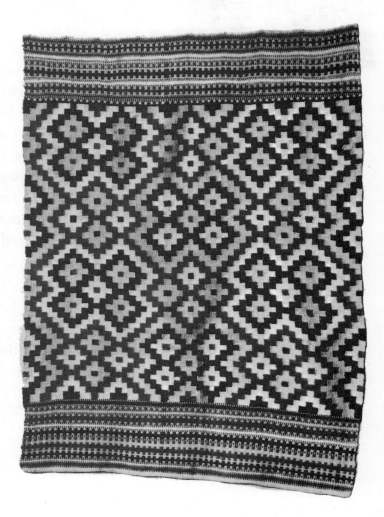

102. Typical west coast square weave tapestry in red, yellow, black, and white; about 4 x 5 feet. NORSK FOLKE-MUSEUM

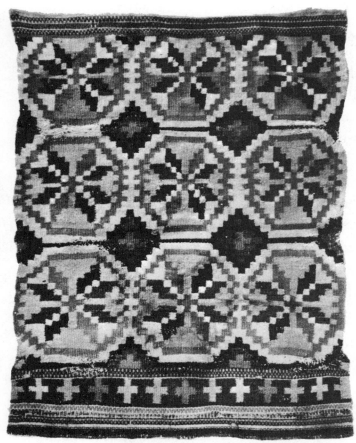

103. Another square weave tapestry.
NORSK FOLKEMUSEUM

Among the west coast square-weave tapestries those of Sogn stand out for their larger, more bold patterns, their wealth of designs. Various rose patterns, the knot, the star, the lily, all executed in a variety of ways and in interesting proportions manage to save Sogn weaving from the monotony evident in some other districts. The unit of design, the square, is sometimes placed horizontally, sometimes tipped up on end. When the two methods are combined, the possibilities are still richer. Yet through all these variations runs the basic square, chosen hundreds of years before as the most economical of weaving motifs. Pieces from the seventeenth century and later still reflect the Middle Ages both in pattern and technique.

Characteristic of the Hardanger tapestries are the small-squared *aaklær* where the rose, framed by tipped squares, is steadily repeated. Generally the colors are light. Nordhordland has a distinctive group

with a series of horizontal borders in different techniques; Vest-Agder *aaklær* are recognizable by their dark countenance. They have as a rule a brownish black ground, with the pattern in red, blue, yellow, and white. This scheme is representative of the oldest ones. Around 1840 green was added and after the 1880's violet was used instead of blue.

The typical Setesdal *aaklæ* is woven in squares with a zigzag border around the edge. There are however some examples with stars and other designs in squares and without the border. The textile work of this district is not very distinctive, due partly to the fact that here the women were expected to work along with men and consequently had less time to spend on handcrafts than did the women of Telemark and Gudbrandsdal.

Very few *aaklær* are left in Setesdal and they are not much more than one hundred and fifty years old. One pattern, a combination of knots and grape leaves, is also known in Vest-Agder and in western Norway. However, the Vest-Agder and Setesdal examples are in a group by themselves. They are larger than those of west Norway and are always woven in two narrow pieces which are then sewed together. This brings in a problem in matching, very difficult in such pieces as the irregular striped coverlets or in the zigzag borders of Vest-Agder and other areas. It is a problem that is not always solved satisfactorily.

Textiles from Glomdal in eastern Norway show blue-green to be a favorite color. It is used for the background in various picture weaves and in combination with red, brown, and cream in at least one square-weave piece. A casual distribution of colored squares in this particular example gives it a rather checkered effect, with no real design evident.

"Swedish tapestries" are mentioned again and again in inheritance lists and may have included pieces done in Norway in imitation of the Swedish ones as well as the imported articles themselves. The district of Västergotland in southwestern Sweden was famous for its

loom brocades which peddlers carried far and wide. These coverlets or tablecloths were softer and lighter than the Norwegian tapestries for they were made with a linen warp and a linen weft thread between each wool pattern weft. They required at least a two-harness loom. With more harnesses greater pattern variety could be achieved.

In this type of weave the pattern weft passes over and under various groups of warp threads to make a "flushed" or "overshot" pattern. Areas in which the pattern weft passes over become the surface pattern, the areas between show only the ground web. Eight-pointed stars, crosses, diamonds, and triangles comprise most of the patterns but their variations are infinite. Different colors may be combined in the same piece, either as horizontal stripes, or as con-

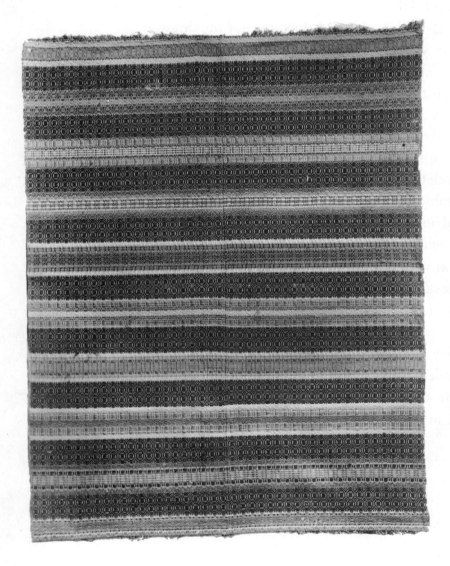

104. "Swedish tapestry" from Lista, Vest-Agder in black, red, green, and violet on gray ground; about 51 x 64 inches.
NORSK FOLKEMUSEUM

trasting border and center. Most common in Norway seems to have
been the type in which a square area in the center is done in a con-
trasting color. The pattern weave in this center area is the same as
that in the rest of the piece. Only the color is different. Red, blue,
and green with a natural linen weft were much used in Sweden. In
the Swedish tapestries of Setesdal the colors ranged between dark
brown and light yellow. Like the *aaklær* they are seamed down the
middle.

Several other loom brocades have been made in Norway, among
them the monk's belt or patch pattern, rosepath, and various of the
pattern twill and diaper weaves. In addition to these, all shuttle
weaves, there were two popular types, the *skilbragd* and *sjonbragd*
in which the pattern is laid in by hand. Collectively these brocades
are called *bragd*-weaves, a term which suggests the change between
the wool pattern areas and the cotton or linen ground. They are
done in stripes or borders. *Bragd*-woven coverlets were used to face
fur bedcovers or as wall hangings, the colors usually black, red,
yellow, or green on a white ground.

Northern Norway, including Nordmøre, Trøndelag, and Nordland
is typically *bragd*-weave territory. There was no square-weave here
and little picture weaving, hence the brocades were developed to a
high degree. *Bragd* techniques were also popular in other parts of
Norway, notably the southern coast, Telemark, and the Oslo area.
Vest-Agder's post coverlets, so-called because of the vertical streaks
or "posts" woven into the horizontal stripes, were famous. Rosepath
was sometimes called Telemark weave, indicating great popularity
in that district. In time the *bragd*-weaves displaced square-weave
to some extent even in Sogn. Nordhordland combined *bragd*- and
square-weaves in the same piece, a development which has apparently
been unique to that district.

The Norwegian name for patch pattern is *tavlebragd*, which sug-
gests checkered work. Except for the fact that the individual blocks

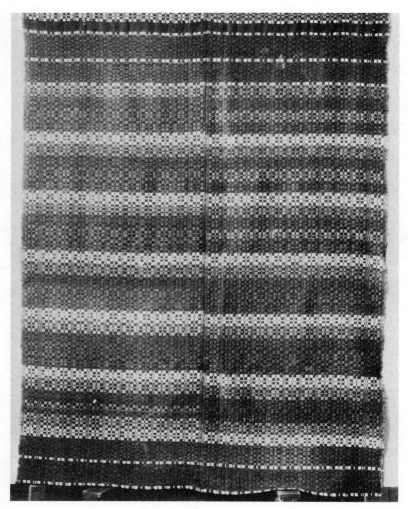

105. Patch pattern tapestry from Gudbrandsdal. NORSK FOLKE-MUSEUM

need not be square, the name describes the weave very well. The squares or rectangles are not overlapped but are placed one above the other so that only the corners of diagonal squares touch. Four harnesses are required for the weave, two for plain weave and two to make the block design. As a rule, only one pattern color is used, of a contrasting hue to that used for the ground.

In the rosepath design, the blocks proceed in overlapping steps, the weft flushed over a birds-eye threading. One type of rosepath is similar to a twill weave except that in the former the warp threads do not show. Rosepath has been a popular pattern in many countries. It is a smaller and as a rule more delicate design than some of the

other weaves, and allows for a more varied effect. It may be an allover pattern of small flower-like motifs, a series of smoothly flowing zigzag lines, a bold border, or a maze of angular concentric lines. In Scandinavia it is often used for a sort of sampler of border motifs, each one more fascinating than the last.

In addition to the above shuttle weaves there was the popular *krokbragd*, an imitation tapestry pattern using three harnesses. It produces a rather blended, indistinct geometrical design.

Of the two hand-patterned brocades, *skilbragd* was the more favored. It is another block design, but instead of having the pattern set in the loom, the pattern warp can be separated from the ground warp by hand. Thus the pattern areas can be combined and over-

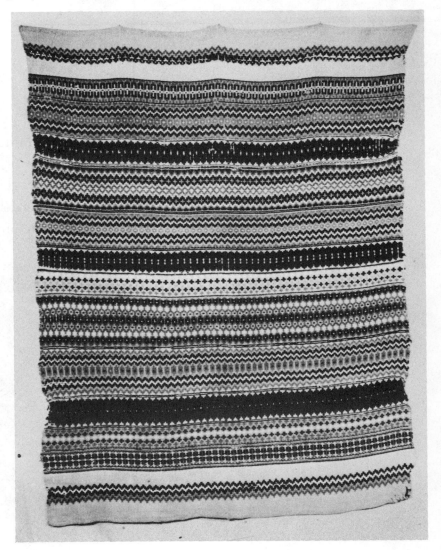

106. *Krokbragd* tapestry from Suldal, Ryfylke, Rogaland.
NORSK FOLKEMUSEUM

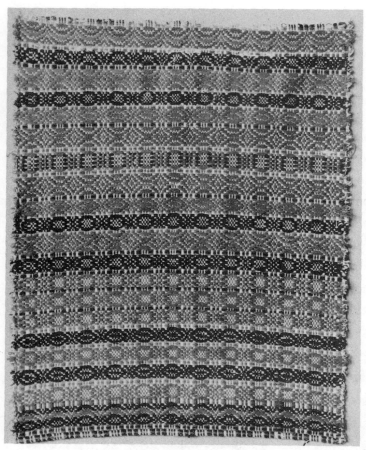

107. *Skilbragd* tapestry from Mo, Tele-mark. NORSK FOLKEMUSEUM

lapped at any point. There is no definite arrangement of blocks.

Sjonbragd is an embroidered weave of separate motifs—human figures, trees, and the like—which are laid in by hand as the weaving progresses. Since it is a rather slow process it is used mainly for borders. Like the other brocades it is done on a cotton, linen, or some-

108. Pillow cover in solid pile weave. Ground color is yellow with grey-brown, blue, green, red, and yellow pattern. KUNST-INDUSTRIMUSEET I OSLO

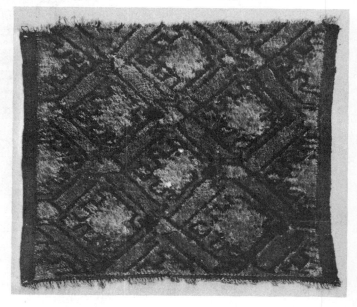

times wool ground, with a pattern weft of wool yarns dyed in an infinite variety of mellow home-produced colors.

A whole chapter could be devoted to the subject of *ryer*. The English translation "rugs" is quite inadequate to cover the multiplicity of uses assigned to this popular item. It was used for protection and warmth in the small open fishing boats of the coast. As a warm bed covering it replaced furs and skins in all parts of Norway. It made a luxurious sleigh robe and a festive bench cover. It was used for wall hangings and for pillow covers and, of course, for rugs. At least as early as 1460 it was being used as a bed cover and by the 1600's it was common throughout the land.

Similar in appearance to today's shag rugs, the *ryer* had a knotted pile, rather than one looped from a special weft, and was usually patterned. It was made of lengths of yarn fastened into the ground web at definite intervals as it was being woven. The pile varied in length from less than one-half inch to more than three. When the longer pile was used, the knot rows were spaced farther apart, usually a little less than the length of the pile. With the shorter piles an effect similar to the Oriental rugs and velvets of the late Middle Ages as well as to ancient Coptic pile knot pieces is achieved. Here pattern and design can be given free rein.

Simple stripes and borders, flower motifs, criss-crossing lines, all can be worked into an ordinary two-harness rep ground. One type

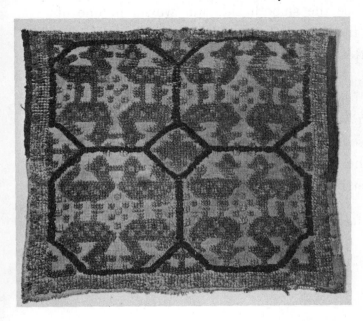

109. Pillow cover in half-pile. Red background with blue, green, red, yellow, and grey-brown pattern. KUNST-INDUSTRIMUSEET I OSLO

covers the whole surface with the short pile designs. Another leaves the ground weave between with a resultant carved pile effect. This "embroidered" pile work was used for pillow covers and wall hangings rather than bedspreads, rugs, or robes. The unattractive knotted back was better concealed and these pieces were too valuable to be subjected to undue wear. Short pile work is more closely related to picture weaving than to the common *ryer* and is not as typically Norwegian.

The earliest *ryer* of which we have descriptions looked remarkably like animal pelts, and were doubtless a substitution for these. On the west coast where *ryer* went to sea with the fishermen and hence needed to be able to withstand the salt water, they held up much better than animal skins which soon rot under the constant wetting from sea spray. Womenfolk of the coastal regions took the long, smooth, and wiry hairs from their local breed of sheep and spun them very loosely into thread which when used undyed formed a pile that looked much like fur. The ground web was likewise of wool, but of an inferior grade. Until quite recently the huge boat *ryer* could be seen along the coast, hanging from the side of a beached fishing boat to dry. Sometimes they were checked in large squares, sometimes striped, always in the natural dark shades.

Bed *ryer* show much greater variety in color and pattern both as to pile and ground weave. Originally the bed *ryer* were intended to be used pile side down, hence the smooth side was woven in one of various pattern weaves, the knots of the pile hidden beneath the threads. Any type of pattern weave might be used from the simplest of twills to double weave. Most popular were variations of birds-eye.

Wide colored bands either lengthwise or crosswise were characteristic of the district in which the *rye* was made. For example, Gudbrandsdal women used lengthwise stripes in both the ground and the pile; in Sogn the weave was usually a lengthwise striped diaper weave with cross-striped pile. Trøndelag used a twill ground

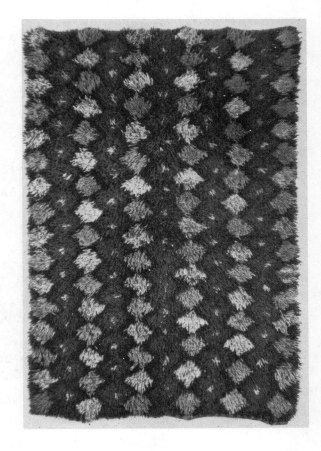

110. *Rye* (pile bedcover) from Meløy, Helgeland,
Nordhordland, in black, violet, bright red, fire
yellow, and white. KUNSTINDUSTRIMUSEET I OSLO

111. *Rye* from Gloppen, Nordfjord in bird's-eye
weave. BERGENS MUSEUM

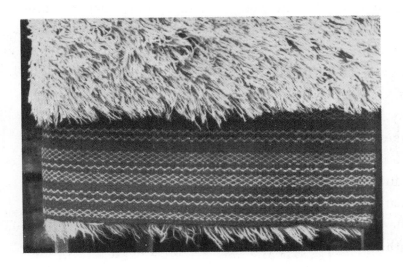

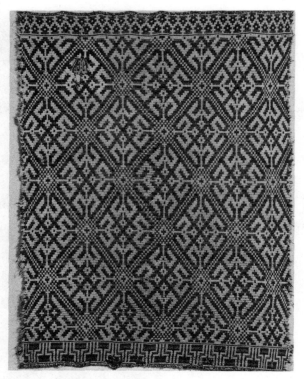

112. *Rye* in double weave from Ekre, Heidal, Gudbrandsdal. Red background with brown, white, and yellow pattern. KUNSTINDUSTRIMUSEET I OSLO

with checks, stripes, or maybe a date worked into the pile and with embroidery or beading at the head end of the smooth side.

In most of the Norwegian *ryer*, wool was used for at least one of the ground threads, usually both. Linen sometimes replaced wool in the warp and in some of the poorer districts cattle hair was mixed with a little sheep's wool for the weft. One interesting variation used in various districts was the rag pile. These bits of cloth were sometimes employed in hit or miss fashion, sometimes worked into striped or bordered rugs. Not infrequently a pile rug contained a mixture of yarn and rags.

In a class by itself is the braid or tape weaving so much a part of the Scandinavian attire for uncounted centuries. It is a very old art, examples of it having been unearthed among Bronze Age finds in Denmark and in ancient Egyptian remains. In Norway it was used as a swaddling band to keep the baby's blanket tightly wrapped. It served as girdles, garters, and headbands. Armholes and skirt hems were edged with it, bonnets tied with it. In short, any place where a

narrow band, taut or stretchy, might be needed, braids fulfilled the requirements. Included in the term "braids" are both plaited and woven strips, executed in a variety of ways, nearly always with a most decorative result.

Apparently the animal-patterned tape weaving of Evebø from the sixth century was just such a weave. By the eleventh, twelfth, and thirteenth centuries, geometrical patterns such as swastikas and crosses as well as animal figures were characteristic of northern textile art. Animal motifs gradually lost out and by the eighteenth century most band weaving was strictly geometrical. As with other types of peasant art and attire this work remained longest in the more backward districts; there is a wealth of it remaining in Setesdal and in varying degrees in the other more remote areas.

Two distinct methods produce the woven bands. The first, called card weaving, requires small wooden or cardboard squares with a hole in each corner through which to thread the warp. The warp is stretched out horizontally, with each thread passing through one hole, four threads to a card. The row of cards is placed flat together, parallel to the warp and given a quarter turn, the weft thread inserted into the shed. The cards are turned again and the weft passed through the new shed, and so on.

Braid can be woven on both sides of the cards simultaneously by using two weft threads. If only one side is woven, the direction of the turns must be reversed at regular intervals to avoid a tangle of thread behind the cards. Patterns are produced by using sheds of different colors. In other words, the choice of warp colors determines the design. The weft is completely covered. Usually the warp threads are inserted into the tablets alternately from right and left, resulting in a structure characteristic of knitting, chain stitch, or soumac.

Grindvev is the term used for the second type of band weaving, an overshot weave in which both ground and pattern warps are used and the weft is more or less hidden. The warp is threaded through a

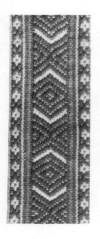

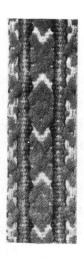

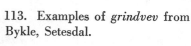

113. Examples of *grindvev* from Bykle, Setesdal.

Left margin, center: Card-woven band from Seljord, Telemark; bottom: Hand-braided band from Setesdal. NORSK FOLKEMUSEUM

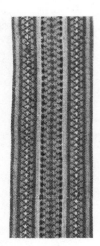

frame called the *bandgrind,* in which vertical slots alternate with small holes, and is then made taut. By alternately lifting or depressing the *bandgrind* the threads in the holes are raised or lowered while the ones in the slots remain in place. This forms the two sheds through which the weft thread must pass for the ground web. The pattern threads are picked up by hand, the weft inserted by hand or with a shuttle. Zigzag lines were commonly used, one line for ribbons, three or four side by side for belts and bands. Crosses, squares, and comblike motifs formed a large part of the weaver's repertoire, in infinitely varied combinations. Red was a favorite color for these belts, sometimes combined with black, green, or blue. The weft was usually white.

Setesdal now has a special kind of band weaver not used in other parts of the country. It is similar to a vertical loom but smaller, and the weaving proceeds downward instead of up. The same patterns can be woven on both the band weaver and the *grindvev* loom.

Braiding or plaiting produces a rather elastic product suitable for garters, waistbands, and the like. For this reason it was a universal skill, differing little from place to place. Various combinations of bright colored yarns were used, the ends formed into a tassel. In

contrast to weaving the work is done by hand with just one set of threads. There is no weft. The threads are twined with adjacent threads, passing all the way across the braid and back in each complete cycle. When both ends of the threads are fastened braiding proceeds on each side of the middle simultaneously but in opposite directions, the two ends of the braid mirroring each other.

Another technique, similar to braiding in execution but for purely decorative purposes, is the *sprang* process. It produces a netlike lace or fringe that has been very popular for towel and pillow edgings. Gudbrandsdal women were very adept at the work and they liked the economy of it, for cotton or linen warp ends left from weaving could be used up in this manner. As in braiding, one or both ends of the threads may be fastened and the twining is done by hand. However in *sprang* each thread passes back and forth across the two adjacent threads, not all the way across the piece. The work proceeds from the center to each side and back so that the pattern reverses at the middle. When both ends of the threads are fastened, a flat stick is used to keep the work from untwining, and the pattern is reproduced mirror-fashion on both sides of the stick. As a rule *sprang* is much more open than braiding. Large meshes give it the character of coarse lace.

The elasticity of *sprang* makes it good for nets. Three thousand years ago it was used in Denmark to make a hair net for some highborn lady. It was found in her grave, still in recognizable condition.

114. *Sprang* from Rindal, Nordmøre. NORSK FOLKEMUSEUM

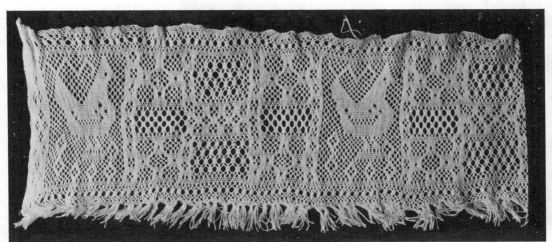

Examples of *sprang* have also been found in Egyptian graves of fifteen centuries ago that are very similar to the *sprang* made in Gudbrandsdal today. Probably it was once done all over Europe but it has since died out in most areas.

It is reassuring to know that so many ancient weaving techniques are still alive in Norway. With the publication of processes and designs there is no reason why this knowledge should ever be lost.

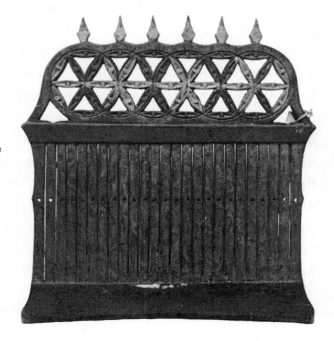

S43. Band weaving heddle
for backstrap loom.
NORWEGIAN-AMERICAN
MUSEUM

S44. Card weaving. The pattern is determined by the threading of the warp cards. Each turning of the cards creates a new "shed," through which the weft or filling "thread" is passed. NORSK FOLKEMUSEUM

Embroidery

7

A GERMAN TRAVELER once wrote, "There hides an artist in each Norwegian farmer." This was at least equally true of the farmer's wife. She spent countless hours adding colored yarns, beads, tatting, beautiful white work, and all the other variations of embroidery art to the materials of the home which she had already prepared and woven with her own hands. She had a feeling for color and pattern, and where her own sense was less sure she could always turn back to the work of her many predecessors. Their designs had, through the purifying action of the centuries, rid themselves of the less pleasing elements and retained the good.

As in weaving there were many excellent geometric patterns to choose from, some of them so similar to weaving that it requires close inspection to distinguish the method. Use of this type of design automatically eliminates the ineptitude of the amateur, for by counting threads carefully it is almost impossible to spoil a good pattern.

Free embroidery, on the other hand, requires greater skill, and is more likely to show imperfections. In this field the Norwegian country woman need bow to no one. The Norwegian free embroideries, particularly the colored ones, are beautiful both as to form and to execution. The colors are bold, boldly used; the effect exhilarating.

As in other craft work there were district variations in embroidery. Nordmøre had a very fine type of whitework. Hardanger is immortalized in the term "Hardanger work," a geometrical type of white embroidery with a pattern of square holes. Gol, in Hallingdal, developed a special and universally popular type of colored wool embroidery, Valdres another, and Telemark still a different kind. Appliqué work was particularly characteristic of Sogn textile decoration; Gudbrandsdal women were fond of tatting. Every area had its speciality but not to the exclusion of the other fields. Most types of stitched work were carried on in various degrees in all districts.

Fickle fashion had no place in the Norwegian farm home. To re-do a room, as in the modern sense, would have required a lifetime of work. A girl's dowry chest was started when she was born and was the work of all the womenfolk in the family. When the girl was old enough she too began to weave and embroider the multitude of linens, pillow covers, ceremonial cloths, and ribbons she would one day need.

It was no *hastverk*. Careless stitching was not to be tolerated. Anything worth doing was worth doing well, particularly since it was expected to last for at least one lifetime and maybe more. The best of homemade materials went into these heirlooms and they wore forever. Any change in style had to evolve over a period of many years and was retarded by the wearing qualities of the materials used for its predecessor.

When around the middle of the nineteenth century, fashion made an irrevocable entrance into the rural districts it meant the end of much of the old intricately done handwork, especially on clothing, and the near demise of home weaving. It took too long to make cloth

by hand for fashions that might change the next year, and the women turned to factory-made cloth and drab, unimaginative city clothes. Men's clothing, too, lost its festive air.

A reawakened appreciation of the old handwork around the beginning of the twentieth century prevented the complete extinction of the old skills and revived interest in local costumes and embroidery. Gay wool embroidery again appeared on sweaters and mittens, pillow covers and caps. Wherever a stable fashion assured at least a reasonable length of use, as in pattern-knit sweaters, women of all classes in Norway turned to the inherited designs for decorations which they felt to be peculiarly their own. Homecraft organizations gave impetus to the movement, in Sweden and Denmark as well as in Norway, and today the old skills are not old but honored components of the new art.

Present-day hand weavers work up designs developed by trained designers from the old textiles. Hand embroidery and hand knitting, their patterns based on the past and adapted to the present, are in great demand not only in Norway but abroad. It is a triumphant return to the old concept that beauty is always beautiful, and seems to indicate that haste and change cannot satisfy the soul. It offers the integrity of the past translated into the terms of the present, thereby providing the security of tradition for contemporary living.

Perhaps the most characteristically Norwegian of all these embroideries is the *rosesaum* or rosework. It has minor variations with special terms such as *krullesaum* or *krotasaum*, both of which mean scroll embroidery. But essentially they are all a type of wool embroidery done in the rococo style. They are very closely related to *rosemaling*. *Rosesaum* may be done on any material, from velvet to canvas, but is most often found on woolens. It varies in style from district to district and the coloring is equally diverse.

Gol, a settlement in Hallingdal, has fostered a type of *rosesaum* which is now considered the "national *rosesaum*." It has been ac-

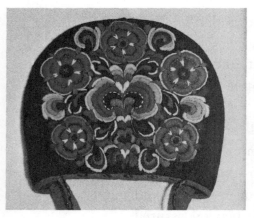

115. Colored wool embroidery from Hallingdal. NORSK FOLKE-
MUSEUM

cepted by the whole country as being the representative type of Nor-
wegian colored embroidery. It uses petal and teardrop shapes exclu-
sively, no stems, but manages to obtain an infinite variety of design
areas. The work is done in satin stitch according to the contour of
the design element. That is, the stitches do not lie in one direction
over the whole piece, but slant to suit the shape of the petal. The
design is built up largely by concentric rows of more or less irregu-
larly shaped petals.

The coloring follows a pattern of light to dark throughout. Usually
two shades of the same color are adjacent. For example a flower may
have a light green center, with a darker green around it. The next
layer may be a light red, the next one dark. Two shades of yellow
may supply a calyx or just odd accents here and there. However the
design is always connected. There are no loose elements. Red is the
predominant color in the design, at least in Gol. This is in keeping
with the recognized penchant for red among Hallingdalers. The
ground color in the Gol *rosesaum* is usually black but the work is
equally effective on other colors and particularly on white.

Valdres, though a close neighbor of Gol on the map, lies in another
valley, effectively separated from Hallingdal by mountains. Its
rosesaum is completely different. There are boldly curving stems

116. Colored wool embroidery from
Hjartdal, Telemark. NORSK FOLKE-
MUSEUM

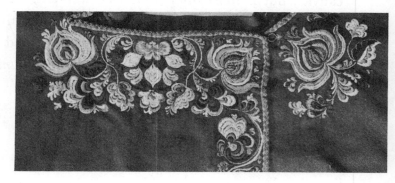

aplenty and the flowers look like flames or autumn leaves. There is little or no shading of colors. Bright yellow and fiery red are placed side by side, and against the black background they blaze. Touches of blue and violet increase the illusion of flames and the tiny stars formed by four crossed lines look like sparks.

Telemark *rosesaum* strongly resembles Telemark painting. It utilizes curled-up leaf and flower shapes on stems that flow rhythmically from one part of the design to another. Curving teardrop shapes one above the other are used here too, but they seem quite different from those in the Gol work. In Tinn, a locality in Telemark, colors are smacked together in a rather startling way and their number is completely unrestricted. In Heddal, another part of the district, the colors of the design may be more subdued but the background is often red instead of the black or dull green of Tinn. Here the embroidery may be done in silk instead of wool.

Setesdal from about 1840 used a *rosesaum* very similar to that found in Telemark. Since the Telemark work is older, Setesdal probably received its inspiration there. There is more red than in the Telemark type and the work is less well done.

Sunnmøre, north of Sogn on the west coast, has a type of *rosesaum* which utilizes isolated motifs, nicely spaced, instead of flowing design. The individual units are very imaginative leaves and flowers, combining pointed and rounded shapes, teardrops and hearts. Crosshatching of various kinds is used to fill in the open areas of the motif.

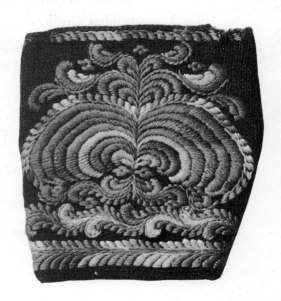

117. Colored wool embroidery from Hylestad, Setesdal.
NORSK FOLKEMUSEUM

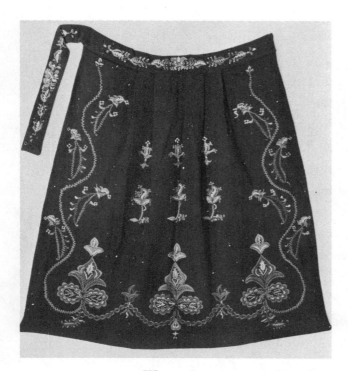

The colors are combined unreservedly, but used against a dark background they are very pleasing. Satin stitch is the main stitch here as in other *rosesaum*.

There is less embroidery on the Sørland dress than on that in other districts but the costume includes a beautiful shawl. It is embroidered in colors on white or black, in designs closely resembling crewelwork. The designs are more jagged than in the usual *rosesaum*, the shading nicely done.

Gudbrandsdal festive dress was bordered with "sewed" roses at the bottom edge, silk flower embroidery on the bodice. One type of man's costume was embellished with finely done *krotasaum*, the typical Gudbrandsdal curling vine motif, on vest and coat.

Hardanger, Sogn, and Voss stuck pretty closely to geometric embroideries, and other districts used brocade or band weaving. Where

119. Embroidered bodice from Lom, Gudbrandsdal. NORSK FOLKEMUSEUM

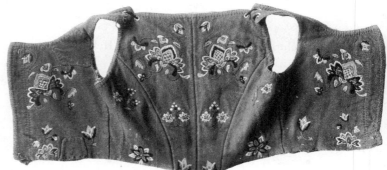

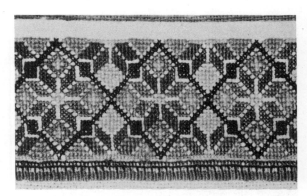

120. Colored cross-stitch used on white Telemark shirt. NORSK FOLKEMUSEUM

rosesaum was not used on the dress itself, it was often found on the large and colorful purse which nearly everywhere hung from the woman's belt.

Besides the naturalistic *rosesaum,* Norwegian colored embroidery included various types of geometric work, done on counted threads. In the oldest type, threads are drawn out of the material and colored yarns darned in. The next type was the geometric satin stitch, and finally cross-stitch. In Telemark all these techniques plus *rosesaum* might be found on the same shirt. Cross, star, and diamond shapes and various types of borders were used on the wrist and neck bands of both men's and women's shirts. They were done in silk or linen thread, as a rule on a white ground. Other items might be of wool, canvas, or knitted material, with wool, silk, or linen embroidery. Later work was done in cotton. Red, blue, green, and black were the most commonly used. Colored cross-stitch was also worked on household linens in the old tried and true designs. Head cloths, belts, purses, and even mittens were decorated with it.

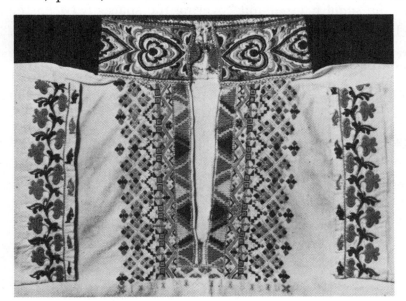

121. Shirt with colored embroidery from Bø, Telemark. NORSK FOLKEMUSEUM

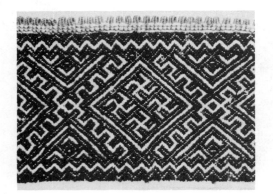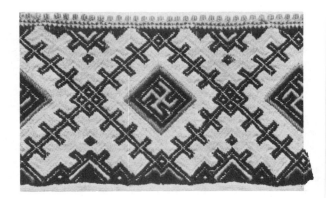

122. Pattern-darned neckbands *(smettesaum)* from Telemark. NORSK FOLKEMUSEUM

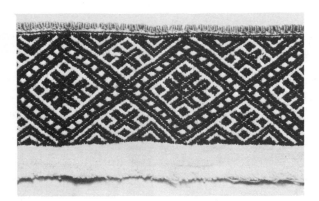

Frequently other embroidery stitches were combined with cross-stitch. One of these, the Holbein stitch, so called because it appears so regularly in pictures painted by the Dutch artist, is a double running stitch. It is done by using stitches of equal length on both the upper and under surfaces of the cloth, with another thread applied afterwards in the same manner but covering the spaces between the original stitches. This results in a solid line and was most often used in a geometric fashion. Sometimes contrasting colors are used, the line showing alternately a stitch of one color and then the other throughout. Cross-shaped peaks jutting out at regular intervals from the line of embroidery are a favorite device and the technique is also used for zigzag borders and even for petal outlines. Telemark and Setesdal have very similar colored embroideries in this technique, but with more red in the Setesdal pieces.

Setesdal has two other types of geometric embroidery, also used in Telemark and other districts. In one the design is made up of squares, in the other the patterns are very similar to weaving and are so closely done that they look loom-made. They have the usual geometric motifs—the swastika, double cross, zigzag line, diamond, and so on. These motifs are very old. The swastika was found on some of the Oseberg textiles and was popular over most of Europe in the thirteenth century. Cross motifs were equally ancient and widespread. The work is used on children's caps and on neck and wrist bands.

Sogn color-work includes cross-stitch, *glit* or pattern darning, and the lightning pattern, a kind of Gobelin stitch. In the last the technique is somewhat like satin stitch, with the thread carried up more threads than it is carried over. That is, it may go up four and over one, the formula repeated throughout. Or the combination may be up three and over one or up four and over two and so on. The lightning pattern, often called flamework or Hungarian work, has been generally used in several European countries. It consists of sharply zigzagged lines, done in strips of different colors, the strips often of varying widths. One example of the lightning pattern remaining in Sogn is a breastpiece or plastron done in streaks of red, yellow, black, and white, repeated throughout. This technique is also used in Trøndelag and other districts.

Cross-stitch plastrons are common in Sogn, all in geometric designs. The eight-petal rose, variations on the lily and knot motifs, and cleaved squares are used in either diagonal or horizontal formation. Red and blue or red and green on white are the usual color schemes.

Blackwork and whitework may be either geometrical or free embroidery but most often they belong to the first group, done on counted

123. Blackwork border from Vik, Sogn. Pattern darning and Holbein stitch. BERGENS MUSEUM

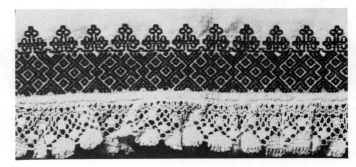

threads. With the exception of some later pieces, most of this work was done on rather coarse material, always white. Blackwork includes both decorative line borders and solid geometric borders. The line borders are done in Holbein stitch, usually in the lily motif. The solid borders of pattern darning are executed in two ways, with the threads running parallel to the border (*dragsaum*) or perpendicular to the border (*smettesaum*). In this work, the wrong side of the embroidery is the negative of the right. It is similar to an overshot pattern in weaving. As in weaving the design units may be placed either horizontally or diagonally.

Blackwork may be used alone or may be combined with whitework. The combination of the two is especially characteristic of Sogn embroidery. These techniques are restricted mainly to borders and bands, but are occasionally used in larger areas on head cloths, guest towels, and other household linens. Blackwork done on large areas is usually done in cross-stitch and the designs are quite open.

Technically speaking, Norwegian whitework is more varied than blackwork. It includes a great variety of drawn work, both single and double, cutwork, pulled-work, free embroidery, and so on. It was introduced or at least popularized by the Renaissance, along with

124. Head kerchief from Voss, in blackwork. NORSK FOLKEMUSEUM

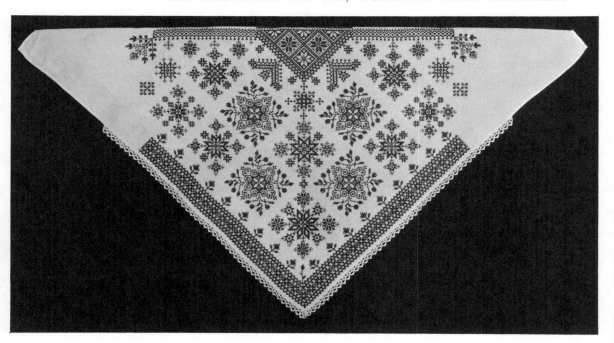

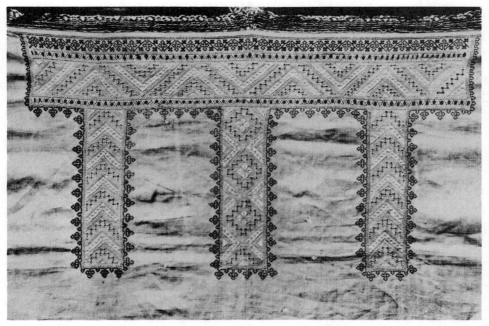

125. Sogn embroidery showing single drawn work, pulled-work, cloister block and Holbein stitches. NORSK FOLKEMUSEUM

the greatly increased use of linen for clothing, and replaced much of the colored embroidery and tape weaving that had previously been used. Undoubtedly it was carried to Europe through Byzantium from the Asiatic countries where linen had been used for uncounted centuries.

Single drawn work ranges from the simplest types of hemstitching to bold border designs. The latter are often used as narrow edgings for other types of embroidery. In this work one or more threads are drawn out one way of the material. The remaining threads form a framework for a darned pattern or for whipping into bars. The bars may be darned together in various ways, leaving round, rectangular, or diamond-shaped holes. Because the vertical ground threads are covered, this work is much stronger than ordinary hemstitching and can be used on things that receive hard wear. The embroidery thread may be in color but on the older examples white is most common.

Double drawn work requires the removal of threads in both directions, with certain key threads left in to form the framework for the

126. Apron border in double and single drawn work and pulled-work. BERGENS MUSEUM

design. These threads are whipped to make the network easier to work with. The open spaces are then filled in with pattern darning or with point d'esprit.

Double drawn work was the most important feature of Selbu textile art and was used in Telemark, Nordmøre, Sogn, and various other districts as well as on the continent. The patterns used were very old and very widespread. The same geometrical forms used in single drawn work, such motifs as the tipped square, the cross or X, the

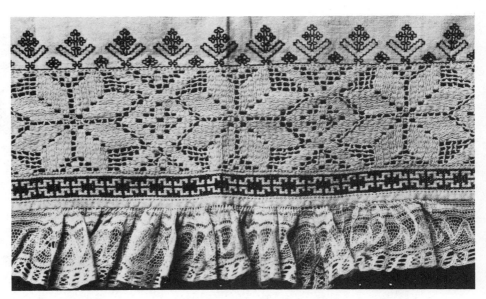

127. Border of double drawn work from Sogn, edged with Holbein and cross-stitch in black. BERGENS MUSEUM

swastika, and combinations of these, were used in double drawn work as well. Human figures and animals comprise another group. Two facing birds are found again and again in drawn work as well as in other techniques. Probably the most numerous of all drawn work patterns is the eight-petal rose or star. It is used almost without exception in Sogn drawn work, usually in combination with the X motif.

All of these figures were used in all textile techniques throughout Europe and most of the rest of the world as well. There was a closer relationship in the textile art of the many lands than in any other craft. In Europe the spread of these motifs was due to a general distribution of Renaissance pattern books and to imported textiles. In many cases the designs were copied exactly, in some there were minor changes.

Italian reticella work was one of the techniques that spread with the distribution of textiles. This is a type of geometrical cutwork, really double drawn work with a more elaborate outline. Threads are drawn out in both directions within a small square or a cross or large

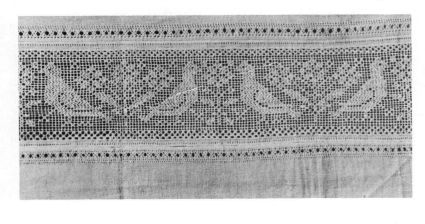

128. Border of double drawn work from Nordmøre, with popular bird and flower motif. KUNST-INDUSTRIMUSEET I OSLO

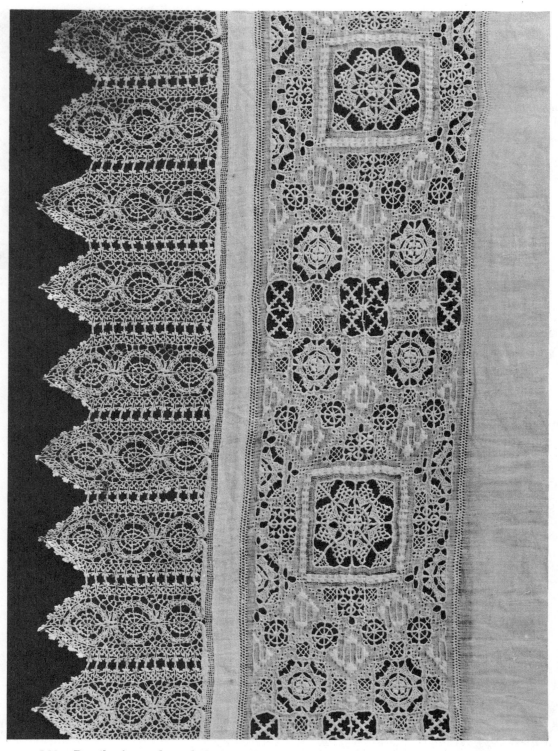

129. Detail of an altar cloth from Hove church in Sogn. Reticella embroidery, from the 1600's. KUNSTINDUSTRIMUSEET I OSLO

stepped square. A network of threads is left to form the framework for the intricate patterns of spokes, wheels, flowers, and picots formed by the interweaving of the design thread. The solid areas between are filled with satin stitch designs, eyelets, and diagonal lines of pulled work. Reticella imitations were made all over Europe, including Norway, where it was soon modified into the famous Hardanger work. This embroidery was done throughout the country. It is closely related to the whitework of Holland and it is likely that it developed under Dutch influence during the 1700's.

Hardanger work is found mainly as wide borders on aprons, guest towels, kerchiefs, blouses, and the like. The open areas may be large square, star, or triangle shapes, with stepped edges. The effect is

130. Hardanger work from Sandven, Fana, Nordhordland. BERGENS MUSEUM

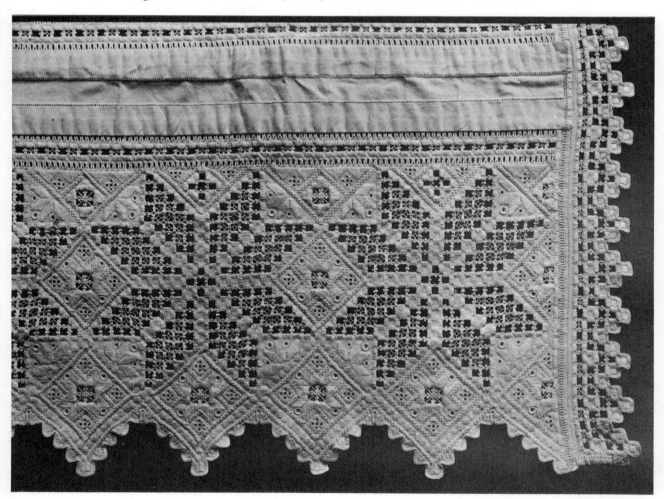

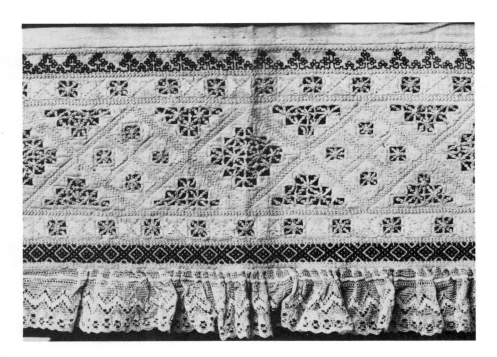

131. Cutwork border from Sogn. BERGENS MUSEUM

strongly diagonal. A network of threads within these areas is darned into bars, usually with picots, and the edges of the design are buttonholed. The square holes thus formed may be filled with various lace stitches, all more geometrical than in reticella work. Diagonal rows of pulled-work frame the cut areas. The ground between is filled with geometrical satin stitch designs, often the eight-petal rose. Along the outer edges of the embroidered area there is usually a narrow single drawn work border.

Rindalen, in the district of Møre, did a kind of cutwork that was very similar to the Hardanger work but not very well known. This work is somewhat finer and closer to Italian reticella and utilizes open crosses and small isolated squares instead of the large tipped squares of Hardanger embroidery. It may have a ground-filling pattern of buttonholed or latticework designs. The latter type is common in both baroque and rococo work, white or colored. In time the holes become smaller, the solid work covers a larger area and acquires flower stems, first stiff and later more and more curving until it becomes a full-fledged naturalistic vine. This development took place in other parts of Nordmøre and in other districts, but it was not

132. Naturalistic whitework from Nordmøre. NORSK FOLKEMUSEUM

universal. Sunndal, one of the most remote parts of Møre, retained its geometric motifs throughout the whole period.

The Sunndal work, called "Nordmøre embroidery" even though it excludes work done in other parts of Nordmøre, is a completely geometric embroidery. Its main techniques are cloister block (blocks of satin stitch), eyelet, and an assortment of ground fillings including pulled-work (small holes pulled in the material by drawing embroidery threads tightly). The design elements are much the same as those used in drawn work and the two techniques may be found on the same piece. The richest period for Nordmøre embroidery was between 1820 and 1845. Earlier than that, drawn work was the predominant type, later the embroidery became coarser, the patterns larger. Coarser cotton materials and cotton thread, both city-made, were responsible at least partly for the degeneration of all types of embroidery after the middle of the nineteenth century.

Two of the less common types of Norwegian needlework were beadwork and appliqué. Beadwork was used in Hardanger and Sunn-

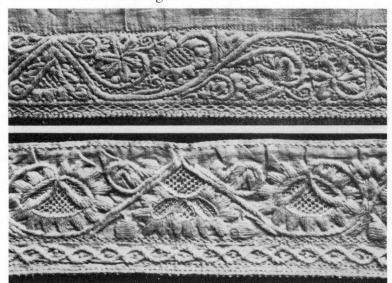

133. Naturalistic whitework from Nordmøre. NORDENFJELDSKE KUNSTINDUSTRIMUSEUM

hordland for the colorful plastron used in the bodice opening, and sometimes for the belt. It replaced geometric colored embroidery, from which the old familiar designs were taken to be used in the new medium. The belts might be done on a beading loom but on the breast-

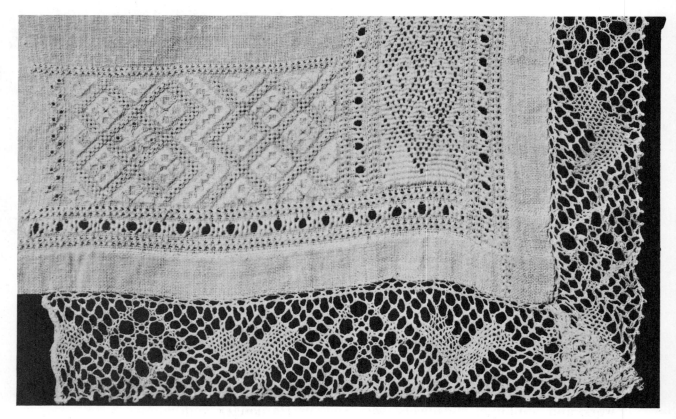

134. Head cloth from Nordmøre. Bar and pattern-darned single drawn work, pulled-work, satin stitch, eyelet. BERGENS MUSEUM

piece the beads were sewed. The colors were the usual blue, red, yellow, white, black, and green.

Appliqué as a type of decorative sewing was especially character-istic of Sogn. Intricately scrolled and pierced designs were cut from material of a contrasting color and applied to skirt borders, aprons, and children's caps. The "leaves," a rather farfetched term in view

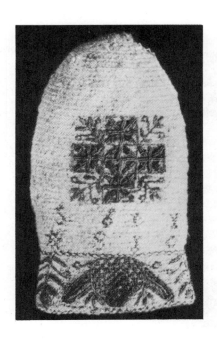

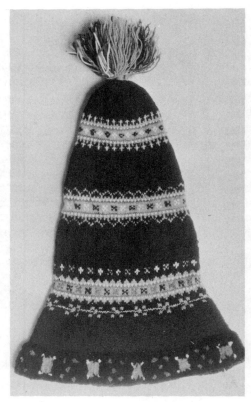

135. Mitten with colored reticella motifs from
Rindal, Nordmøre, 1795. NORDENFJELDSKE KUNST-
INDUSTRIMUSEUM. Right: Knit stocking cap from
Valle, Setesdal. NORSK FOLKEMUSEUM

of their quite imaginative character, were applied with a contrasting
yarn or strip laid down around the edge and couched or whipped to
the material. Red, green, or blue were the usual colors, with red the
most frequent. Red backgrounds required blue or green designs,
and on green the design was always red. A black ground might have
any color appliquéd to it.

Some of the designs might be said to be heart-shaped, but any
semblance of naturalism in the "leaf" patterns is not to be found.
Sometimes the designs were cut out freehand, sometimes with a card-
board pattern. They were always symmetrical. This type of appliqué
has a definite Moorish character. It was brought to Spain from the
Orient during the Middle Ages and from there spread over Europe
during the Renaissance and baroque periods. Its popularity in Nor-
way dates from the 1700's although there are a few examples of Nor-
wegian appliqué in baroque naturalism from the previous century.

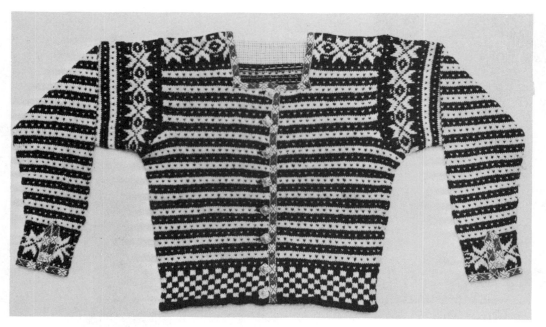

136. Sweater from Fana, Nordhordland. BERGENS MUSEUM

Although Norwegian knitting is very old, the beautiful and popular Norwegian ski sweaters are a comparatively recent development. Mittens and stocking feet decorated with colored embroidery had been knitted for centuries, and strainer cloths were knitted of cattle hair. But that was all. Around 1830 the old handwoven hose with knitted feet were replaced by all-knitted stockings. About the same time pattern-knit sweaters, styled like the jackets and vests they replaced, and knit caps came on the scene.

When knit stockings first became popular they were always of a single color, usually black or white. This is still true in some areas. Ancient patterns were used. Double and triple cable designs, striped effects and squared patterns, all executed in a single color, appeared in the mittens and socks of Setesdal. In the same district a man's sweater was knitted in a fine allover design in contrasting colors, the dark color predominant. Decorative geometrical bands bordered the neck opening and top of the sleeve.

Fana, on the west coast south of Bergen, and Selbu, up in Trøndelag, have two well-known groups of two-color knitting. The Fana

trøye, a jacket-type sweater, has a broad band of geometrical eight-petal roses across the top of the sweater, sleeves included. The rest of the sweater has alternate rows of spaced dots and small geometric designs.

Selbu is particularly noted for its mittens. The palms have small allover designs made up of squares, triangles, or just single stitches. On the back there may be a reindeer, an eight-petal rose pattern, or even tiny human figures. Sometimes a c-wave encircles the mitten at wrist level. The long cuffs often have both color contrast and lace stitch designs.

Color-knit stockings from most districts have a rather solid pattern for the leg part, with the omnipresent eight-petal rose dominant. The tops may be plain or striped or they may be quite unique, with a

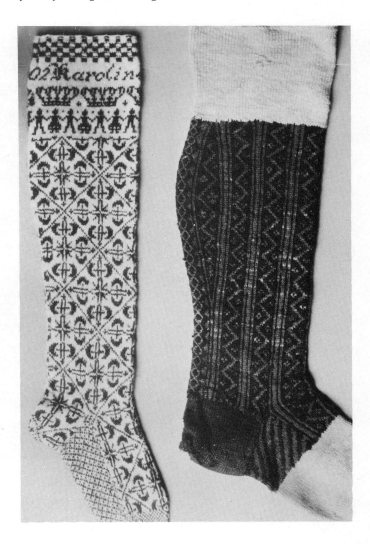

137. Knit stockings from Selbu. NORSK FOLKEMUSEUM

checkerboard border, a row of human figures, perhaps a name and date, or just a nicely planned vine motif with curling leaves. Hallingdal knitting uses the rose motif almost exclusively. The rose may be halved, and used as a repeat border. Black and white are used for both stockings and mittens.

This chapter does not present every type of decorative needlework ever practiced in Norway nor does it pretend to treat each subject exhaustively. It is intended to acquaint the outsider with the scope of Norwegian needlework and to increase the reader's enjoyment and appreciation of Norwegian embroidery. Since applied decoration was so essential a part of Norwegian costume, this material is also necessary to an understanding of the following chapter.

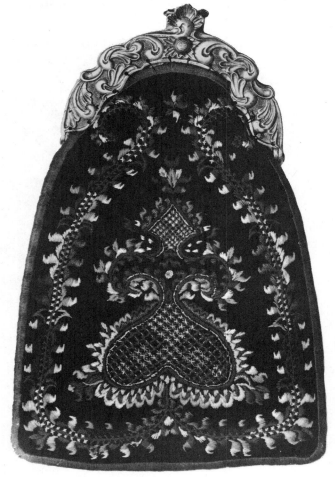

S45. Embroidered purse with brass frame, from about 1880. From Norddal in Sunnmøre. NORSK FOLKEMUSEUM

Costumes

8

LIKE NORWEGIAN folk art, Norwegian costumes show definite differences from district to district. By cut, color, or decoration a given costume indicates its home district and often even a specific locality within that district. Unlike folk art, Norwegian fashions managed to keep up with European trends. This was due no doubt to the fact that clothes are more easily replaced than houses or furniture. And to the universal desire for conformity.

But Norwegian rural society was not enslaved by fashion. It reworked European styles to fit Norwegian country life and rejected entirely such ridiculous fads as wigs and bustles. There were of course some incongruities. French court dress was never meant for Gudbrandsdal valleys, rich though they were. But that is what wealthy Gudbrandsdal farmers wore for several decades. Costumes which gave little or no protection against the cold winds were certainly impractical. But they were worn in Setesdal by both men and

women. Men's hats were often as comical as women's headdresses were bizarre. In spite of such peculiarities the majority of *bonde* styles were sensible and beautiful and a true reflection of Norwegian spirit.

The medieval costume, much the same for both men and women, was predominantly white or grey wool. It consisted of two parts, one a long, smocklike slipover blouse with long sleeves, the other, long pants reaching to the ankle. These pants were intended to be worn with shoes and leg socks. Another type combined pants and stockings in one garment. The blouse, or kirtle, was usually belted and from the belt hung keys, knife, and purse. There were no pockets. A colored edging at the neck opening identified the wearer's district.

As in much of the rest of medieval Europe, a hood with attached short cape provided protection for the head and shoulders in bad weather. This is shown in one very old picture in a dark green color. Outer stockings of cloth reached to the knee or higher and were worn with soft, heelless shoes in cold weather. The stockings were sometimes made of leather, in which case shoes were unnecessary. As was mentioned in the last chapter, knit stockings were not common in Norway until the nineteenth century. They were first introduced as knitted feet for the "leg socks" sewed from woolen cloth. This was a definite improvement upon the rag foot wrappings or the hay-lined shoes which had been used previously.

Underclothes were no problem in the Middle Ages—there were none. The coarse white kirtle was later covered with a jacket and then became a kind of chemise for the women or an undershirt for the men. When more revealing clothes came into vogue the undershirt was prettied up with embroidery on the sleeves and front and became a blouse or shirt. With the introduction of finer and more expensive linen the shirt was made very short for reasons of economy and entirely lost any connection with underclothing.

Doubtless there were definite local costume variations in medieval

times just as there were later, but little information is available. Medieval dress continued with some changes in the Bergen area and in Setesdal until the 1700's. Even as late as the early 1800's medieval dress could be seen on some of the elderly men around Bergen. Elsewhere the Renaissance had taken over.

The most startling change brought on by the Renaissance was the use of extremely full pleated knee breeches. With them a jacket was worn which opened all the way down the front and was held together at the waist with hooks or clasps. A cap sewed of triangular pieces of cloth and shoes with heels completed the outfit. Spain had set the pace in color as well as style and when Philip II decreed black clothes for Spain, Norway along with most of the rest of Europe followed suit. There was some opposition to the use of black, particularly in Setesdal. Most areas managed to relieve the somber dress with a red or blue under jacket, a white outer jacket, or some sort of colored trimming.

During the eighteenth century eastern Norway experienced another change of style, inspired this time by Louis XIV. Long tail coats with ridiculously large pocket flaps, tight knee breeches, and for the first time a vest, brightly colored, made up this most alien costume. It was very popular in Gudbrandsdal and spread through Romsdal, Østerdal, and the Trondheim area, but missed the fjord and mountain districts.

Toward the end of the eighteenth century a new style appeared among the high mountains and fjordlands of southern and western Norway. It was a picturesque attire, highly praised by contemporary travelers, the one most worthy of being called a "national" style. Black, close-fitting breeches, buckled at the knee, replaced the old pleated type. A white or red jacket, with two large flares in the back peplum and an assortment of underjackets and vests, all varying in color and decoration, made the festive costume a really splendid affair. Silver and pewter buttons and colored buttonholes began

to replace the old clasps and buckles, even being put where no fastening was needed, and in such a manner that they could not possibly be used. Often the buttonholes were not even cut.

Only the inner vest was buttoned. The second and third vests and the jackets were left open. This was of course for a purpose. It showed at a glance how one rated financially, for clothes were the main form of display. Colorful braids and embroidery were used as borders and seam finishes and to decorate large areas on the breeches and jackets. Collars and lapels began to appear, frequently in contrasting colors and with embroidered designs. Stockings were either white or black and were embroidered at the ankle or knit in patterns.

Toward the mid-1800's several styles distinct from those of the west coast began to develop in the mountain and fjord districts of south-central Norway. In Telemark the hip-length jacket was replaced by a very short one with the high-standing collar of the Empire period. Several districts began to use long pants which narrowed at the bottom, requiring a placket opening and buttons at the lower edges. But it was for conservative Setesdal to do the extreme. In this resistant district, where the full pleated medieval breeches were worn as late as 1830, the new long pants reached from ankle to shoulder, being held up by short leather suspenders with metal clasps. The pants, cut low on the sides, had a bib piece in front made of green wool broadcloth decorated with embroidery and filigree buttons. The seat of the pants was reinforced by a huge leather patch, apparently for decorative reasons. The jacket was shortened to the briefest of boleros, so short that the white, full-sleeved shirt showed between jacket and pants. A broadbrimmed black hat was used with this costume, and the complete outfit was worn by Setesdal males from the time they could walk.

Hallingdal and Numedal had outfits similar to Setesdal's but in dark colors. Color contrasts in the Setesdal costume gave it a pic-

turesqueness that the Hallingdal and Numedal wear lacked. Long knitted jackets patterned in blue and white and with the same lapels and embroidery as the cloth ones began to find favor in Setesdal in the 1860's.

Men of Øygarden, on the island of Sotra west of Bergen, developed a costume to suit their needs as fishermen rather than to follow mainland fashions. Until about 1845 a medieval jerkin was worn, but it was then opened down the front to become a vest. Over this there was a straight, black, hip-length jacket with a double row of buttons, colored buttonholes, and a green lining. The black trousers were calf-length, quite narrow at the bottom and full at the top. They were worn without belt or suspenders and were held up by tucking in over a large pad which encircled the wearer at the lower edge of the vest. White pants of this same type are still being worn as underpants by some of the old men of the district.

Sooner or later the younger men in all districts began to wear short jackets and long pants, though not in such extreme design as those of Setesdal. The bib was eliminated from the trousers but there was still a flap on the front closing which buttoned up the sides and across the top with large silver buttons. Collars became flatter, shirts longer, colors darker. By the end of the century city styles were in command all over.

A revival of interest and pride in local traditions in the twentieth century stimulated a desire for some kind of folk costume among the people of Norway. More or less authentic copies of old costumes were made for festival wear. Even city dwellers adopted some sort of country dress. The majority of the men chose the Telemark costume of the early 1800's, the long white jacket and black breeches, both beautifully embroidered, that had been used in one form or another throughout the land. Women adopted the Hardanger costume.

The medieval woman's dress differed from the man's kirtle only

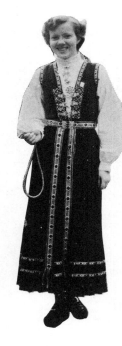

in length and color. Her dress reached well below the knees and might be black, red, or natural-colored wool. The same colored edging at the neck opening and same belt from which to hang her keys increased the similarity between the two costumes. Renaissance styles had a similar effect on each, breaking the costumes up into several pieces. The kirtle became a combination blouse and chemise. The skirt and a new item, the bodice, met at the waistline and were belted at the waistline instead of low on the hips as previously. Aprons, in dark colors and worn only for festive occasions, were another new feature of the Renaissance.

The bodice was sleeveless and low-necked, with a colorful breastpiece or plastron to fill in the neck opening. Skirts were dark, usually blue or black, except for the bridal skirt which was red and finely pleated. In wintertime a black jacket was added for warmth. This costume belongs to the seventeenth century and is the basis for all later costumes. Several districts in the Bergen area wear essentially the same dress today, with small variations in color or cut to distinguish them.

Most famous of these Renaissance-inspired costumes is the Hardanger. It was sentimentalized in song and painting during the late 1800's, and its overpopularization brought on such abuses in the choice of materials and ornamentation that it completely lost favor. It came to be a sort of masquerade costume, worldly and degenerate.

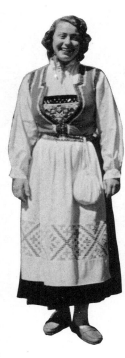

The true Hardanger costume is both dramatic and dignified. Formerly the long, tightly gathered skirt was of blue wool, combined with a red bodice bordered in green or brown. Now a black skirt is worn instead, and the bodice may be red, green, or brown, with contrasting borders. A brightly beaded plastron in geometrical design and a beaded belt have replaced the old yarn decorations. In both old and new styles the bodice is framed and accented by the snow-white blouse and the white apron with a border of typical white Hardanger work. One or two brooches worn at the throat complete the dress.

Two styles of headdress have been worn with this costume. Both are pure white. One is a finely pleated kerchief, arranged like a bonnet, which frames the face halo fashion. The kerchief's point billows out stiffly in back. The other type is wing-shaped. The foundation is covered by a large white kerchief, unpleated, which falls down softly in back. The *skaut* or headdress is worn only by

138. Top left opposite: Sunnfjord costume. Bottom left: Hardanger costume. EINAR HAUGEN. Right: Os costume, Hardanger type. HISTORISK MUSEUM

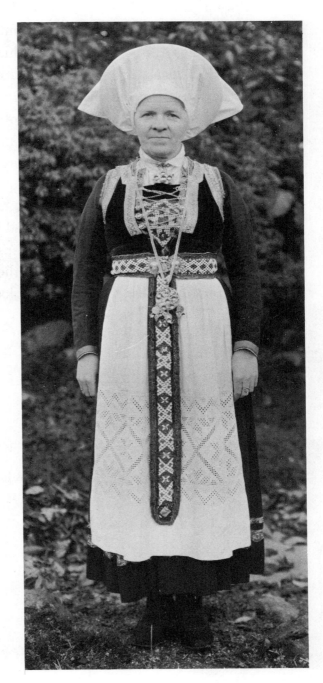

women. Young girls wear a colorful band around the hair, fastened in back with a silver clasp, or sometimes a small cap tied on with ribbons.

Voss, north of the Hardangerfjord, and Fana, near Bergen, have essentially the same costume as Hardanger. The bodice is usually red. In Fana it is edged with an azure blue silk border and sometimes a row of white beads. The headdress rises high and round in front and projects into a sharp point at each side. It is covered with a white cloth. The Voss bodice, which is very narrow across the back shoulder, has a green velvet border edged with white beads or silver thread. Intricate geometric designs are beaded or embroidered on the plastron. At the lower edge of the skirt there is a wide green velvet band with silver lace along the top. The Voss *skaut,* a three-cornered kerchief beautifully embroidered in white or in the characteristic Voss blackwork, is tied over a leather piece which holds it out stiffly in back. Girls wear a red ribbon wrapped around their heads. Their long braids are looped around the head and fastened to the ribbon in back with silver clasps.

A Sunday visitor to some of the little west coast islands near Bergen would see nothing in the local costumes to indicate a rela-

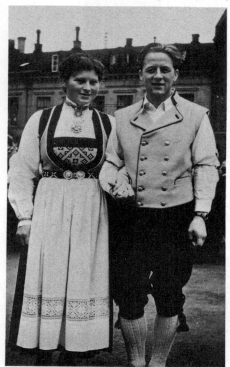

139. Couple in Voss costumes. EINAR HAUGEN

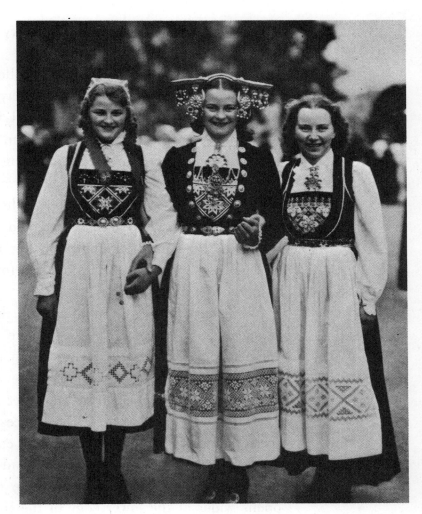

140. Voss costumes. FOT. NOR-
MANN

tionship with the gay dress of Hardanger or Sogn. The dark Refor-
mation-type jacket and skirt, dark apron, white kerchief around the
neck, and white headdress of Lønøy and Øygarden might suggest
Puritan dress or nun's clothing but not Norwegian folk costumes.
But under the dark jacket there is a bright bodice, probably red or
green with a small beaded or embroidered plastron, silver bodice
lacings and silver belt, four silver brooches, and a white blouse. And
under the dark, finely pleated skirt there may be several more skirts,
for to look prosperous one must look plump!

Although the headdress looks very simple, it requires four sepa-
rate pieces. First a twisted linen roll is fastened around the head. A

kerchief, folded to a triangle and rolled to frame the face, comes next. Then the black cap for everyday wear, and finally the white Sunday kerchief. The Øygarden girl was accustomed to a heavy headdress from the time she was born. As a baby she wore, all at the same time, a gathered cap, a kerchief, a rectangle of linen which hung down over her neck, and finally a dark cap with wool embroidery. At six years she graduated to the same type of headdress her mother wore and she was expected to wear it night and day until she died. If someone came upon her while her headdress was off she quickly covered her hair with a towel or anything at hand, to preserve her modesty.

While a woman was in mourning, her white neck kerchief was replaced by a large white sheet. She was nearly enveloped in it. This custom has been used in several parts of western Norway, where white was the color of mourning for several centuries. In later times a small white scarf replaced the sheet in most areas.

Sogn dress has the same basic pieces as the other west coast districts but with a definite difference in cut. The skirt may be shorter than floor length and often has a band of colored appliqué around the lower edge. The bodice is quite narrow in back and usually opens wider at the lower edge of the front opening than at the top. It is somewhat shorter than waist length and the belt may be worn above the natural waistline.

In some areas of Sogn a beaded or embroidered plastron is worn. Doubtless this was true all over the district at one time. Now, however, the bodice is most often laced together with chains strung through rings at each side of the bodice. Or the bodice may be worn with no lacing or crosspiece of any kind. The bodice edges are always faced to the outside with a contrasting color, usually black velvet but sometimes colored wool material which is couched along the edge with a contrasting thread. Black, green, red, or blue may be used for the bodice, or it may be of silk brocade. The long-sleeved jacket worn in cold weather is worn under the bodice.

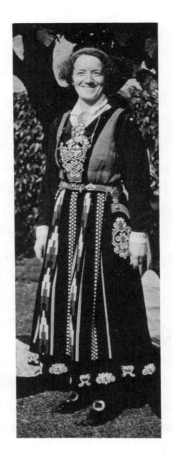

141. Sogn costume; black skirt with red and white embroidery. EINAR HAUGEN

Sogn skirts are usually black. Dark striped or plaid skirts are also used. Aprons, worn for dress occasions, are usually a dark color. They may contrast with the skirt or they may have contrasting stripes. Various types of embroidery may be used on the white blouse but whitework or blackwork are most favored.

Silver brooches and chains are a necessary part of the costume. In some cases two chains are worn, one to lace the bodice, the other to hang a large pendant or silver perfume container around the neck. Chains are also worn at the blouse opening. Long chains are used to lace the winter Sunday shoes.

There are two main kinds of belts. One is a leather strap set with a series of rectangular silver plates, closely spaced. Small rings or dangles hang from the lower edge of each plate. The belt is fastened with a silver clasp. Married women wear a silver-ornamented red streamer hanging from the silver belt.

The other type of belt has a canvas base. It is studded with nail-heads, usually brass but sometimes silver or tin, and fastened with a "belt brooch." There have been some gilded belts and in outer Sogn beaded belts were sometimes used. A large embroidered purse hung from the belt by a brass hook.

Bridal finery required still more silver but it was not necessary for the bride to own it herself. She could rent a bridal crown from the church, or she could get it from someone in the district who made a business of renting out all the silver jewelry a bride would need. Much of the silver had to be given up in the silver levy of 1808 and 1809 when famine and a war with Sweden laid heavy demands upon the country's money.

Sogn girls wore a *bara,* a five-inch-wide strip of cloth bound around the head, and in winter a grey wool cap. The women of the district have had two types of cap. The black one is a small brim-less bonnet somewhat like the one worn in Gudbrandsdal and is tied under the chin. It is decorated with silk ribbons and beading. The white cap puffs out at each side and is bound with a silk scarf. A white ruching of drawn work and crocheting frames the face. Silk neck scarves were also used.

Located at the northern boundary of Sogn is the Nordfjord area. The women of the valley have worn as their costume a black skirt, black jacket with flower-embroidered velvet edging the neckline, and black apron with either white or black flower embroidery. The white neckpiece is fastened with silver buttons. This district has also used a long-sleeved bodice instead of the jacket. If the bodice was of blue material, the sleeves were of green, and vice versa. The sleeves were made like blouse sleeves with dropped shoulder line and fullness. For high occasions a silk kerchief was worn over the shoulders and tucked into the neckline in front.

The Nordfjord headdress required a headband to which a small hat or bonnet could be pinned so that it sat on the back of the head,

and a black silk kerchief with colored border which was fastened over the cap in such a way that it looked like a capsized boat. Arranging the headdress was an art and required the aid of "specialists." On Sunday the headdress was carried in its own box to the church-yard where the specialists were on hand to practice their art.

Sunnmøre, north of Sogn, has a rather dark costume, with a somewhat different cut from that of the other west coast districts. There is no plastron and the bodice neckline is much higher, though still low enough to show the finely embroidered neckline of the white blouse. The shoulder extensions of the blouse, which come well down the upper arm, are likewise embroidered, as are the cuffs. Both free and geometrical embroideries are used, always in white. The bodice, apron, and skirt are made of black wool. Multicolored motifs are embroidered on the bodice and apron, and on the large purse with brass closing which hangs from the belt. The headdress may be a tiny black velvet bonnet, tied under the chin, or it may be a white scarf, unfolded, which is bound around the head and hangs down over the shoulders in back.

Between Nordmøre and Sunnmøre lies the valley of Romsdal. The Romsdal costume as worn today includes a red bodice with a special kind of bold *rosesaum*, a dark skirt with an embroidered border on a smaller scale than that on the bodice, and a red purse. Apron and blouse are white. The cap is dark with a brim that hangs

142. Sunnmøre costume. EINAR HAUGEN

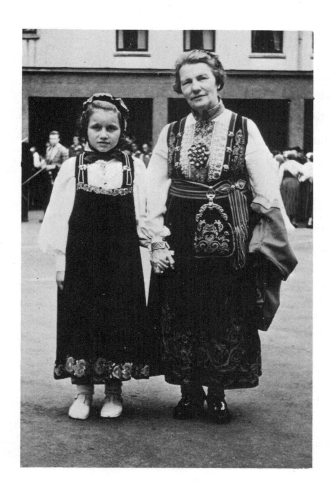

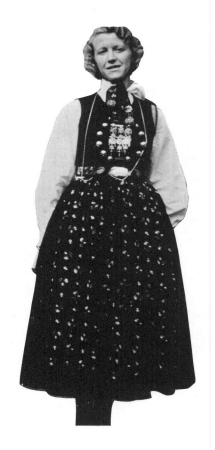

143. Above: Child, at left, in Halling-
dal costume; woman in Telemark dress
minus the jacket (see Figure 150). Right:
Numedal costume.

EINAR HAUGEN

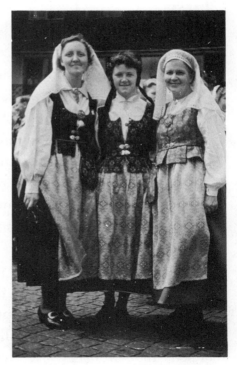

144. Trøndelag costumes. EINAR HAUGEN

down over the ears somewhat like certain Dutch caps. Hedmark has a similar cap.

In past years the most common Røros costume has been a long-sleeved dress in dark colors for older women, and with light trimming for girls. The skirt is finely pleated at the waist and may have a colored facing at the hem. The upper part of the sleeve is full, the lower tucked to fit closely. A tiny silk cap tied under the chin with wide ribbons indicates the wearer's status at a glance. If she is a young girl her everyday cap is brown with a red or pink band. For special occasions she wears one beautifully embroidered in colors. If she is an "old girl," a spinster, her cap is black with small stars of white glass beads. A married woman wears an all-black cap with black ribbons.

The focal point of this costume is a beautiful silk shawl in various colors. It is sometimes bordered with a wide fringe. A well-to-do woman might have several of these fine shawls, some of which she had inherited. All would be passed on to her own daughters and valued at least as highly as jewelry.

The Røros costume now has competition from another Trøndelag style which is more closely related to the east Norwegian costumes and is apparently a recent revival of a once-popular design. It has a brocade bodice with a peplum, held together with clasps at the waist, a contrasting brocade apron, and a dark skirt. A white blouse and a white drawn work head cloth complete the costume.

Sunday dress in eastern Norway avoids extremes of styling in favor of a simple, rather low-cut bodice and a white blouse with a small round or pointed collar. There is no plastron and apparently there has never been one in this region. The small, triangular, metallic-lace-covered ornament that was pinned to the bride's bodice may be a remnant of a brief period of Renaissance-type plastrons, but that period is beyond recall. Lacings, on the other hand, were retained, though usually as concealed string lacings which were threaded through sewn eyelets on the inside of the bodice opening.

Bright borders around the arm and neck openings of the bodice have likewise disappeared. Now the bodice is covered with a large naturalistic color embroidery, or it is made of a figured or plaid material. In Gudbrandsdal the bodice opening is fastened only part way up at the center front, exposing a V-shaped section of the white blouse below the curve of the bodice and giving the neckline a distinctive appearance. Valdres and Østerdal costumes require brooches to fasten the bodice at the top, leaving an open slash effect between neck and waist. All the districts use brooches at the blouse opening. Tatting and fringes are frequently used on the blouses and kerchiefs of Gudbrandsdal. The aprons of this district are dark with vertical stripes or flower motifs.

Rather dark colors are favored for Gudbrandsdal plaids. One skirt combines red, green, and brown. Such materials are for more ordinary use. A really dress-up dress may have a blue-green skirt with a black border and black bodice, both the border and bodice

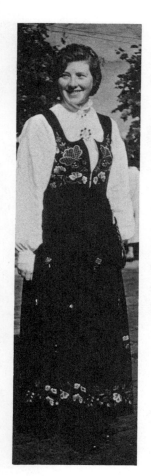

145. Gudbrandsdal (Vaagaa) costume. EINAR HAUGEN

embroidered in gay colors, a fine white blouse, and a small gold brocade cap.

Here, as in most other districts, a purse or "loose pocket" hanging from the belt was an essential part of festival dress. Among other things it held a short-handled silver spoon, for it was the custom to carry one's own eating equipment to celebrations. The back of the purse was leather. The front might be of wool, silk, or velvet, in blue, red, or black and with rococo flower motifs in wool yarn and sometimes metallic thread. Its curved clasp was of brass and was engraved or cast in an acanthus design.

Variations of the Gudbrandsdal costume have recently become very popular in Norway, displacing to some extent the Hardanger costume as a so-called "national" costume. It is made up in various colors, even in pastels and white, and in these versions loses its "folk" quality.

Plaids are used in Hedmark and the Østerdal districts as well as in Gudbrandsdal. Blue seems to be a favorite color. The dress most commonly used now in Hedmark is a lightweight blue skirt and bodice with red, yellow, and green *rosesaum*. The skirt embroidery is executed in vertical rows, three motifs in each row. The rows are about ten inches apart. On the bodice, embroidery accents the waistline tucks and a red border edges the split peplum. The neckline is somewhat cut out to show the white blouse. The bonnet is also blue and embroidered and is similar to the Romsdal type. Women of eastern Norway have not subscribed to oddly shaped headdresses. Their preference has been a close-fitting cap, fashioned in one of various ways, and tied under the chin. For church a kerchief was tied over the cap.

Hedmark once had a blue jacket dress with a little greenish yellow silk cap and a yellow neckerchief. Such jacket dresses were popular over much of the country in the 1800's. The skirt was the usual

146. Valdres costume. EINAR HAUGEN

type, tucked or pleated to a waistband, but instead of a bodice there was a close-fitting jacket with narrow sleeves and a short pleated peplum. Festival clothes required a fine silver belt and brooch. For everyday dress the belt might be of leather. Colorful woven belts were also used.

From the meager information given in inheritance lists it seems that one of the last local costumes worn in Romerike was a bodice and skirt combination similar to the other east Norwegian costumes. The main distinction was a slightly flared peplum on the bodice. The skirt was striped vertically and the bodice was plainly cut and undecorated. Because Romerike was so near Oslo it was too much in fashion's current to maintain a really local form of dress. For this reason a description of the Romerike costume must remain sketchy and inadequate.

A very different type of costume is the so-called "long skirt" or "Empire skirt" of Telemark, Hallingdal, and Setesdal. It has a very high waist, a vestigial bodice, and suspender-like shoulder straps. In Telemark and Hallingdal the dress is long, in Setesdal it reaches only to the knee. A direct relationship between the men's and women's costumes in these districts will be seen immediately. It is the women who have the credit for originating the idea. A thoroughgoing description of the Setesdal women's costume was written down in the late eighteenth century. The first high-waisted costumes for men did not appear until about 1830. Thus the women had at least a forty-year head start. This same written account disproves the name "Empire skirt" for although there is a similarity in cut, the First Empire, which fostered the high-waisted skirts in France, did not begin until 1804.

The Setesdal costume, which is the most distinctive of this group, consists of one to three skirts, knee-length or shorter, and a full-sleeved white blouse with a round collar. The first skirt is of white wool, gathered onto a narrow breastband and held up by short straps.

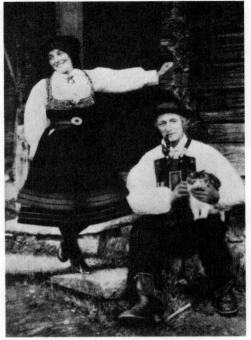

147. Setesdal costumes. MITCO

It has three black bands around the lower edge. This skirt is the work skirt and when worn alone is held in by a black leather belt around the waist. The second skirt is black, cut the same as the first one, but shorter, and with green or red and silver bands at the bottom. There may be decorative embroidery or bands on the breast-band and straps and on the skirt border. Originally there was a plastron but that has now disappeared. Only brides wear the third skirt, a red one. It is the shortest of the three and has a silver border at the hem. A silk apron is worn over it. All three skirts are stiffened at the hem, and are creased inward at the center front and center back so that they give the effect of culottes.

As in most districts an abundance of silver trinkets—chains, belts, brooches, and the like—are worn with the Setesdal bridal dress. The bridal crown is an essential part of the costume. In one area it is a large round turban-like affair, covered with a silk cloth to which have been sewed dozens upon dozens of concave silver disks which glitter and tinkle with every move. Black stockings and low black shoes are part of every costume. Since the skirts are so short

the garters worn at the knee are made for decoration as well as utility. They are woven or embroidered in bright colors and have pert tassels.

An important part of the Setesdal dress is the belt, which is worn approximately at the natural waistline. With the white skirt the belt is a wide black leather one. The bright, geometrically embroidered belt which is worn over the black skirt may have a silver clasp and should match the embroidery on the suspenders and on the short, black, long-sleeved jacket worn in winter. The bride wears a silver belt with silver-ornamented streamers. For dress-up a red and white pattern-striped shawl is worn over the left shoulder, under the right arm, and held together in front with one hand. The head kerchief for both girls and women is black. Silver brooches worn on the blouse and silver chains lacing the jacket together across the breast, silver buttons and silver necklaces help to make the Setesdal woman one of the most besilvered women of Norway.

Like Setesdal, Telemark and Hallingdal have had a very high-waisted skirt, gathered to a minute bodice. But in these districts the formula is not nearly as set as it is in Setesdal. Telemark costumes have also included the normal length bodice and skirt similar to those of western Norway and, even where the "long skirt" is concerned, there has been great variation from area to area in both districts.

For state occasions, the Hallingdal skirt is worn unbelted. This means that it falls shapelessly to the floor from a band of varying

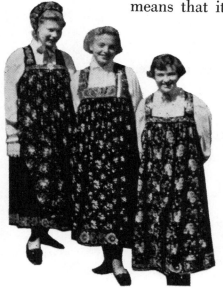

148. Hallingdal (Gol) costumes. EINAR HAUGEN

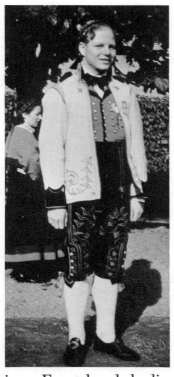

149. Hallingdal bridegroom's costume. EINAR HAUGEN

size and location. Front band, bodice back, and shoulder straps are most often embroidered in a colorful Hallingdal *rosesaum* (see Chapter Seven). The skirt is usually a dark blue, with a *rosesaum* or pattern-darned border. Some Hallingdal costumes include an apron, either in a flower-printed *mousseline* or in plain wool with a *rosesaum* border. On weekdays a black leather belt pulls in the skirt fullness at the waist. A dark plaid jacket is also part of the work dress. Beautiful white embroidery decorates the white blouse, which is similar in cut to those of other districts. There is also the universally popular brooch, sometimes two of them. Headdresses differ from one locality to another but one of the most popular is the one worn in Gol. It has a round crownpiece, straight at the back edge, and a band which is seamed to the crown somewhat in the manner of a beret. The whole thing is covered in the bright Gol *rosesaum*.

In most parts of Telemark where the very full "long skirt" was used, a wide and colorful woven belt was worn at the waist. Very short red or blue long-sleeved jackets were part of this outfit. The

skirts were long but not always foot-length and with the shorter ones women wore beautifully embroidered stockings. Black or dark blue skirts were most common, with a black or dark green or, in one area, a red bodice.

In Heddal, the eastern section of Telemark, the bodice is full-size, beautifully embroidered, and edged with contrasting bands. There is no plastron—the embroidered blouse and huge brooches take its place. But there may be lacings or sometimes only the silver *maler* or lacing rings. Multicolored geometric embroidery in varying techniques is used on the standing collar, the front, and the cuffs of the blouse. A two-part clasp fastens the striped card-woven belt whose ends hang down like a sash. The short jacket is red, richly embroidered, and with a rather low, straight neckline. It opens at one side and is fastened with a two-part clasp.

Headdresses worn in Telemark are usually some form of the silk kerchief, tied and draped in various ways. Formerly this district claimed a distinctive kind of head covering that utilized a large flat base like a plate which was fastened to the back of the head and covered with a silk cloth. Young Telemark girls wear a simple head-band.

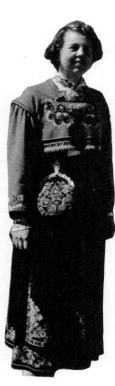

Aust-Agder and Vest-Agder are the southernmost districts of Norway and by virtue of their location were one of the most thriving trade areas of the country. Continental styles coming by way of the North Sea countries gained entrance to Norway through its large ports, and from there passed along the fjordways and mountain paths to the most distant parts. The laced bodice of Italy and the finely pleated bell-shaped skirt of Spain were combined in North Germany and Denmark and passed on to Norway in the late 1600's. Sørland (southern Norway) took up this new Renaissance style and, with few changes, kept it until about 1870. From Holland came floral baroque which was taken over by Sørland for crewelwork shawls and aprons as well as for *rosemaling* and carving.

150. Heddal costume; from eastern Telemark. EINAR HAUGEN

151. Hallingdal costumes.
NORSK FOLKEMUSEUM

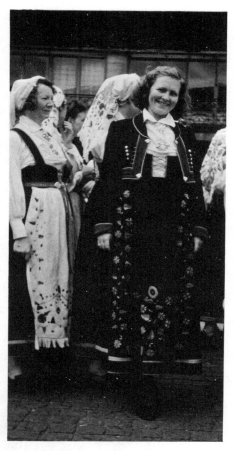

152. Aust-Agder costumes, with and without jackets. EINAR HAUGEN

The finely pleated Renaissance skirt with a stiffly billowing hem-line was used in Setesdal and parts of Telemark and probably in other parts of Norway, but it was in the southernmost districts that it remained longest. The Vest-Agder skirt was never as short or as high-waisted as the Setesdal skirt, nor did it stand out as far. It was made of black wool, bordered at the hem with three colored bands, usually two red with a green one between. The waistband was cut in a peak in the center back and was somewhat raised in front. Suspenders were buttoned on. An underskirt made in the same style, of white material, was worn with it.

Vest-Agder's bodice seems to have no close counterpart in Nor-way. Its most distinctive feature is the cut of the lower back edge which rises sharply in the center to follow the line of the skirt. The front neckline is moderately low. A row of exactly twelve lacing

rings lines each side of the opening. The lacings are pulled tightly at the lower edge, but the bodice spreads open above and may not even be completely laced at the top. In addition to the silver lacings and rings, a silver clasp may be worn at either side of the bodice opening at the lower edge. A brooch on the white blouse and silver buckles on the shoes follow the custom of the rest of Norway.

For winter wear there was a jacket, cut about the same as the bodice but with long sleeves, and hooked down the front rather than laced. It was made of black woolen, with cuffs of a contrasting material.

As in other districts the main difference between girls' and women's clothing was in the headdress. Women used a rather high cylindrical shape made of birch bark, cardboard, or thin wood, over which was stretched a strip of cloth made up of several pieces of colored material sewed together. It was worn toward the back of the head. Ruchings and white kerchiefs were a part of the headdress and were worn in different ways in different localities. The girls' headdress was likewise based on a circular frame but it was fat and round like a sausage rather than high and sharp. On Sundays it was covered with a white kerchief, on weekdays with a more ordinary cloth covering. The winter work costume included a knit jacket and wooden shoes. In summer the women went barefooted.

Toward the mid-1800's a new type of skirt came into use without completely replacing the old pleated type. It was the dark woolen or half-woolen skirt with contrasting vertical stripes which became so widespread throughout the northern countries during the last century. In Vest-Agder the stripes were usually green or brown, on a black ground. This type of material was also used for aprons.

In its dress as well as in other phases of folk art, Rogaland showed the influence its neighbors, Hardanger and Vest-Agder, exerted upon it. The Rogaland bodice combined the moderately low neckline and chain lacings of the Vest-Agder bodice with the contrasting edging

at armhole and neck that was used in Hardanger and most of the other west coast districts. There was no plastron, at least in the later examples, but the bodice itself was colorful and often of luxurious materials. Dark shawls, embroidered in Dutch tulip motifs filled the need for individuality as plastrons did in Hardanger or Voss. The mid-nineteenth century saw a swing toward jacket dresses, the jackets cut very much like the bodice, though with long sleeves. Jacket and skirt were sometimes of silk damask, more often of home-made woolens.

Because of the variety of costumes within each district and the variations due to individual taste, it is impossible to give specific and unqualified directions for making a given costume. Changing styles have caused some controversy as to which stage in costume development is the most worthy of being perpetuated. Hence there may be several costumes representing one district. In such areas as Sogn where folk costumes have been used until recent times, and where city fashions have had less effect, the costume specifications are quite clear. Other areas, such as Romerike, have been too open to urban trends and have nothing left upon which to base a local design.

There is still a good deal of costume research to be done in Norway. Scholars are working on this and other phases of folk art now and will undoubtedly succeed in finding more helpful material. Then it will be up to the people and their homecraft societies to select a costume representative of each district. By doing this the confusion that has attended costume occasions will be eliminated, and each district will have a definite tradition of dress to hand down to future generations.

S46. Couple from Meraaker, Nord Trøndelag, 1927.

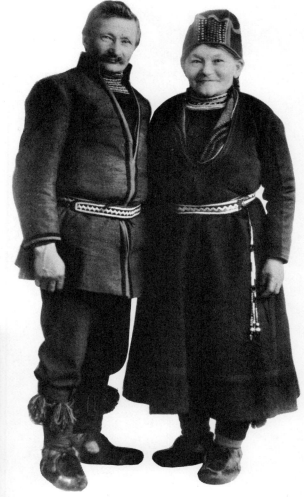

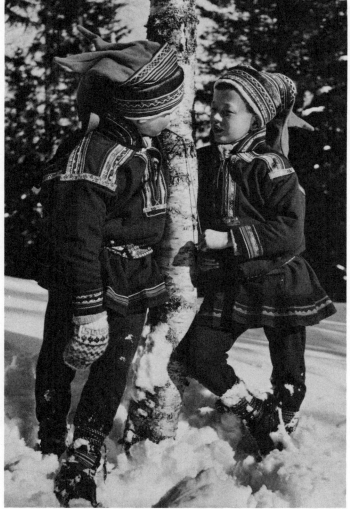

S47. Lapp boys from Kautokeino, Finnmark. Lapp costumes are in various shades of blue, with bright colored borders. They vary somewhat in style from one area to another, the basic piece being the rather full, belted, slipover shirt or dress. NORSK FOLKEMUSEUM

BIBLIOGRAPHY

Numbers in parentheses refer to chapters in this book for which listing is most valuable.

ANDERSEN, POUL. "Væv og vævild," *Festskrift til Museumsforstander H. P. Hansen.* Aarhus: Rosenkilde og Bagger, 1949. (6)

ARNEBERG, HALVDAN. *Norsk Prydkunst.* Kristiania: H. Aschehoug and Co., 1920. (3,4)

ASTRUP, EDLE, MOLAUG, RAGNHILD B., AND ENGELSTAD, HELEN. *Sting og Søm.* Oslo: H. Aschehoug and Co., 1950. (7)

BERGE, RIKARD. *Norskt Bondesylv.* Risør: Erik Gunleikson, 1925. (5)

BLOCK, MARY. *Den Stora Vävboken.* Stockholm: Bokførlaget Natur och Kultur, 1939. (6)

BOSSERT, HELMUTH T. *Peasant Art in Europe.* New York: E. Weyhe, 1927. (3,4,5)

BRØGGER, A. W., FALK, HJALMER, AND SHETELIG, HAAKON. *Oseberg Fundet,* Kristiania (Oslo): Den Norske Stat, 1917-28. Vols. 1,2,3,5. (1)

BRØNDSTED, JOHS. "Keltisk og Romersk Tid," *Nordisk Kultur,* Vol. XXVII (Kunst). Oslo: H. Aschehoug and Co., 1931. (1)

BUGGE, ANDERS, GREVENOR, HENRIK, ELIASSEN, GEORG, AND KIELLAND, THOR. *Norsk Bygningskunst.* Oslo: H. Aschehoug and Co., 1927. (2)

BUGGE, ANDERS AND STEEN, SVERRE. *Norsk Kulturhistorie.* Oslo: J. W. Cappelens Forlag, 1938. (1,3,6,8)

CHENEY, SHELDON. *A World History of Art.* New York: Viking Press, 1943. (1)

DAMM, ARNE AND JUST, CARL. *Look at Norway.* Oslo: N. W. Damm and Son. [1949?].

DEDEKAM, HANS. *Hvitsøm fra Nordmør.* Trondhjem: Nordenfjeldske Kunstindustrimuseum, 1914. (7)

ENGELSTAD, EIVIND S. *Kunstindustrien.* Oslo: H. Aschehoug and Co., 1950. (1,3,5,6,7,8)

ENGELSTAD, HELEN. *Fortids Kunst i Norges Bygder: Norske Ryer,* Serie II, Publikasjon I. Oslo: Kunstindustrimuseet, 1942. (6)

Folkekunst, andre og tredje aargang, hefte 5–15. Oslo: Norsk Bygdekunstlag, 1949. (3,4,6)

FOOTE, ANNE AND SMEDAL, ELAINE. *Decorative Art in Wisconsin*. Madison, Wis. [1948].

FREMBLING-MAIRE, ELIZABETH. "European Folk Art," *School Arts*, XLVI (April 1947), 254–88. (7)

Gamal Rosemåling frå Telemark, portfolio of color plates by Knut Hovden. Telemark Husflid- og Husindustrilag og Telemark Husflidssentral. (4)

Gammel Rosemaling i Rogaland, mappe 1,2,3,4. Color plates by Knut Hovden. Rogaland Husflidslag og Stavanger Husflidsforening. (4)

GARBORG, HULDA. *Norsk Klaedebunad*. Kristiania: H. Aschehoug and Co., 1917. (7,8)

GARDNER, HELEN. *Art Through the Ages*. New York: Harcourt, Brace, and Co., 1936 (revised edition) (1)

GJESSING, THALE. *Gudbrandsdalens Folkedrakter*. Oslo: Johan Grundt Tanum, 1949. (7,8)

HALVORSEN, CAROLINE. *Den Norske Husflidsforenings Handbok i Vevning, 5te utgave*. Oslo: J. W. Cappelens Forlag, [1927]. (6)

HOLME, CHARLES. *Peasant Art in Sweden, Lapland, and Iceland*. London: The Studio Ltd., 1910. (1,4)

KAUFFMAN, HENRY. *Pennsylvania Dutch American Folk Art*. New York: Studio Publishing Co., 1946. (3,4) (Dover reprint)

KIELLAND, THOR. "Norwegian Tapestries," *American-Scandinavian Review*, XXXV (March 1947), 22–29. (6)

KLOSTER, ROBERT. "Billedvev og ildsted," *Bergen Museums Årbok*, 1934. (2,4,6)

———. "Ekspansjon i bygdekunsten," *Bergen Museums Årbok*, 1941. (1,8)

———. "Håndverksbygden og bygdehåndverkeren," *Bergen Museums Årbok*, 1945. (1)

———. "Røkovnen, badstue og røkstue," *Bergen Museums Årbok*, 1923–1924. (2)

———. "Vestnorsk bygdekunst," *Bergen Museums Årbok*, 1937.

KRONQUIST, EMIL. *Metalcraft and Jewelry*. Peoria, Ill.: Manual Arts Press, 1926. (5)

LARSEN, KAREN. *A History of Norway*. New York: Princeton University Press for the American Scandinavian Foundation, 1948. (1–8)

LEXOW, EINAR. "Gammel vestlandsk vævkunst," *Bergen Museums Årbok*, 1914–1915. (6)

———. "Norges Kunst i Middelalderen," *Nordisk Kultur*, XXVII. Oslo: H. Aschehoug and Co., 1931. (1,3,4,6)

LOFTNESS, SONYA. "Character of Norwegian Design," *School Arts*, XLVI (April 1947), 266–68. (4)

————. "Norwegian Handicrafts," *School Arts*, XLV (December 1945), 118–20. (4,5)

MEYER, JOHAN. *Fortids Kunst i Norges Bygder: Gudbrandsdalen*. Kristiania: Alb. Cammermeyers Forlag, 1909. (1–5)

————. *Fortids Kunst i Norges Bygder: Numedal*. Oslo: H. Aschehoug and Co., 1930. (1–5)

————. *Fortids Kunst i Norges Bygder: Sunndalen på Møre*. Oslo: H. Aschehoug and Co. (W. Nygaard), 1938. (1–5)

————. *Fortids Kunst i Norges Bygder: Telemarken*. Kristiania: H. Aschehoug and Co. (W. Nygaard), 1913–1924. (1–5)

————. *Fortids Kunst i Norges Bygder: Østerdalen I og II*. Oslo: H. Aschehoug and Co., 1934–1936. (1–5)

Norsk Bygdekunst fra Middelalder til Nutid. Oslo: H. Aschehoug and Co., 1929. (3–7)

Norsk Kunsthistorie, Oslo: Vol. I, 1925 (1–3). Vol. II, 1927. (3–5)

Den Norske Husflidsforening Håndbok i Veving, 9de utgave. Oslo: J. W. Cappelens Forlag, 1950. (6)

Norske Bygder: Glåmdal. Bergen: John Griegs Forlag, 1942. Vols. 1,2,3,4. *Romerike I and II*. Bergen: John Griegs Forlag, 1934. (1–8) *Setesdalen*. Christiania: Alb. Cammermeyers Forlag, 1921. (1–8) *Sogn*. Bergen: John Griegs Forlag, 1937. (1–8) *Vest-Agder I and II*. Bergen: John Griegs Forlag, 1927. (1–8)

Norwegian American Commerce (Silver-work issue) Vol. XV, No. 6 (June, 1950). (5)

NYLÉN, ANNA-MAJA. *Swedish Peasant Costumes*. Stockholm: Nordiska Museet, 1949. (8)

OPRESCU, GEORGE. *Peasant Art in Roumania*. London: The Studio Ltd., 1929.

PAYANT, FELIX. "European Peasant Art," *Design*, January 1938. Vol. 39, No. 7, pp. 1–31.

PERCIVAL, MACIVER. *Chats on Old Jewelry and Trinkets*. New York: Frederick A. Stokes Co., 1912. (5)

PETERSEN, JAN. "Eldre Vikingestil," *Nordisk Kultur*, Vol. XXVII. Oslo: H. Aschehoug and Co., 1931. (1)

PLATH, IONA. *Decorative Arts of Sweden*. New York: Charles Scribner's Sons, 1948. (2–7) (Dover reprint)

PRIMMER, KATHLEEN. *Scandinavian Peasant Costume*. London: A. and C. Black, 1939. (8)

READ, HERBERT. "Greeks and Barbarians," *Now*, Vol. 5. London: Freedom Press (1)

Rosemåling frå Nordmøre. Portfolio of color plates. Nordmøre Husflidslag (4)

SANDAL, TORA. "En Trøndersk Tekstilgruppe," *Nordenfjeldske Kunstindustrimuseum Årbok,* 1947. (6)

———. "Fra en rosemalers verksted paa Nordmøre," *By og Bygd,* 5. Aargang. Oslo: 1947. (4)

SANDVIG, ANDERS. *De Sandvigske Samlinger.* Kristiania: W. C. Fabritius og Sønner, 1907. (2,3,5,7)

———. *Vår Gamle Bondebebyggelse.* Lillehammer: i kommisjon med Noregs Boklag (2,3)

SHETELIG, HAAKON. "Karveskur paa Vestlandet," *Bergen Museums Årbok,* 1913. (3)

———. FALK, HJALMAR, AND GORDON, E. V. *Scandinavian Archeology.* Oxford: The Clarendon Press, 1937. (1)

SIBBERN, ANNICHEN. *Norske Strikkemønstre.* Oslo: Grøndahl and Sons Forlag (7)

SMEDAL, ELAINE. "Introductory Index of Norwegian Handicrafts Design in Wisconsin." Unpublished M. A. thesis, University of Wisconsin, 1945. (3,4,5)

——— AND TRESSLER, ANNE. *Norwegian Design in Wisconsin.* Madison, Wisconsin: Campus Publishing Co., 1946. (3–7)

——— AND TRESSLER, ANNE. "Painted Decoration on Wooden Articles." Dittoed direction sheets, Department of Debating and Public Instruction, University of Wisconsin (4)

STRZYGOWSKI, JOSEF. *Early Church Art in Northern Europe.* New York and London: Harper and Bros., 1928. (1)

SUNDT, EILERT. *Om husfliden i Norge.* Kristiania: Selskabet for Folkeoplysningens Fremme, 1867–68. New edition, Oslo: Blix Forlag, 1945.

TANGERMAN, E. J. *Design and Figure Carving.* New York: McGraw-Hill Book Company, Inc., 1940. (3) (Dover reprint)

TRÆTTEBERG, GUNVOR. "Draktstudier fra Øygarden," *Bergen Museums Årbok,* 1941. (8)

VISTED, KRISTOFER. "Nyere Folkekunst," *Norsk Kunsthistorie,* Vol. II. Oslo: Gyldendal Norsk Forlag, 1927. (3–7)

———. *Vor Gamle Bondekultur.* Kristiania: J. W. Cappelens Forlag, 1923. (1–8)

——— AND STIGUM HILMAR. *Vår Gamle Bondekultur,* Vol. II. Oslo: J. M. Cappelens Forlag, 1952.

VON WALTERSTORFF, EMELIE. *Swedish Textiles.* Stockholm: Nordiska Museet, 1925. (6,7)

VREIM, HALVOR. *Norsk Trearkitektur*. Oslo: Gyldendal Norsk Forlag, 1939. (1,2)

————. *Norwegian Decorative Art Today*. Oslo: Fabritius og Sønner, 1937.

VÅGE, MAGNUS. "Rogalandsbunaden," *Stavanger Museums Aarshefte*, 1925–28. (8)

Yrke, Nr. 5 and 6, 1947. Oslo. (5)

ØDVIN, MAGNHILD. "The Folk Museum at Bygdøy," *American-Scandinavian Review*, December 1930. (1–6). Vol. XVIII 741–752.

INDEX

working, 44, 77; painting, 97, 105, 114; clothing, 220

Engraving: Migration style, 8; of iron, 120; of silver, 129

Eyelets *(maler)*, 132-33

Eyelet embroidery, 197

FANA: knitting, 200-201; women's dress, 210

Filigree: in Roman period, 6; in Migration period, 8; techniques, 129-31; on *maler*, 133; on clasps, 134-35; on pins, 139, 140, 141, 143, 144; on buttons, 146

Fireplace: in *aarestue*, 29; in *røkovnstue*, 30; in *peisestue*, 39; *mur*, 40. *See also peis*

Fire screens, 38

Flamework embroidery, 189

Flat-carving: Gothic, 42, 70; Renaissance, 58, 72; texturing, 65; in Telemark, 70, 71

Floor: in *aarestue*, 29; in *røkovnstue*, 36, 93

Floral motifs: in *rosemaling*, 89, 97, 101, 104, 108, 109, 110, 114. *See also rosesaum*

Fobs, 128

Folk art: beginning of, 23; decline of, 24; revival of, 24, 25

Foreign influences: Stone Age, 4; Bronze Age, 4, 5; Iron Age, 5, 6; Roman period, 6; Migration period, 7; post-Migration period, 9; Viking period, 10, 11, 14, 15; Romanesque period, 20; 18th century, 23; on *rosemaling*, 95, 98, 104, 105, 107-108, 109-10; on metalwork, 115, 116, 117; on weaving, 153, 161; on embroidery, 191, 195, 199; on clothing, 205, 224

Free embroidery, 182, 183-86, 215

fremskap. See Cupboard

Furniture: in *aarestue*, 29; in *røkovnstue*, 31-36; in *peisestue*, 45, 47; in Setesdal, 68; in Numedal, 76, 77; in Glomdal, 83, 84; in Romerike, 84-85; in Hallingdal, 103, 104

Førland, Eilert, 110

GARTERS, 176, 178-79

geisfuss, 72

Geometric embroidery: colored, 186, 187-89; blackwork, 190; whitework, 192, 193, 196, 197, 215

Geometric motifs: in Stone Age, 4; in Bronze Age, 4; in carving, 62; in woodburning, 76; in *rosemaling*, 96, 107; in weaving, 154, 155, 177; in knitting, 200

Glomdal (Østerdal): conditions in, 51, 95; housing, 51-52; carving, 82-84; *rosemaling*, 88, 95-97; metalwork, 120, 121; square weaving, 167; *rosesaum*, 183-184; men's dress, 205; women's dress, 218, 219

Gold plating, 131

Gothic styles: introduction of, 20-21; in chip carving, 37, 67; in carving rosettes, 38, 55, 71, 72, 118; discussion of, 42, 49, 57, 58, 72; in flat carving, 70; in ironwork, 118, 119; in *maler*, 133; in clasps, 134; in belt plates, 136; in *slangesølje*, 140-41; in buttons, 147; in weaving, 164

Goths: trade with, 6, 7; origin of, 7

Gouge carving, 72

Graves: in Viking period, 11-12

Grave-crosses, 122

Griffon, 89

grindvev weaving, 177-78

Grunnset, market town, 95

grøtspann, 76

Gudbrandsdal: housing, 51; conditions in, 51, 80, 98; carving, 59, 60, 77-80, 99; *rosemaling*, 88, 98-100; iron-

Nordhordland: conditions in, 63; drinking vessels, 64; weaving, 166-67, 169; pile weaving, 175; embroidery, 195; knitting, 200

Nordland: weaving, 169

Nordmøre: housing, 52; *rosemaling*, 90; metalwork, 126; *bragd*-weaving, 169; *sprang*, 179; embroidery, 192, 193, 196-98, 199. *See also* Møre

"Nordmøre embroidery," 197-98

Nore church, 74

Numedal: conditions in 73, 104; carving, 73-77; *rosemaling*, 88, 104-106; ironwork, 120; silverwork, 132, 134, 142, 143; men's dress, 206; women's dress, 216

OLAF Tryggvason, 11

Olav Haraldsson, 11

Opdal: carving, 82; *rosemaling*, 114

Opdal church, 74

Open-hearth house. *See aarestue*

Oriental motifs and influence, 8, 11, 20, 56, 116, 158, 173, 199

Ornaments: silver, 126-28

Oseberg ship: description of, 12; contents of, 12; carvings, 14; weavings in, 149, 156; motifs, 189

Oseloft door: ironwork, 118

Oslo: trade with Romerike, 84, 85; trade with Glomdal, 95

overskjæring, 152

PAGAN symbols, 116

Paint: preparation of, 92

Painting: in pre-Renaissance home, 36; of house exteriors, 52; of carving, 99; floral. *See rosemaling*

Paleolithic art. *See* Stone Age

Panelling, Renaissance: of cupboards, 42, 58, 83; of walls, 51, 52; baroque, 59, 83; in Romerike, 85; in Glomdal, 85, 97

Pastoral painting, 77

Patch pattern *(tavlebragd)*: in weaving, 169-70

Pattern-darning, 189, 190, 192

peis: construction of, 39, 40; location of, 41, 46, 47; support for, 121

peisestue, 41-42, 47, 76

Pendant: discussion of, 131-32; *Agnus Dei*, 123, 131; bracteate, 7, 131

Pictorial art: in Viking period, 15-16; Romanesque, 19-20; in Glomdal, 51, 85, 96; in Telemark, 70; in Romerike, 85, 97; discussion of, 87, 89-90; in Gudbrandsdal, 98, 100; in Numedal, 105; in Setesdal, 107

Picture weaving, 153, 156-63

Pierced work, 120-21

Pile weave: solid pile, 172-74; half pile, 173-74

Pillow covers, 155, 163, 172-73

Pins: discussion of, 128, 137-45; shield, 138; *bursølje*, 138; mask pin, 138; *bolesølje*, 138-39; *skaalesølje*, 139; *Trandeimsølje*, 139-40; *rosesølje*, 140, 141; *slangesøbje*, 140-41; *taggesølje*, 141; spur pin, 142; horn ring, 143-44; *sprette*, 144-45

Plaiting, 178-79

Plane: for carving, 61

Plank construction, medieval, 42, 62

Plant motifs: in Viking art, 15; Romanesque, 18, 19, 20, 38; Renaissance, 58, 59; baroque, 59; rococo, 60; in Gudbrandsdal, 59, 60, 77-79, 98, 99; in Vest-Agder, 65, 108; in Setesdal, 67, 107; in Telemark, 72, 73, 101, 102; in Numedal, 74, 76, 104, 105, 120; in Sunndal, 81, 82; in Glomdal, 84, 96, 120; in Romerike, 85, 97; discussion of, in *rosemaling*, 89; in Hallingdal, 103; in Rogaland, 109-10; in Sogn, 110; in Møre, 112, 114; discussion of, in weaving, 161

Plastering, introduction of, 52

in Numedal *rosemaling*, 105
rosesaum embroidery, 183-87
Rosette, 67, 71, 72, 111, 118
roskap. See Cupboard
Rugs: square-woven, 163; pile-woven, 173-76
Runic writing, 7, 74, 119
Rural artists. *See* Craftsmen
ryer, 173-76
røkovn, 30, 31, 32, 39
røkovnstue, 30-31, 36
Røros: copper mines at, 117; women's dress, 217

SAND, Torstein, 103
Satin stitch embroidery, 184, 187, 196
Saw, 61
Scratch carving, 76
Scroll embroidery, 183-87
Scroll motifs, 87
Sea horse, 89
Selbu: embroidery, 192; knitting, 200-201
Setesdal: housing, 53; carving, 58, 67-69, 118; ale bowls, 67, 93, 94, 106-107; conditions in, 106; *rosemaling*, 106-107; metalworking, 117, 118, 139, 140; weaving, 167, 169, 178; embroidery, 185, 188, 189; knitting, 199-200; men's dress, 205, 206, 207, 221; women's dress, 220-22
Shawl, Sørland, 186
Sheath, knife, 128, 136-37
Sheep, 152
Shell motif, 60, 102
Shield motif, 158
Ship burial, 11-12. *See also* Oseberg ship
Shirts, embroidery of, 187
Shoes, 204
Siding, 52
Sigurd the Dragon-Killer, 19-20
Silk, 152

Silver: importance of, 122-23; superstitions about, 123-24; *huldre*, 124; *bonde*-made, 125-26; city, 125-26; bridal, 126-28, 214; preparation of, 128; chasing of, 129; engraving of, 129
Silver brooches, Migration style, 7-8. *See also* Pins
Silver crisis, 126, 214
Silverworkers, 125-26
Silverworking techniques, 128-31
sjonbragd, 169, 172-73
skilbragd, 169, 171, 172
skjøve, 61
skulpesnitt, 72
skybragd motif, 161-62
Sleighs, 60, 98
smettesaum border: in embroidery, 190
Snake hinge, 119
Social conditions: in Bronze Age, 5; in post-Migration period, 9; in Viking period, 11; in 13th century, 21; in 14th century, 22; in 18th century, 23.
Sod roofs, 27, 28
Sogn: conditions in, 63, 111, 112; carving, 62-65; *rosemaling*, 110-12; candlesticks, 121; square weaving, 166; pile weaving, 174; embroidery, 186, 189-94, 196; appliqué, 198-99; women's dress, 212-14
"Sogndal painter," 111
Soldering, 130-31
Sordal: storehouse at, 118
Spinning, 151
Spoons, 66, 82, 137
sprang, 179-80
Square-weaving, 163-67
Staining: in chip-carving, 84; to resemble wood, 100
Stamping: of wood, 64, 66, 82, 84; of woven material, 151
staup, 64
Stave churches: at Urnes, 16, 17, 18;

construction of, 18, 20; at Borgund, 19; at Nore, 74; at Opdal, 74

Stavework, 64, 83-84

Stefan Stalledreng, 119

"Stefan's work," 119

Steins, wooden, 65, 84, 85

Stencils: use of, 90

Stockings, 200, 201, 204, 206

Stone Age, in Norway, 4

Stor-Elvdal, 95

Strapwork. *See* Interlaced band ornament

stue, 47, 50

Sunndal: carving, 81-82; conditions in, 81; embroidery, 197

Sunnfjord: drinking vessels, 64; women's dress, 208

Sunnhordland: beadwork, 197, 198

Sunnmøre: *rosesaum*, 185, 186; women's dress, 215

Sun-wheel, 67, 69

Sun worship, 119

Superstition: about house construction, 27-28, 37, 38, 69, 119; about bride's bowl, 68-69; in religious art, 116; about silver, 123-24

sval, 31, 46, 50, 52

svalgang, 18

svarvestol, 61

Swastika, 189, 192

Sweater, 200-201

Sweden: trade, 9, 95; band ornament, 10; in control of Norway, 21, 24

Swedish tapestries, 167-68, 169

Swedish weaving, 95

Symbolism: in metalwork, 144, 145

Sørland: *rosesaum*, 186; women's dress, 224. *See also* Vest-Agder; Aust-Agder

TABLE: devlopment of, 32-34; supports, 74; legs, 85, 93

Tapestry: in *aarestue*, 30; in Oseberg ship, 149; Øverhogdal, 153; horizon-

tal, 154; vertical, 155; Baldishol, 156-57; picture-woven, 156–63; square-woven, 163-67; "Swedish," 167-68, 169

Tape weaving: at Evebø, 156; discussion of, 176-79

teksle, 61

Telemark: buildings, 53; carving, 60, 69-73; craftsmen, 65-66, 117; conditions in, 69, 73, 100, 101; *rosemaling*, 88, 100-103; ironwork, 119; brasswork, 120; silverwork, 134, 138; braids, 178; *rosesaum*, 184, 185; geometrical embroidery, 187-88; whitework, 192; men's dress, 206; women's dress, 220, 222, 223-24

Textiles, 36, 46, 152

Thread: preparation of, 150-52

Three Wise Men tapestry, 160-61

Tinn: metalwork, 132, 142; *rosesaum*, 185

Tools: adopted from Romans, 6; woodworking, 61

Trade: routes, 4, 5; with Denmark, 5; with Celts, 5, 6; with Romans, 6; with Goths, 6, 7; with western Europe, 8; in Viking period, 10, 11; modern, 23, 95, 98

trau (trough), 61, 66

Treasure boxes, 66

Tree: motifs, 96, 97, 154, 155; of Life, 158

Trondheim: trade with Glomdal, 95; influence on painting, 114; silverwork, 125; men's dress, 205

Trøndelag: housing, 52; carving, 60, 82; *rosemaling*, 114; double weaving, 154-56; picture weaving, 163; *bragd*-weaving, 169; pile weaving, 174; colored embroidery, 189; women's dress, 217-18

Tulip: in carving, 73; in *rosemaling*, 87, 97, 105, 107, 110; in weaving, 161

Twisting of iron, 119

Dover Books on Art

Dover Books on Art

PRINCIPLES OF ART HISTORY, H. Wölfflin. This remarkably instructive work demonstrates the tremendous change in artistic conception from the 14th to the 18th centuries, by analyzing 164 works by Botticelli, Dürer, Hobbema, Holbein, Hals, Titian, Rembrandt, Vermeer, etc., and pointing out exactly what is meant by "baroque," "classic," "primitive," "picturesque," and other basic terms of art history and criticism. "A remarkable lesson in the art of seeing," SAT. REV. OF LITERATURE. Translated from the 7th German edition. 150 illus. 254pp. 6⅛ x 9¼. 20276-3 Paperbound $4.50

FOUNDATIONS OF MODERN ART, A. Ozenfant. Stimulating discussion of human creativity from paleolithic cave painting to modern painting, architecture, decorative arts. Fully illustrated with works of Gris, Lipchitz, Léger, Picasso, primitive, modern artifacts, architecture, industrial art, much more. 226 illustrations. 368pp. 6⅛ x 9¼. 20215-1 Paperbound $6.95

METALWORK AND ENAMELLING, H. Maryon. Probably the best book ever written on the subject. Tells everything necessary for the home manufacture of jewelry, rings, ear pendants, bowls, etc. Covers materials, tools, soldering, filigree, setting stones, raising patterns, repoussé work, damascening, niello, cloisonné, polishing, assaying, casting, and dozens of other techniques. The best substitute for apprenticeship to a master metalworker. 363 photos and figures. 374pp. 5½ x 8½.
22702-2 Paperbound $5.00

SHAKER FURNITURE, E. D. and *F. Andrews.* The most illuminating study of Shaker furniture ever written. Covers chronology, craftsmanship, houses, shops, etc. Includes over 200 photographs of chairs, tables, clocks, beds, benches, etc. "Mr. & Mrs. Andrews know all there is to know about Shaker furniture," Mark Van Doren, NATION. 48 full-page plates. 192pp. 7⅞ x 10¾. 20679-3 Paperbound $5.00

LETTERING AND ALPHABETS, J. A. Cavanagh. An unabridged reissue of "Lettering," containing the full discussion, analysis, illustration of 89 basic hand lettering styles based on Caslon, Bodoni, Gothic, many other types. Hundreds of technical hints on construction, strokes, pens, brushes, etc. 89 alphabets, 72 lettered specimens, which may be reproduced permission-free. 121pp. 9¾ x 8. 20053-1 Paperbound $3.50

THE HUMAN FIGURE IN MOTION, Eadweard Muybridge. The largest collection in print of Muybridge's famous high-speed action photos. 4789 photographs in more than 500 action-strip-sequences (at shutter speeds up to 1/6000th of a second) illustrate men, women, children—mostly undraped—performing such actions as walking, running, getting up, lying down, carrying objects, throwing, etc. "An unparalleled dictionary of action for all artists," AMERICAN ARTIST. 390 full-page plates, with 4789 photographs. Heavy glossy stock, reinforced binding with headbands. 7⅞ x 10¾. 20204-6 Clothbound $15.95

Dover Books on Art

DESIGN AND FIGURE CARVING, E. J. Tangerman. "Anyone who can peel a potato can carve," states the author, and in this unusual book he shows you how, covering every stage in detail from very simple exercises working up to museum-quality pieces. Terrific aid for hobbyists, arts and crafts counselors, teachers, those who wish to make reproductions for the commercial market. Appendix: How to Enlarge a Design. Brief bibliography. Index. 1298 figures. x + 289pp. 5⅜ x 8½.

21209-2 Paperbound $4.50

THE STANDARD BOOK OF QUILT MAKING AND COLLECTING, M. Ickis. Even if you are a beginner, you will soon find yourself quilting like an expert, by following these clearly drawn patterns, photographs, and step-by-step instructions. Learn how to plan the quilt, to select the pattern to harmonize with the design and color of the room, to choose materials. Over 40 full-size patterns. Index. 483 illustrations. One color plate. xi + 276pp. 6¾ x 9½.

20582-7 Paperbound $4.95

A HISTORY OF COSTUME, Carl Köhler. The most reliable and authentic account of the development of dress from ancient times through the 19th century. Based on actual pieces of clothing that have survived, using paintings, statues and other reproductions only where originals no longer exist. Hundreds of illustrations, including detailed patterns for many articles. Highly useful for theatre and movie directors, fashion designers, illustrators, teachers. Edited and augmented by Emma von Sichart. Translated by Alexander K. Dallas. 594 illustrations. 464pp. 5⅛ x 7⅛.

21030-8 Paperbound $6.50

Dover publishes books on commercial art, art history, crafts, design, art classics; also books on music, literature, science, mathematics, puzzles and entertainments, chess, engineering, biology, philosophy, psychology, languages, history, and other fields. For free circulars write to Dept. DA, Dover Publications, Inc., 180 Varick St., New York, N.Y. 10014.